W9-CZS-574

THE OHIO STATE UNIVERSITY

PATHWAYS TO THE HEART AND MIND

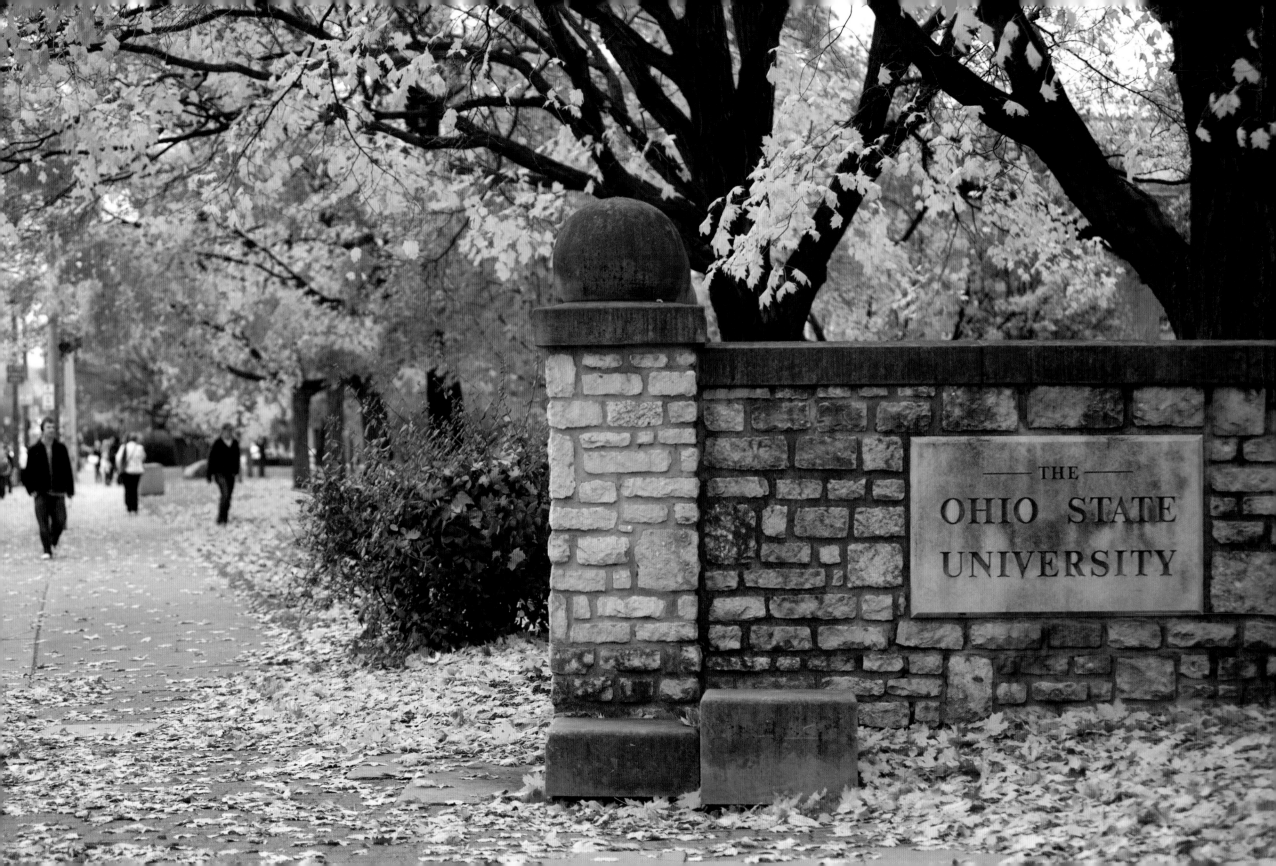

THE OHIO STATE UNIVERSITY

PATHWAYS TO THE HEART AND MIND

INTRODUCTION BY E. GORDON GEE • TEXT BY HUGH McMANUS
PHOTOGRAPHY BY ROBERT A. FLISCHEL

DAVID-FLISCHEL ENTERPRISES, LLC
CINCINNATI, OHIO

DEDICATION

Because their destinies are forever linked,
this book is respectfully dedicated to
The Ohio State University and the people of Ohio.

The Ohio State University: Pathways to the Heart and Mind

Publishers: Kimberly David & Robert A. Flischel

Editor: Jean Findley, LEAP Publishing Services

Introduction: E. Gordon Gee

Photographer: Robert A. Flischel

Designer: Craig Ramsdell, Ramsdell Design

Writer: Hugh McManus

Managing Editor: Mara Mulvilhill

Senior Editor & Research Director: Suzanne Jolly

Digital Editor: Charles Behlow

Field Editor: Duke McGonegle

Pre-Production Associate: Margaret David

Location Scout: Brianna Powers

Executive Committee:
Scott David, Leo Flischel, Pat Gaito, Kathy Smith

Preliminary Design: Madison Design Group

Printed in China

© 2012 David-Flischel Enterprises, LLC

No part of this publication may be reproduced in any material forms or by any means, electronic or mechanical, including any information retrieval system, without written permission from the publisher. Reviewers may quote briefly.

David-Flischel Enterprises, LLC

Telephone: (513) 272-2700 • (513) 271-3113

Email: davidflischelentps@gmail.com

ISBN (hardcover) 978-0-9745962-5-9

Library of Congress Control Number: 2012913993

Frontispiece: Entrance to the university at West Woodruff Avenue and High Street.

Dedication: Commemorative window honoring The Ohio State University, Western Hills High School library, Cincinnati Ohio.

Introduction: Looking west on the North Oval Mall.

Section I: Page 10 & 11
Left: View of the Oval from the Thompson library reading room.
Right: Pathway along the Olentangy river.

Section III: Page 62 & 63
Left: View of the Recreation and Physical Activities Center.
Right: Jesse Owens Memorial.

Section III: Page 118 & 119
Left: Position chart for script Ohio.
Right: Marquee of the Ohio Theater, which inspired the design of "Script Ohio."

Afterword: View of Columbus Ohio from the confluence of the Scioto and Olentangy rivers.

Acknowledgements: Detail of a light fixture with Buckeye detailing, Ohio Union.

Endpapers: Vintage endpapers courtesy of The Ohio State University Archives.

CONTENTS

THE HEART AND MIND OF A BUCKEYE

Each year around this time, a familiar sense of awe tugs at my heart. It is early spring on our campus. The tree outside my window is in full bloom, the grass on the Oval is vibrant green. With this view in mind, I put reflections to paper.

Every day, 57,000 students and 40,000 faculty and staff members traverse our campus. They are engaging in intellectual discussions of the highest order, working on humanity's most pressing challenges, embarking on groundbreaking research, writing the next Great American Novel, and reaching as high as they dare to reach.

I imagine that these bright, busy people sometimes forget to slow down and simply look around. I am so very grateful when I do. Often it is in those rare moments of rest when we are struck by flashes of insight. And it is usually during these quiet moments when I am reminded of the majestic beauty of our campus.

Flipping through these pages, I see the familiar, breathtaking scenery that inspires me each day. This book captures the very essence of Ohio State, not only the panoramas and the vistas, but the vitality and grand traditions that make us who we are. We are taken into the halls of academic buildings, under the dome of Ohio Stadium, and above the Thompson Library, looking down on the spectacular Oval. We are given a peek at a pick-up game of football by Mirror Lake, a classroom of ballerinas ready for rehearsal, and the legendary Horseshoe, where we can feel the spirit radiating from the clanging cymbals of the Best Damn Band in the Land.

With thousands of people walking our campus each day come many different pathways to success. But what is so special about The Ohio State University is that all of us share one heart and one enduring tradition.

I do hope you enjoy this fabulous portrait of our beautiful home. Go Bucks!

Sincerely,

E. Gordon Gee
President

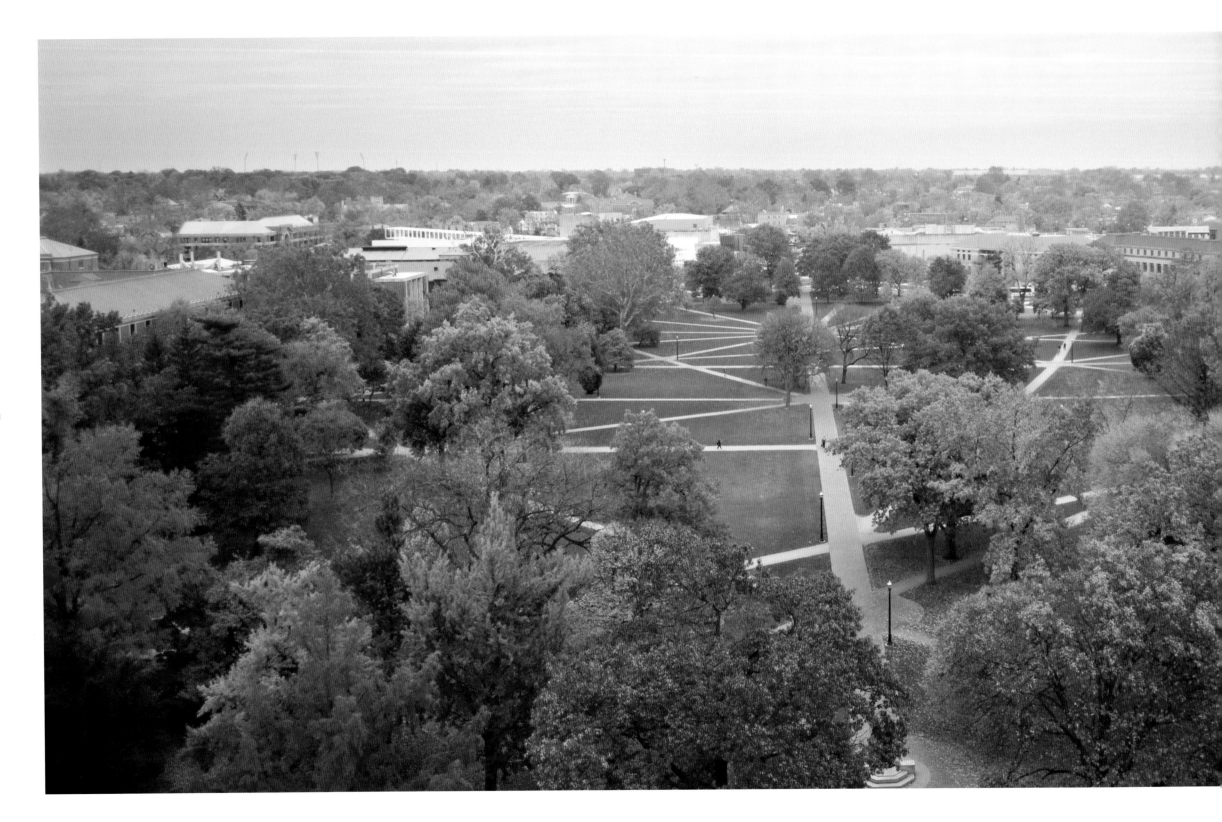

LANDSCAPE

For visitors, the Oval is the gateway that bestows both the first and the lasting impression of The Ohio State University campus. For students and faculty, the Oval serves a functional purpose as well as being a permanent beacon for their time at OSU. Not included in the original campus design, the Oval, like the men and women who traverse it daily, has developed and evolved over the years, becoming more distinguished, more refined, and more loved. For students and faculty alike, the Oval provides an open space that is removed from the halls of academia and dorm life. The many walking paths allow for a nearly endless number of routes on a beautiful day. During the spring and summer, students enjoy the beauty of the space for socializing, studying, and participating in cultural activities. The Oval is an icon for The Ohio State University's pride and spirit and the timeless traditions that surround the campus.

ON THE OVAL

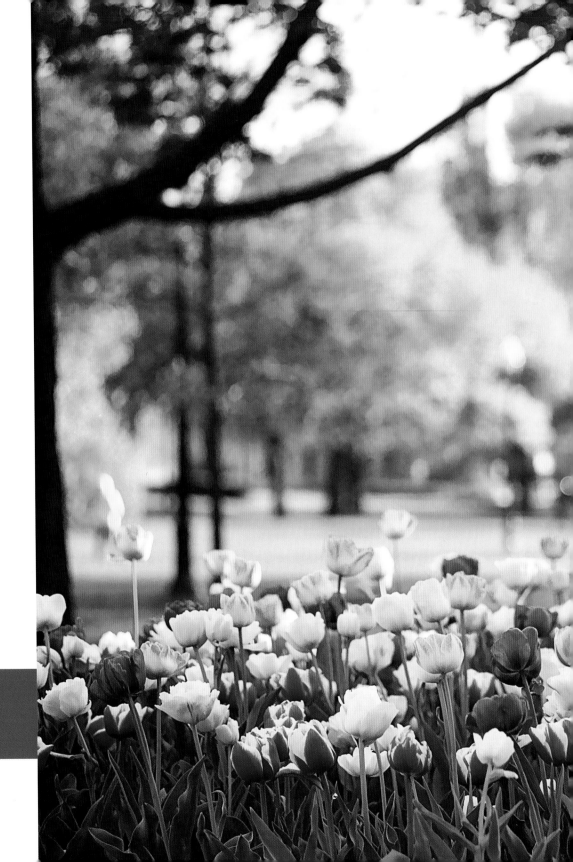

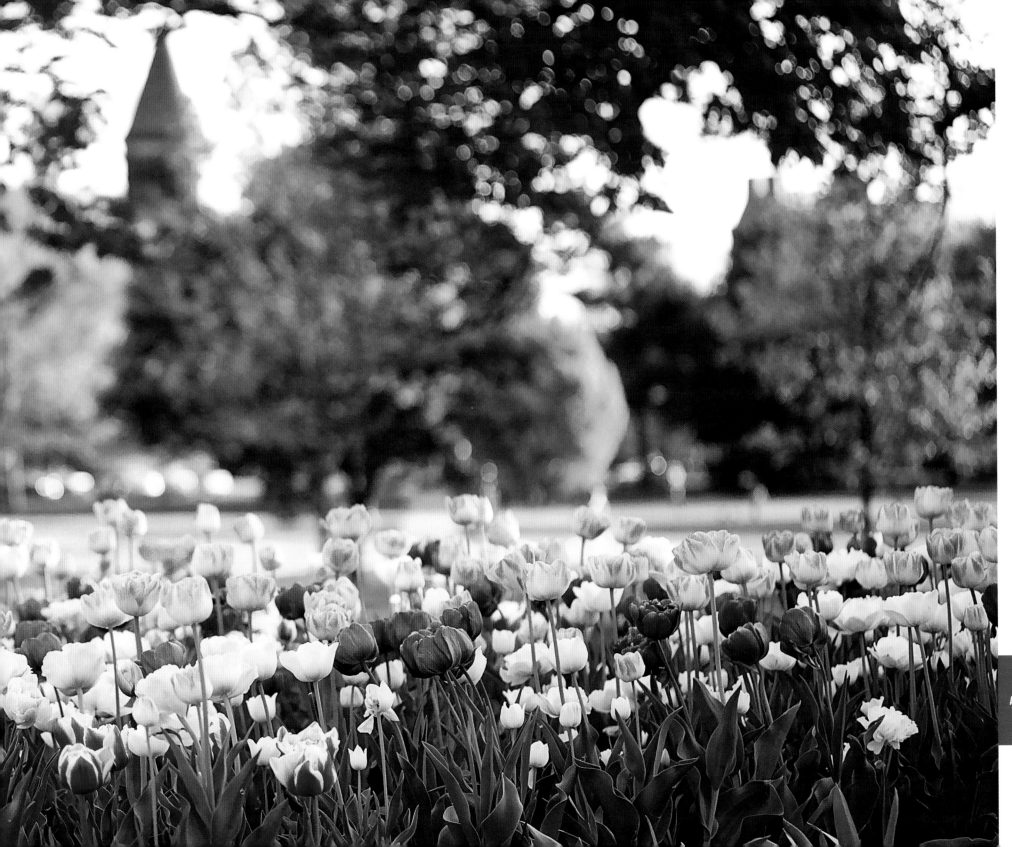

A view of the Oval across a bed of tulips.

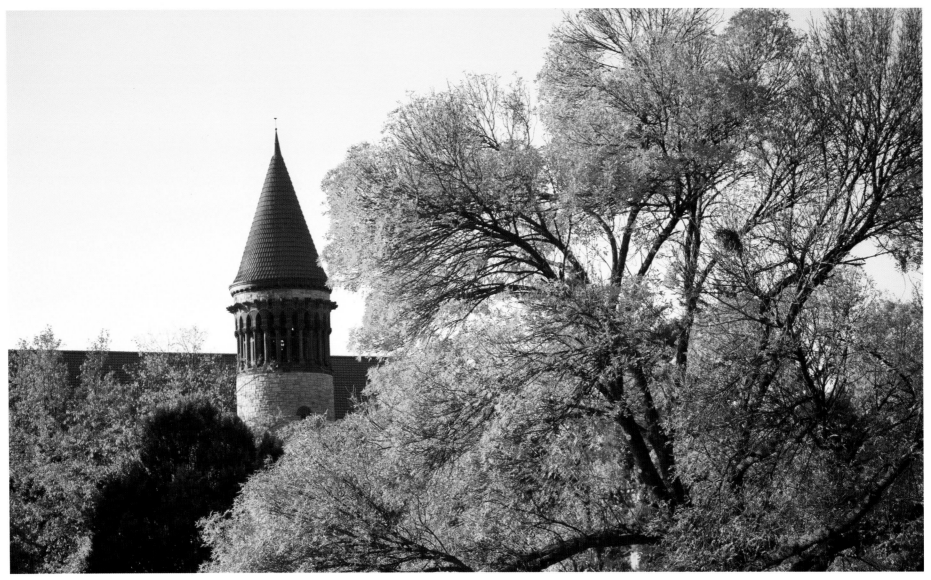

View of Orton Hall, The Ohio State
University's oldest building, dedicated
and opened in 1893. It is recognized
on the National Register of Historic
Places and is an excellent example of
Richardsonian Romanesque architecture.

Opposite page: The opportunities
are endless for repose and
reflection on the Oval.

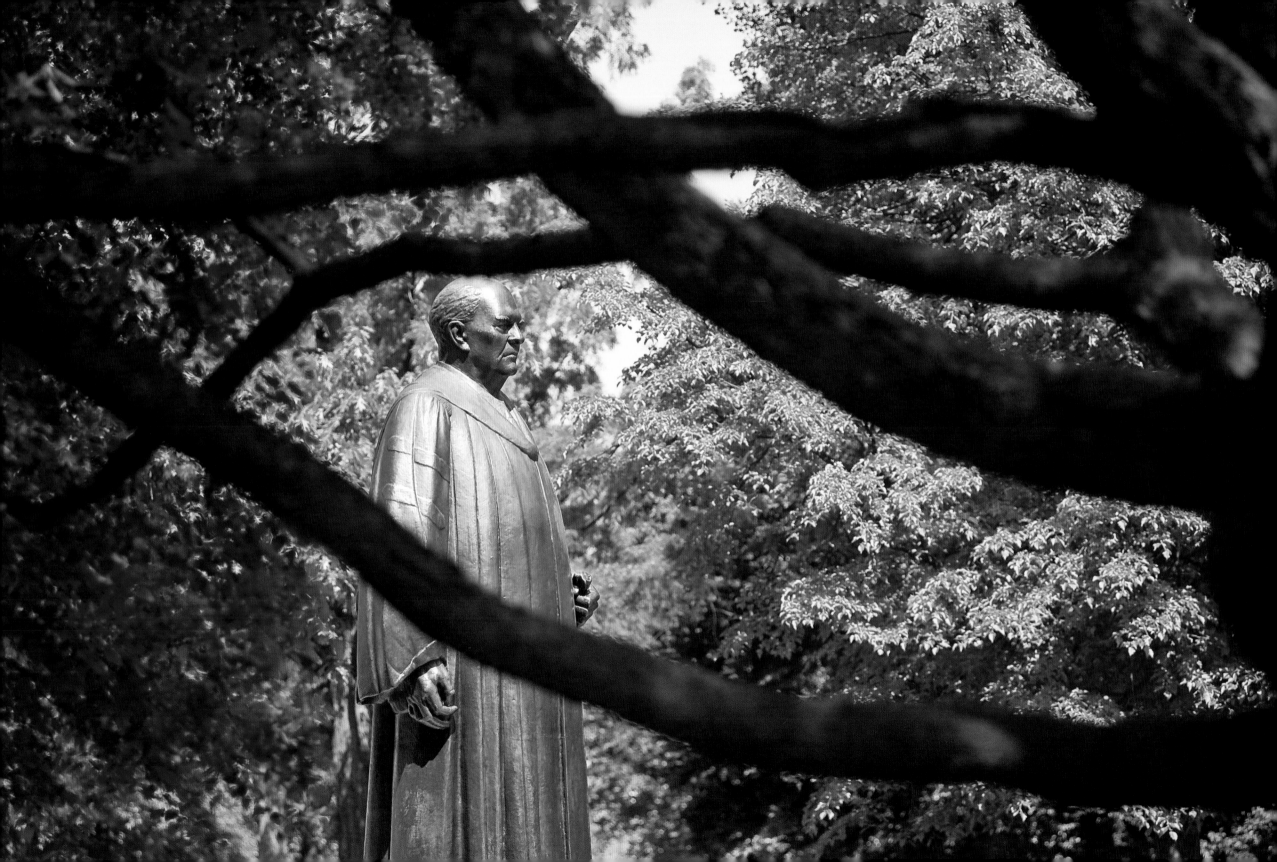

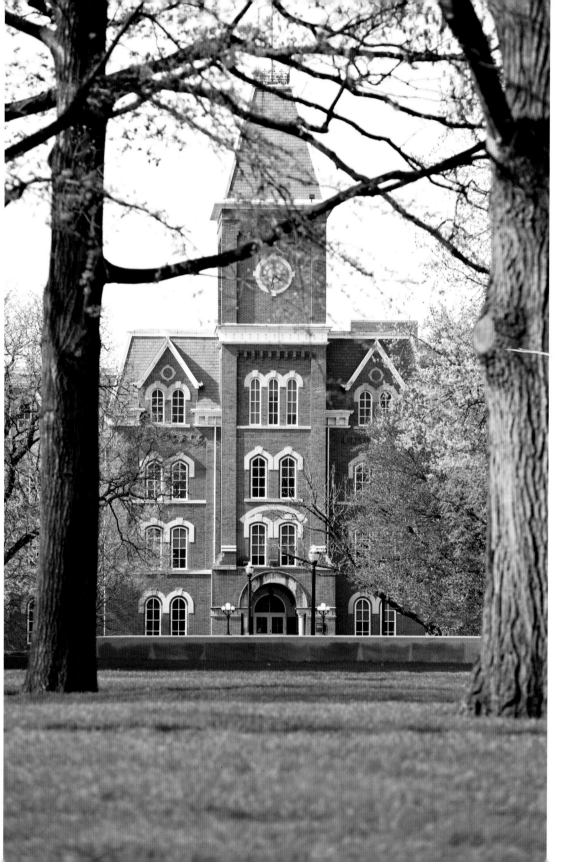

Opposite page: Bronze sculpture by
Thompson Erwin Frey of President
William Oxley, given by the classes
of 1923, 1925, 1926, and 1928.

CAMPUS VISTAS

Here under these shades,
Along these cool, leafy walks…
Under the silver laces of sun-lacquered branches
Of oak and sage elm, many unforgotten deeds
Have left a phantom…
Old friendships … old faces … old dreams
Of life … ambitions…
And here in these halls are ghosts
Of our forgotten selves… husks
Of our old ways, flung off for newer things;
They linger… and perhaps they call at times
For the old self… call on the beat of the chimes
And the breath of each new Spring.
But we are going… and under these trees
And these shades and grass-scented crannies
We leave our older selves,
And know that
In the sweet odors of these lawns,
In the bloom-honeyed winds in the trees,
In the deep gloom of these shadowed walls
They sleep.

—MAKIO 1924

Evening view of University Hall, a replica of
The Ohio State University's first building.

A sprawling river birch, just one of many remarkable trees that populate the Oval.

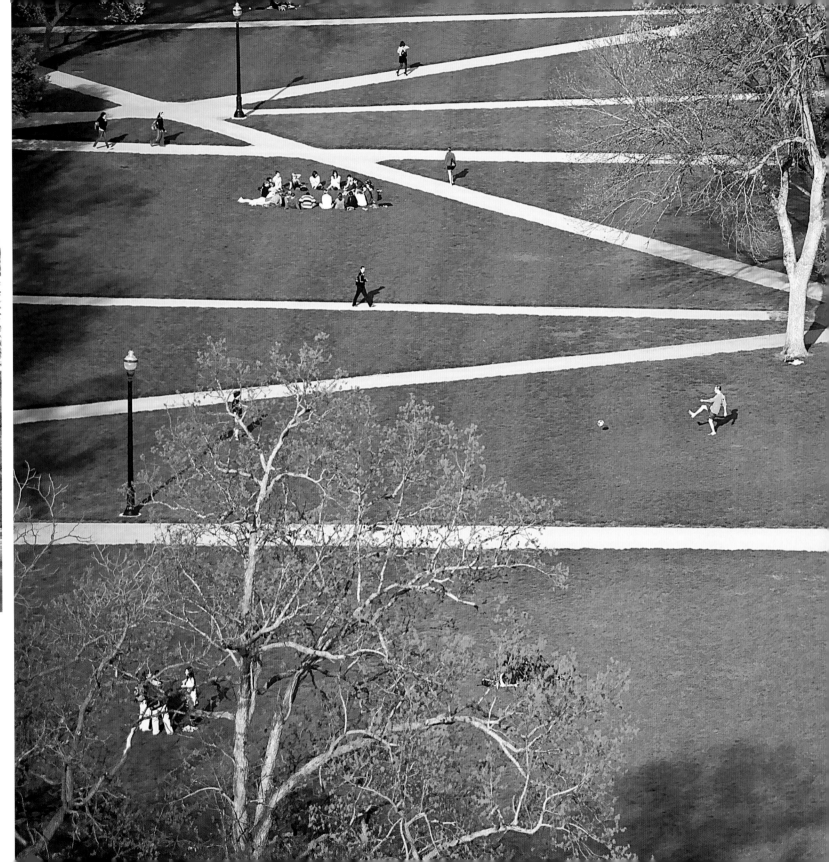

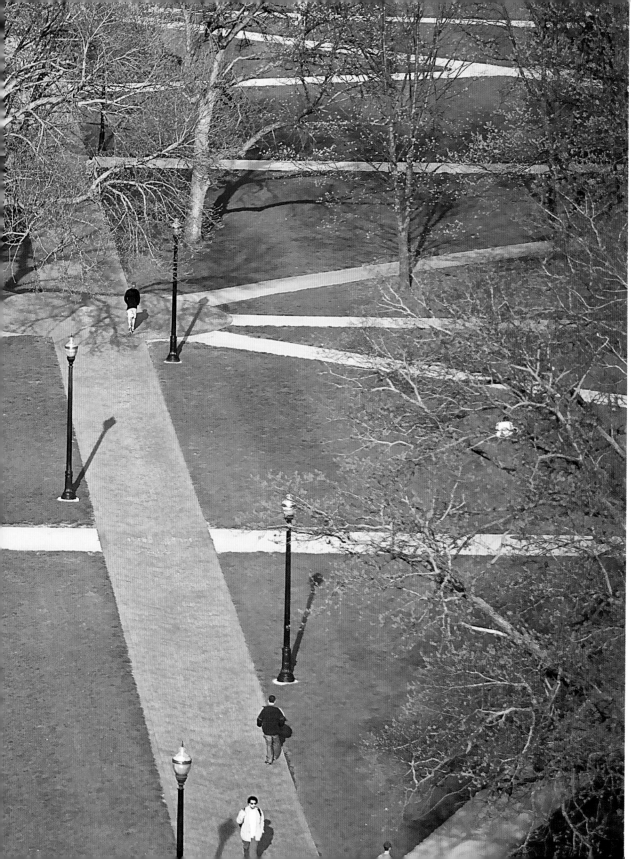

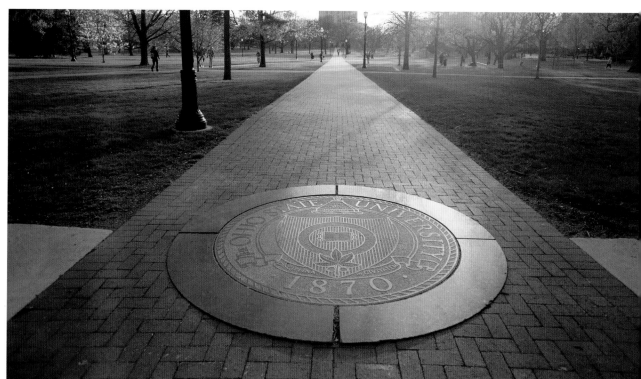

"The Long Walk" in early spring.

Early spring on the Oval, view from the
Campus Reading Room, Thompson Library.

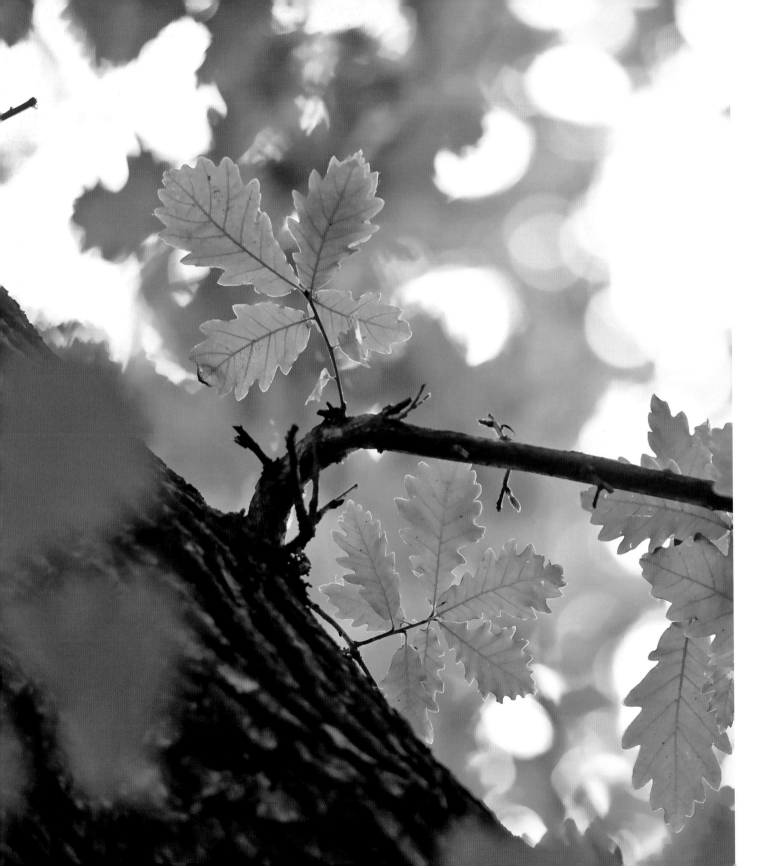

The Ohio State University is inescapably linked to one of the 20th century's most poignant and enduring accomplishments. Early in the century, it took Adolf Hitler decades to foment his dark vision of Aryan supremacy. On a warm August day in 1936 Berlin, it took a young African-American OSU student, Jesse Owens, exactly 100 meters and just over 10 seconds to provide an astonishingly definitive rebuttal as he won the first of his four Olympic gold medals. His time that day would not be beaten until more than a decade after Hitler's death.

Famously, Hitler refused to acknowledge Jesse Owens's accomplishments, but still the German Olympic Committee awarded all gold medalists one English oak sapling for every gold medal they won. Jesse Owens received his four—and, sadly, that is where the undisputed historical records end. One of the trees was rumored to have been planted at a high school in Cleveland. While there is no plaque or other documentation signifying where this tree was planted, it is widely believed that it was at Rhodes High School, where Owens once trained and practiced. Another one was said, by Jesse Owens himself, to have been planted on All-American Row at The Ohio State University. However, there is no such oak tree on All-American Row today, and OSU has no record of Owens's oak. If one were to believe that Owens's oak was indeed planted on All-American Row, then perhaps it was one of the trees transplanted during later campus construction.

If so, the most likely candidate is a majestic English oak that today flourishes near the campus library. This oak is the same species and is of a similar size and shape to the oak at Rhodes High School. Nearly eight decades after that August in Berlin, the legend of Jesse Owens's accomplishments and the mystery of the English oaks together have grown as sturdy as mighty oaks themselves.

Detail of an English oak on the north side of Thompson Library. This tree is believed to be one of four planted by Jesse Owens after the 1936 Olympics.

Winter evening on the Oval, view from the Campus Reading Room, Thompson Library.

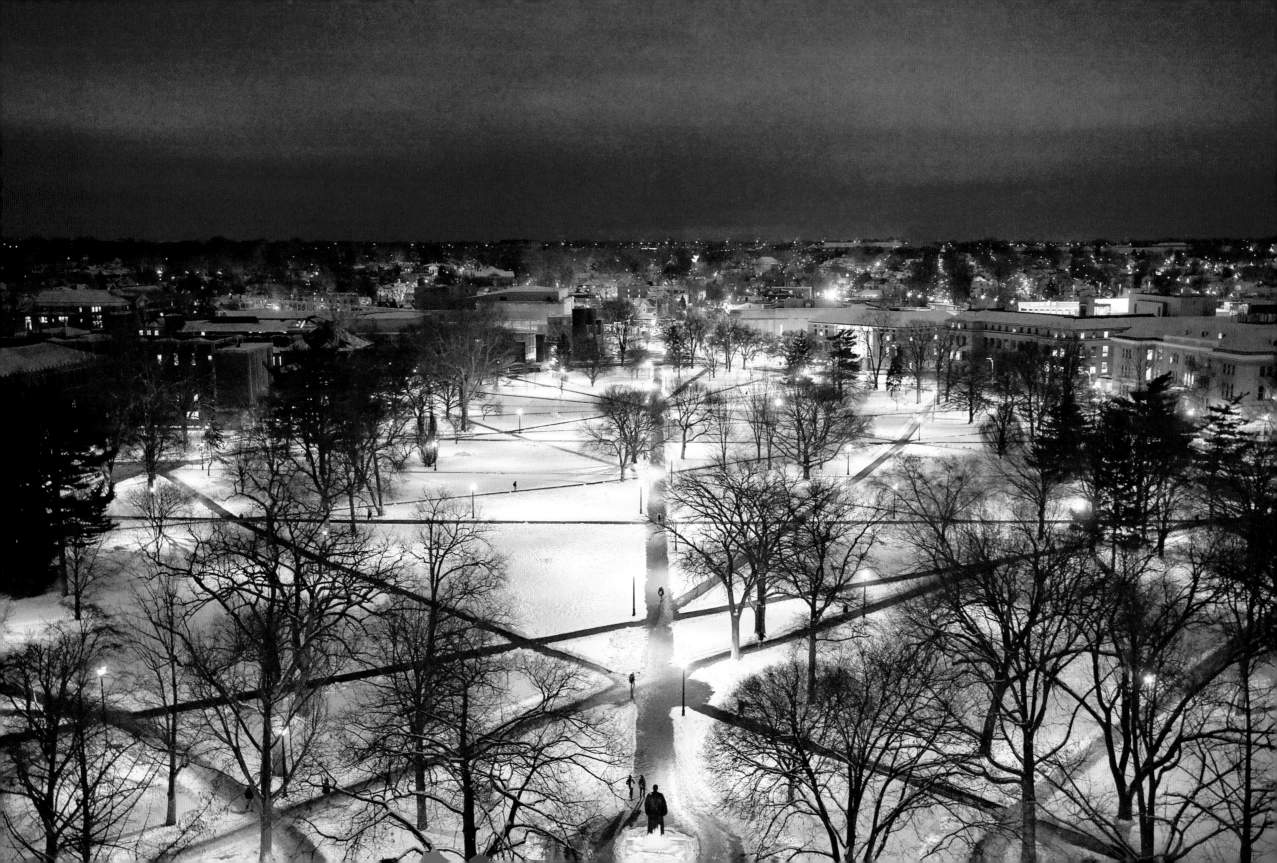

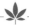

Mirror Lake Hollow is home to a number of OSU landmarks, including Bucket and Dipper Rock, the Browning Amphitheatre, and Mirror Lake. Notably, Mirror Lake was not always the shaded, enchanting escape it is today. Originally it was an unremarkable bog. Excerpts from the 1874 Fourth Annual Report from the Board of Trustees states that the "unwholesome bog around the springs has been cleaned out, and the channels opened and straightened; pools of clean, pure spring-water have been formed, and the place now presents an agreeable and inviting appearance" (Horizon, The Lake, paragraph 13). Additionally, long before any campus traditions or amphitheatres, Mirror Lake Hollow had a much different historical purpose. A plaque on the grounds references the use of the bog during the mid 1800s as a path for the Underground Railroad. The end of the bog's path led the nearly freed slaves to a house on the northeastern branch, home of Robert Neil. From there they were pointed towards Lake Erie, where freedom and safety awaited. Mirror Lake Hollow has gone from an unremarkable bog, to a part of the Underground Railroad, to sparkling spring, and has more recently become a location of escape and rest for students. It exemplifies both the growth and progress of its campus, and the life journey of its students.

MIRROR LAKE HOLLOW

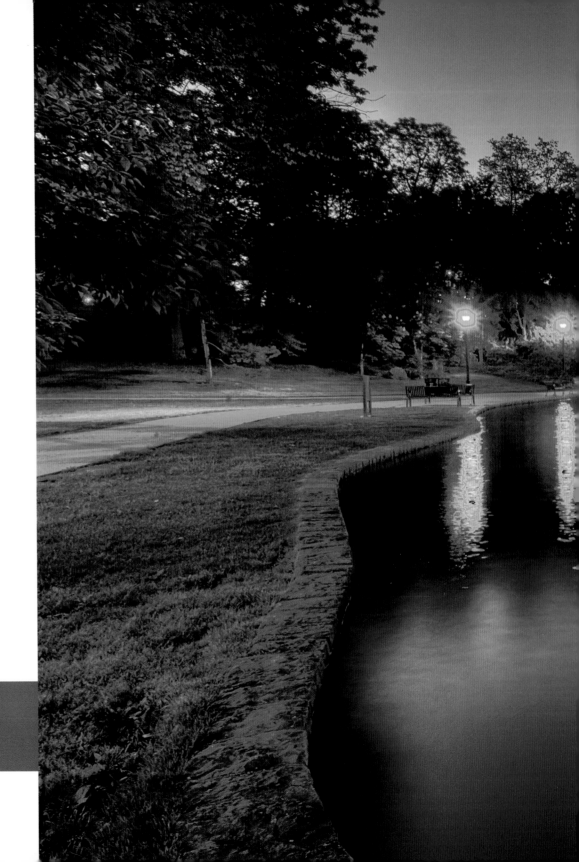

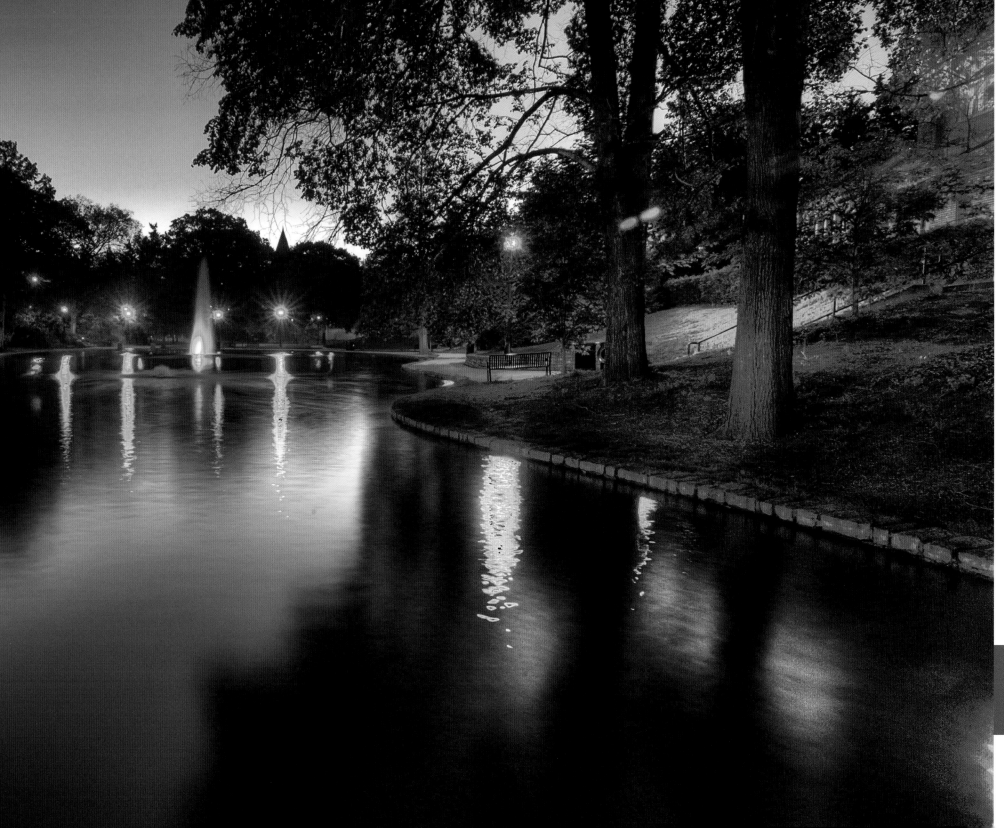

Dawn on Mirror Lake,
view from Neil Avenue.

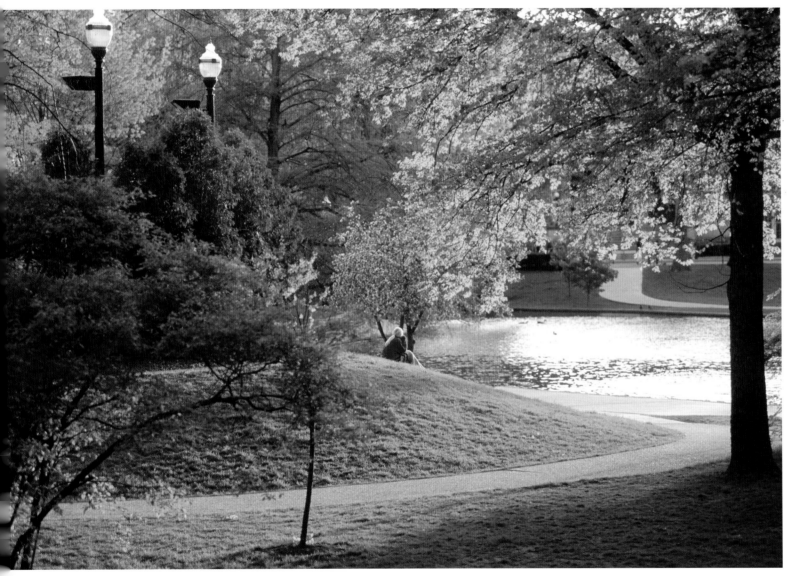

Spring Break on Mirror Lake.

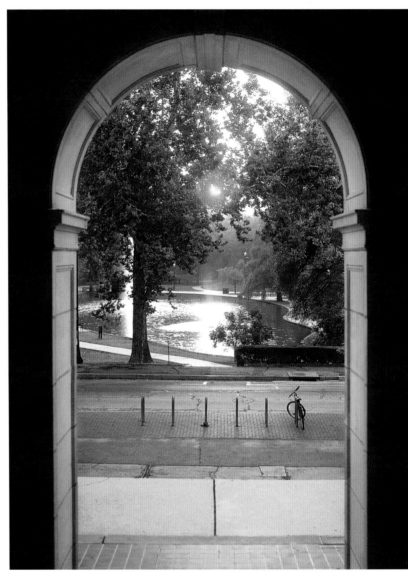

Summer morning on Mirror Lake, seen through an entrance arch of Campbell Hall.

Opposite page: Collage of autumn maple leaves.

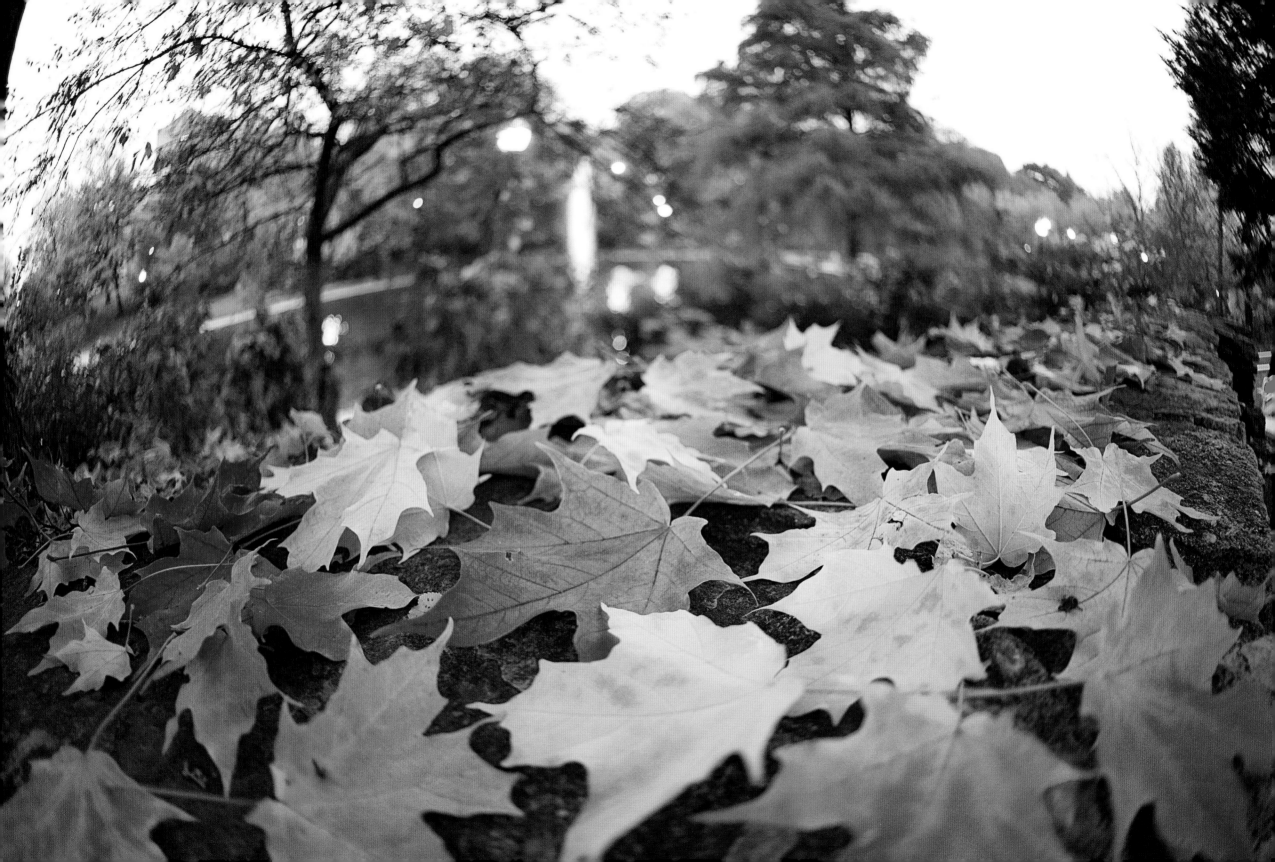

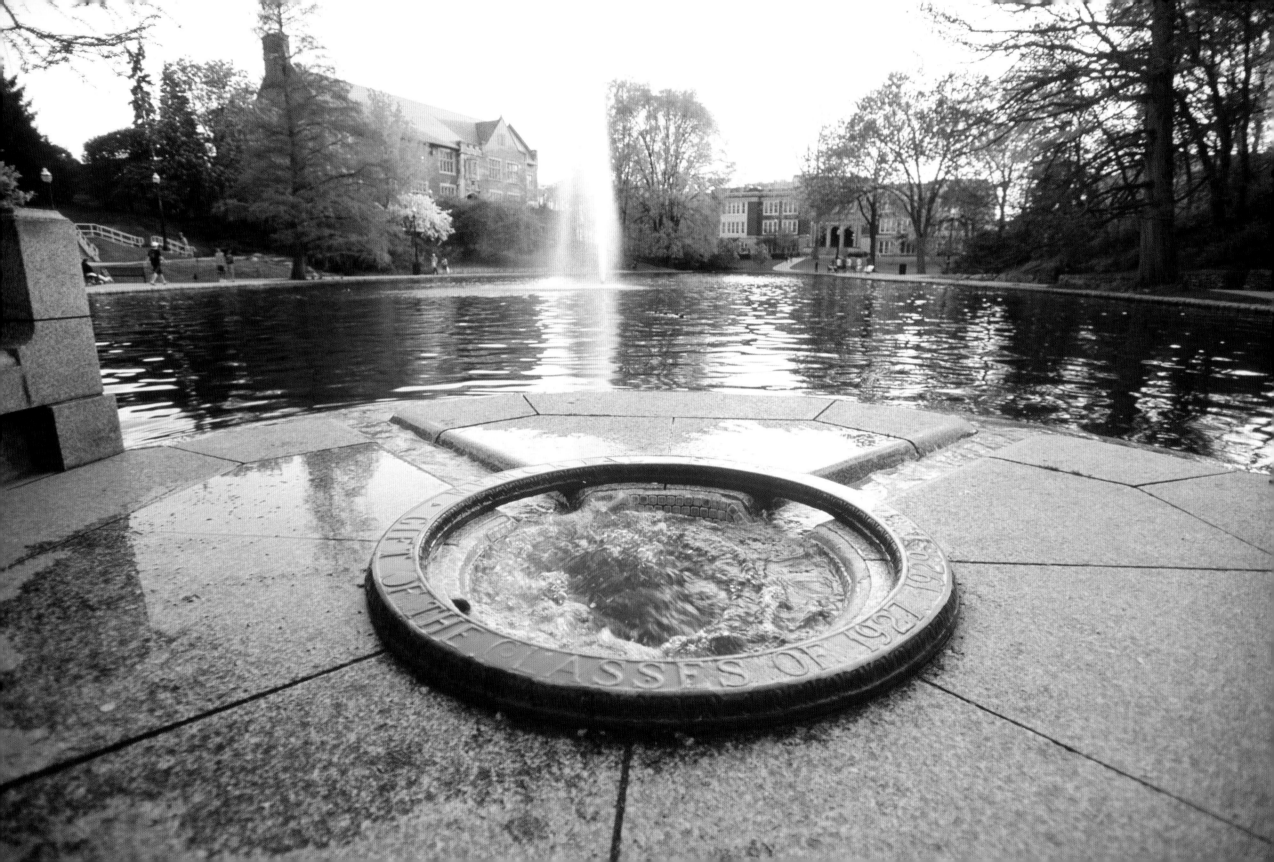

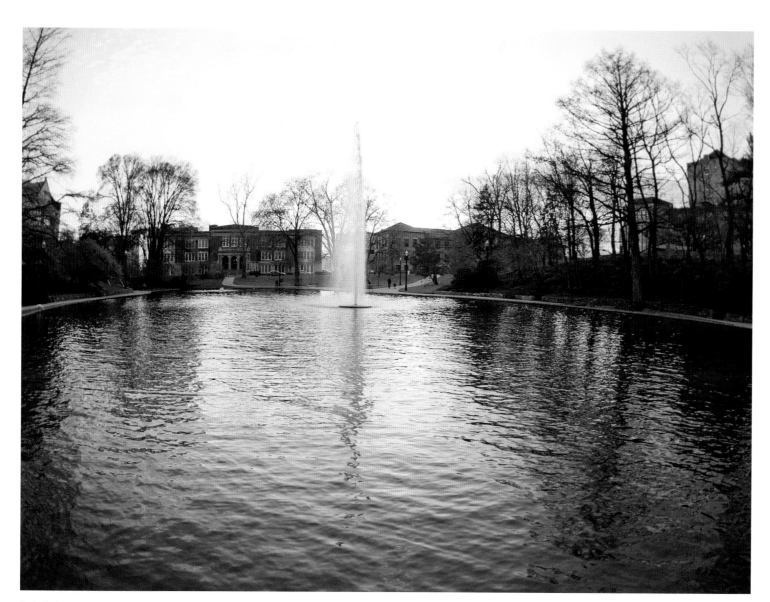

Early Spring evening, Mirror Lake.

Opposite page: Memorial Fountain,
Mirror Lake, gift of the classes
of 1927, 1929, and 1930.

Languid water reflects the delicate charm of spring in the hollow. The sun paints shadows lightly on the green slopes. From the leaves comes a shimmering radiance. In the dusk the evening sky softens the glow and couples follow the paths slowly as the water gently courts the shore.

—MAKIO 1936

27

View through the gnarled
branches of a crabapple tree,
western bank of Mirror Lake.

Opposite page: Study session.

Mirror Lake in midwinter.

Opposite page: A grove of elm trees
surrounds the western edge of Mirror Lake.

THE LADY OF
MIRROR LAKE

According to The Lantern, in the autumn of 1915, some students and faculty reported seeing a distraught woman sitting on the banks of Mirror Lake in the early morning and evening, and some even described her walking across the lake. Who was she? It turns out that the body of a Professor Clark was found in Mirror Lake in 1903. He had apparently taken his own life, depressed after losing a considerable amount of money in the stock market. His widow vowed never to abandon the spot where he died. After her death in 1915, her ghost began to appear at the lake.

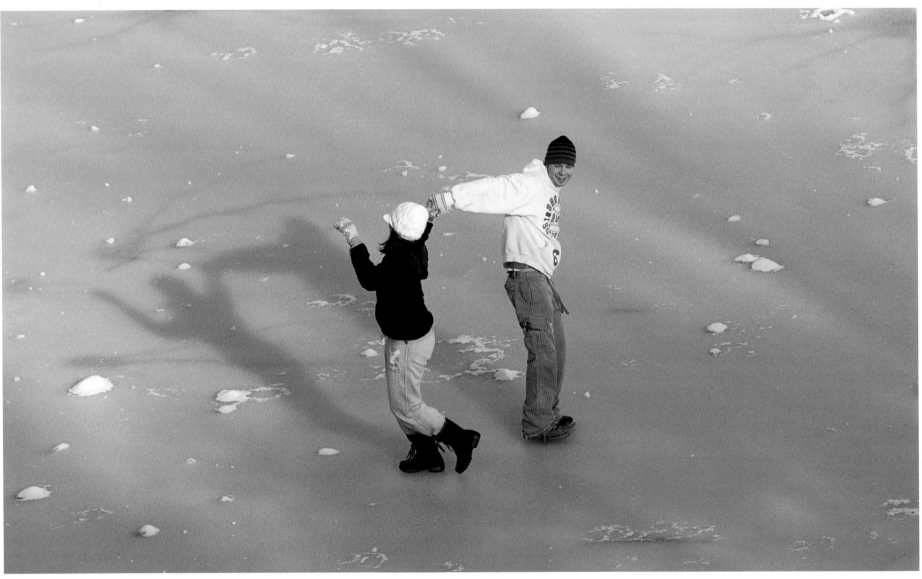

Ice dancing on Mirror Lake.

Opposite page: Pick-up football
game, Mirror Lake Hollow.

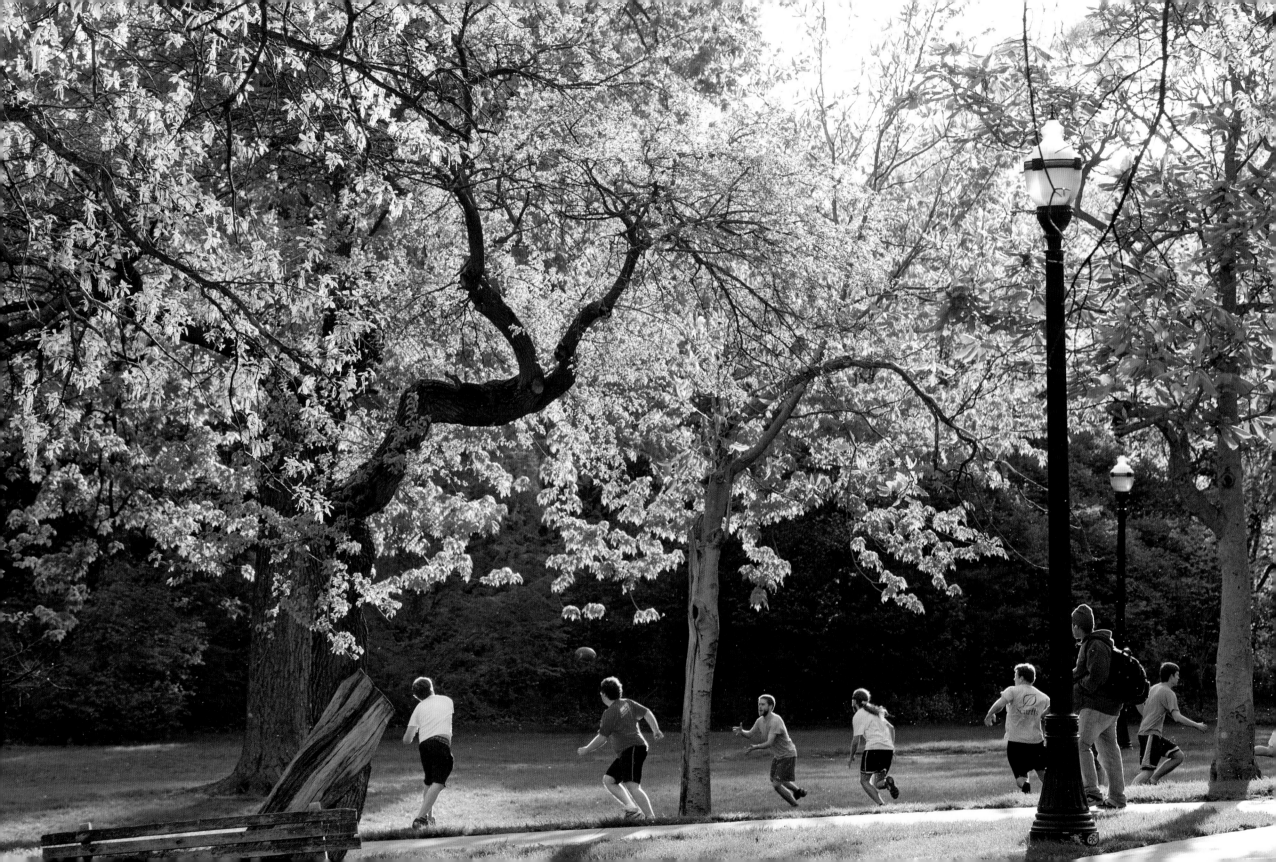

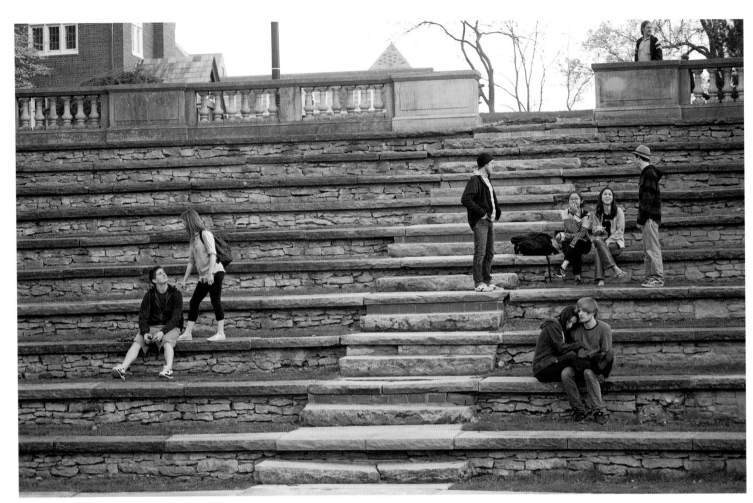

Spring gathering at Browning Amphitheatre.

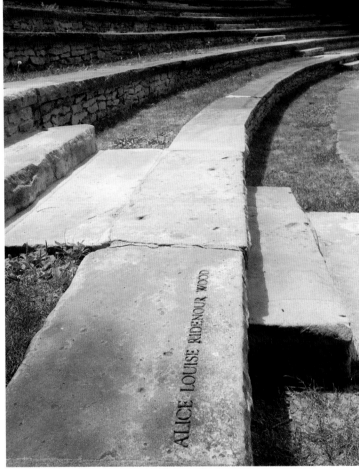

Memorial to alumnus Alice Louise Ridenour Wood, Browning Amphitheatre.

Opposite page: Early spring view of Browning Amphitheatre.

THE BROWNING AMPHITHEATRE

For generations, the Browning Amphitheatre has been home to plays, cultural events, and countless weddings. Dedicated in 1926, this campus landmark is a stone's throw away from Mirror Lake. Designed in the ancient Greek style, the Browning Amphitheatre is a half circle with raised sloping seating and breathtaking stonework. This site is also home to Light up the Lake, an event which each year welcomes The Ohio State University students, faculty, and friends back to campus after the Thanksgiving break with an awe-inspiring display of lights throughout the Browning Amphitheatre and Mirror Lake area. The Browning Amphitheatre is nestled nicely in the heart of The Ohio State University campus, and through our memories there, nestled nicely in our hearts as well.

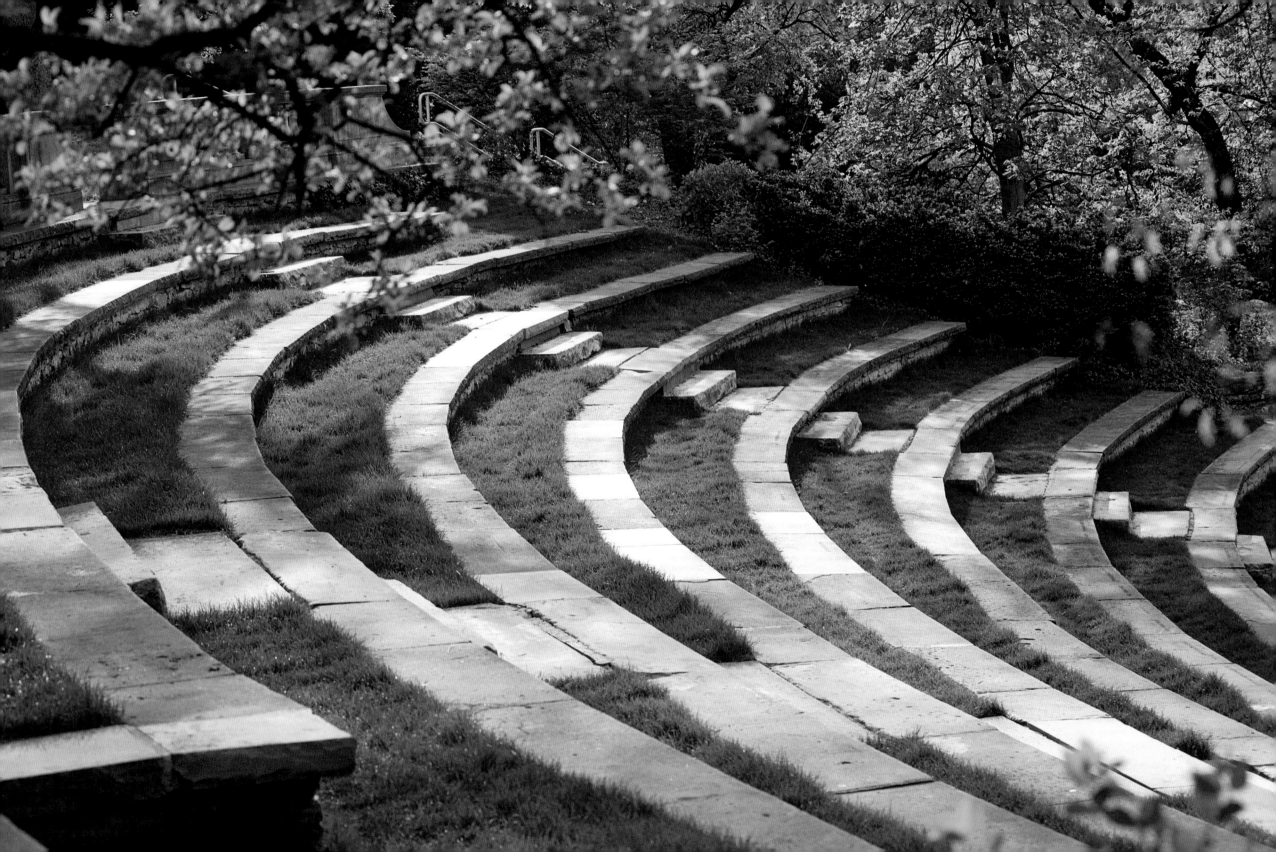

OSU is home to many storied and well-known traditions. Yet, one annual tradition is not televised, not covered by media, and seldom spoken of outside of the OSU family. Every spring the campus erupts with blooms, bursting forth in every hue on Mother Nature's palette. Campus-wide the earth is suddenly awash with the colors of spring: redbud, forsythia, daffodils, and tulips start this colorful parade. Next come dogwood, crabapple, magnolia, and lilac. This springtime color wheel concludes with azalea and the wisteria vines gracing Enarson Hall. Poets have linked spring with youth for millennia. Perhaps nowhere else is spring a better metaphor for youth than on a college campus, where spring signifies the end of a successful year. For seniors, the season is a true harbinger of rebirth through the graduation ceremony, where one by one as the flowers bloom and diplomas are handed out, these OSU students are reborn, standing on their own, ready to take their places in the world.

CAMPUS IN BLOOM

A glimpse of Oxley Hall through a veil of magnolia blossoms. Oxley Hall is an example of English Renaissance architecture and was OSU's first women's dormitory.

Daffodils erupt on a hillside bordering Mirror Lake.

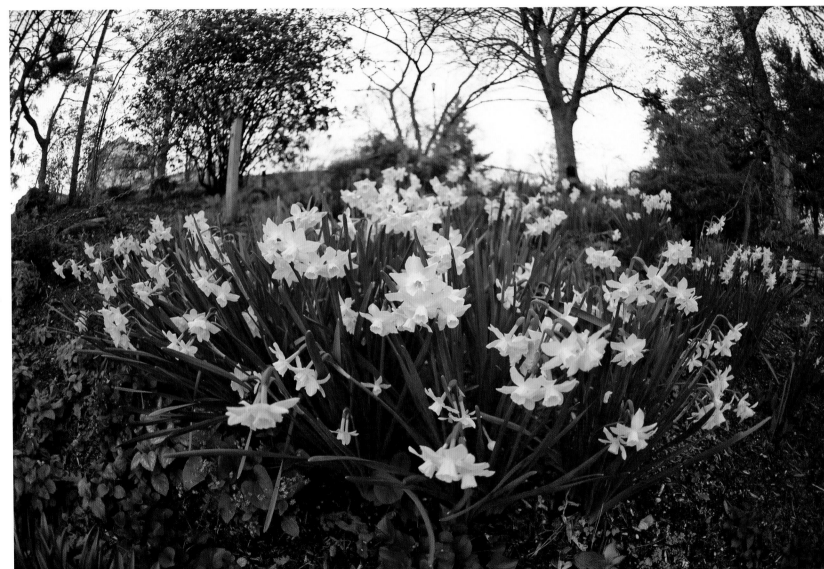

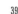

I perhaps owe having become a painter to flowers.

—CLAUDE MONET

Looking down a pathway formed by arching
redbud trees along Fred Taylor Drive.

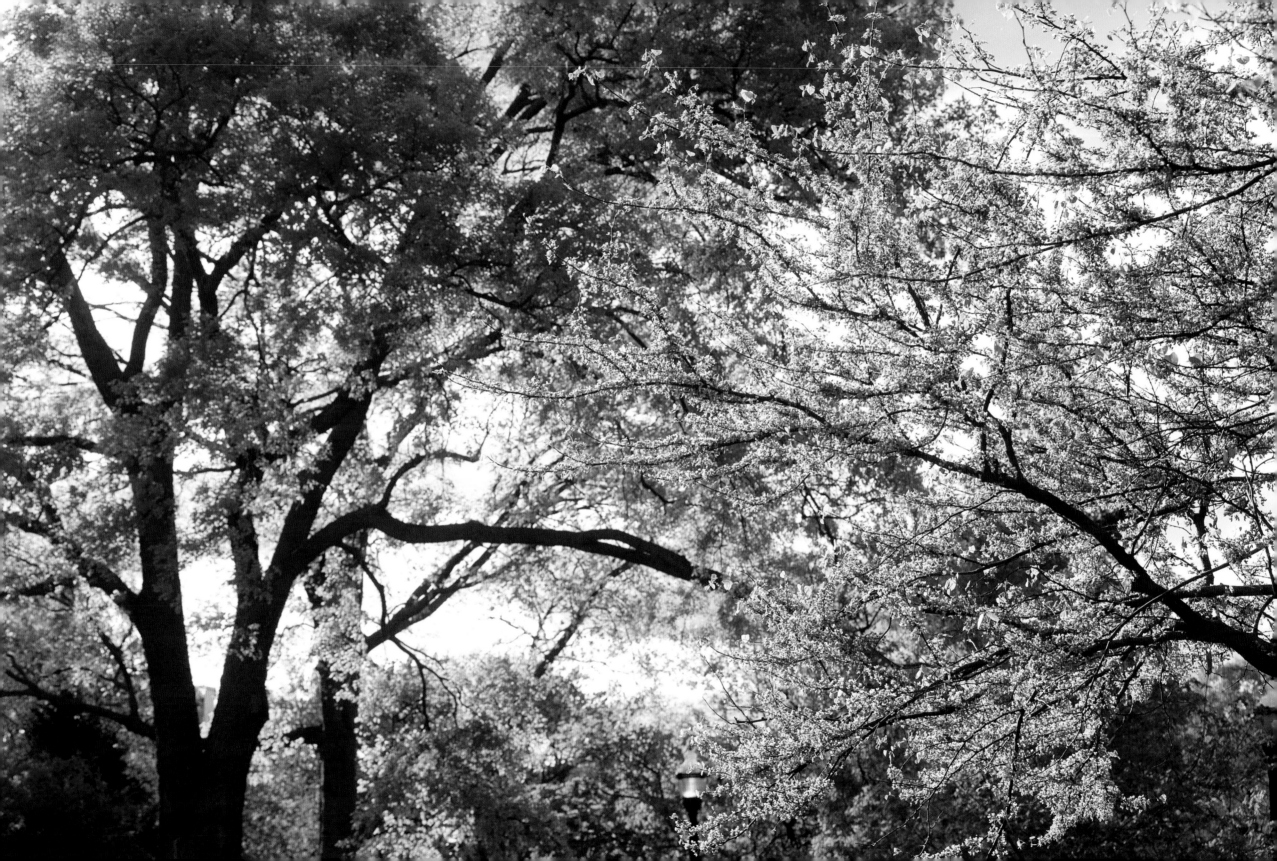

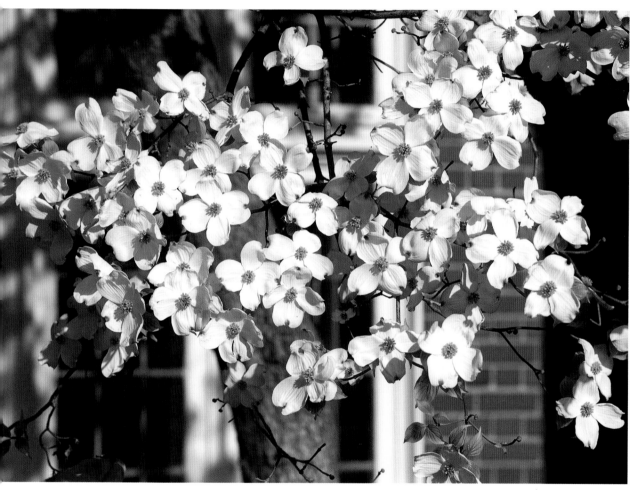

American dogwood blossoms behind the Kuhn Honors & Scholars House.

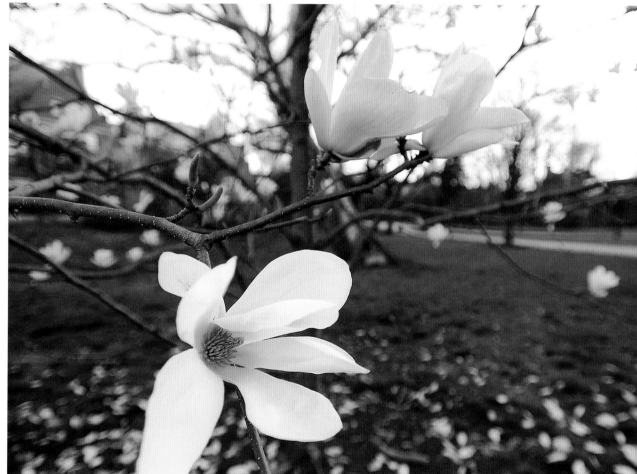

A Gold Star magnolia flanks the eastern path through Mirror Lake Hollow.

Opposite page: A vista of redbud and
hackberry trees on the back lawn of
the Kuhn Honors & Scholars House.

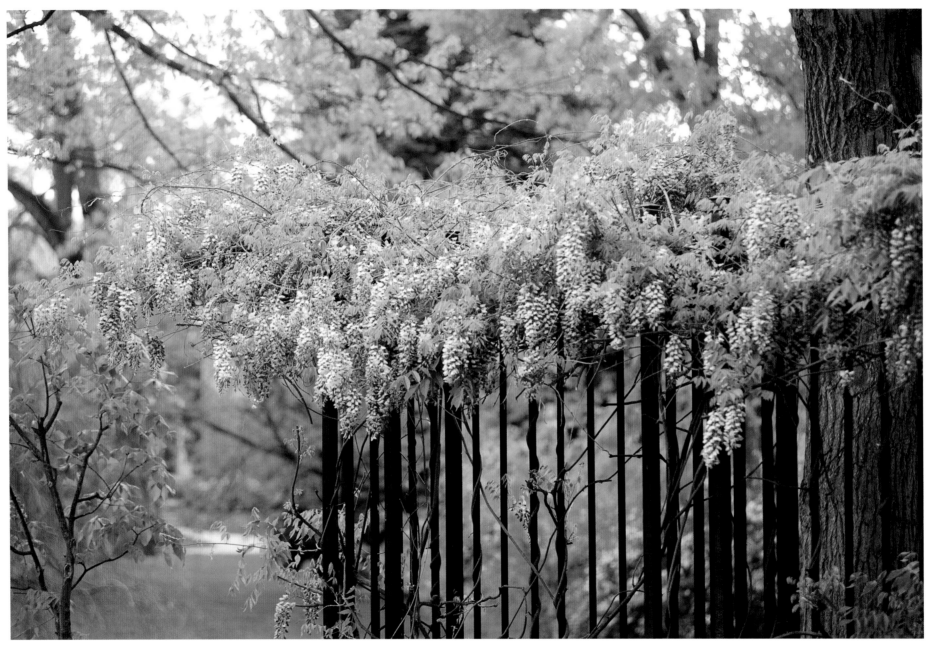

42

Wisteria vines on the west
side of Enarson Hall.

Opposite page: A lilac bush on the
northern side of Oxley Hall, overlooking the
busy corner of West 12th Avenue & Neil.

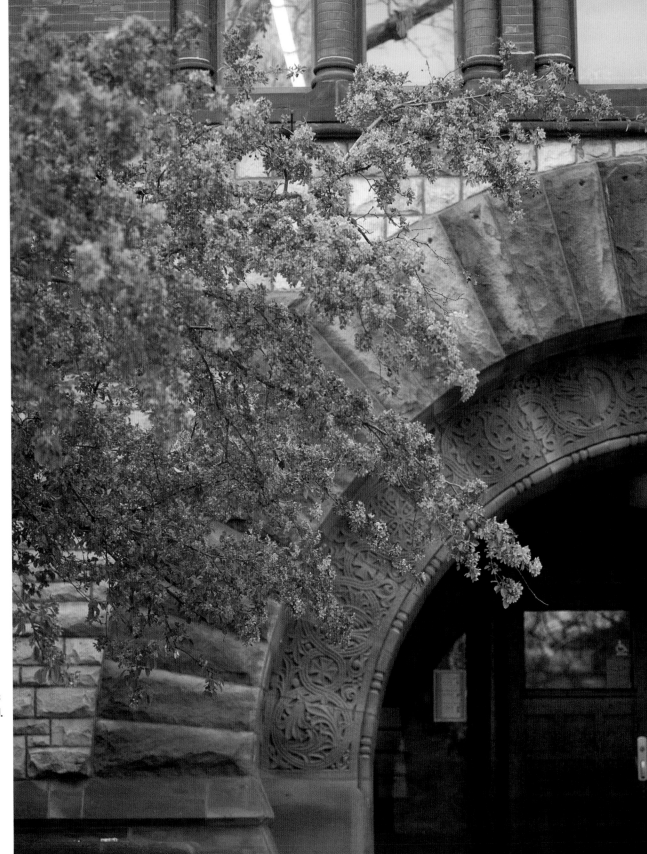

A flowering red crabapple tree flanks
the entrance of Hayes Hall.

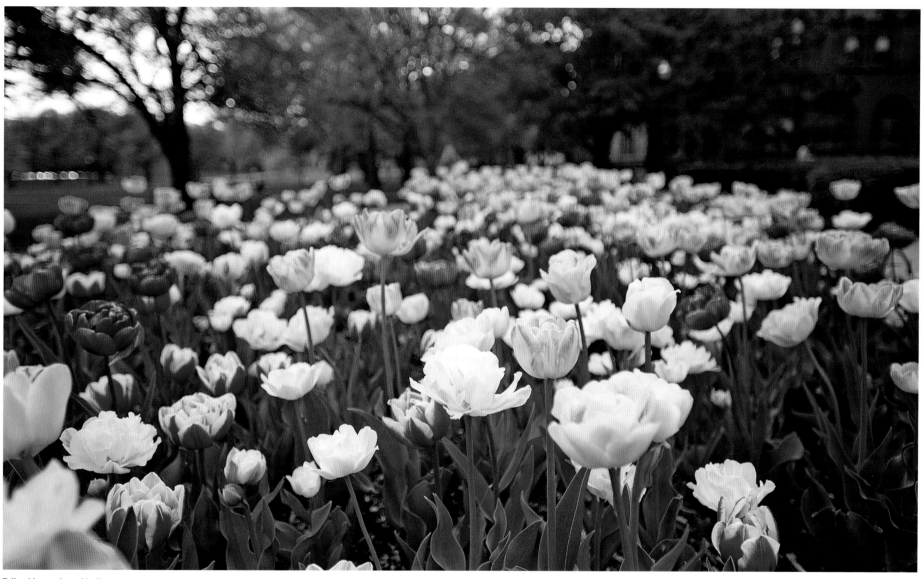

Tulips bloom alongside the
northern walkway of the Oval.

Snowy white viburnum on
Oxley Hall's front lawn.

Opposite page: Azalea and redbud trees
surround the east bank of Mirror Lake.

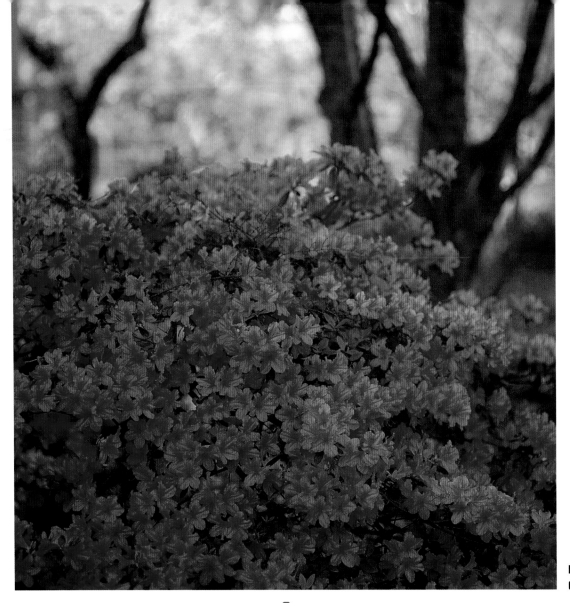

Hot pink azaleas, western edge of
Chadwick Arboretum & Learning Gardens.

THE CHADWICK ARBORETUM

The Chadwick Arboretum was dedicated in 1981 and named after Dr. Lewis C. Chadwick, who devoted nearly 40 years to The Ohio State University as a research and horticulture professor. Seventeen gardens over 60 acres display samples of more than 2,000 different varieties of plants from around the world, as well as a preserve of native Ohio flowers. The Chadwick Arboretum is partially maintained by volunteers and is a true testament to their teamwork and devotion to the common goal of using the land for education as well as enjoyment. The beautiful, scenic grounds of the Chadwick Arboretum have been a special site for many weddings over the years, and countless students have found the arboretum an ideal location for introspection and a tranquil escape from the demands of college life.

Opposite page: Coralburst
crabapple in full bloom, Chadwick
Arboretum & Learning Gardens.

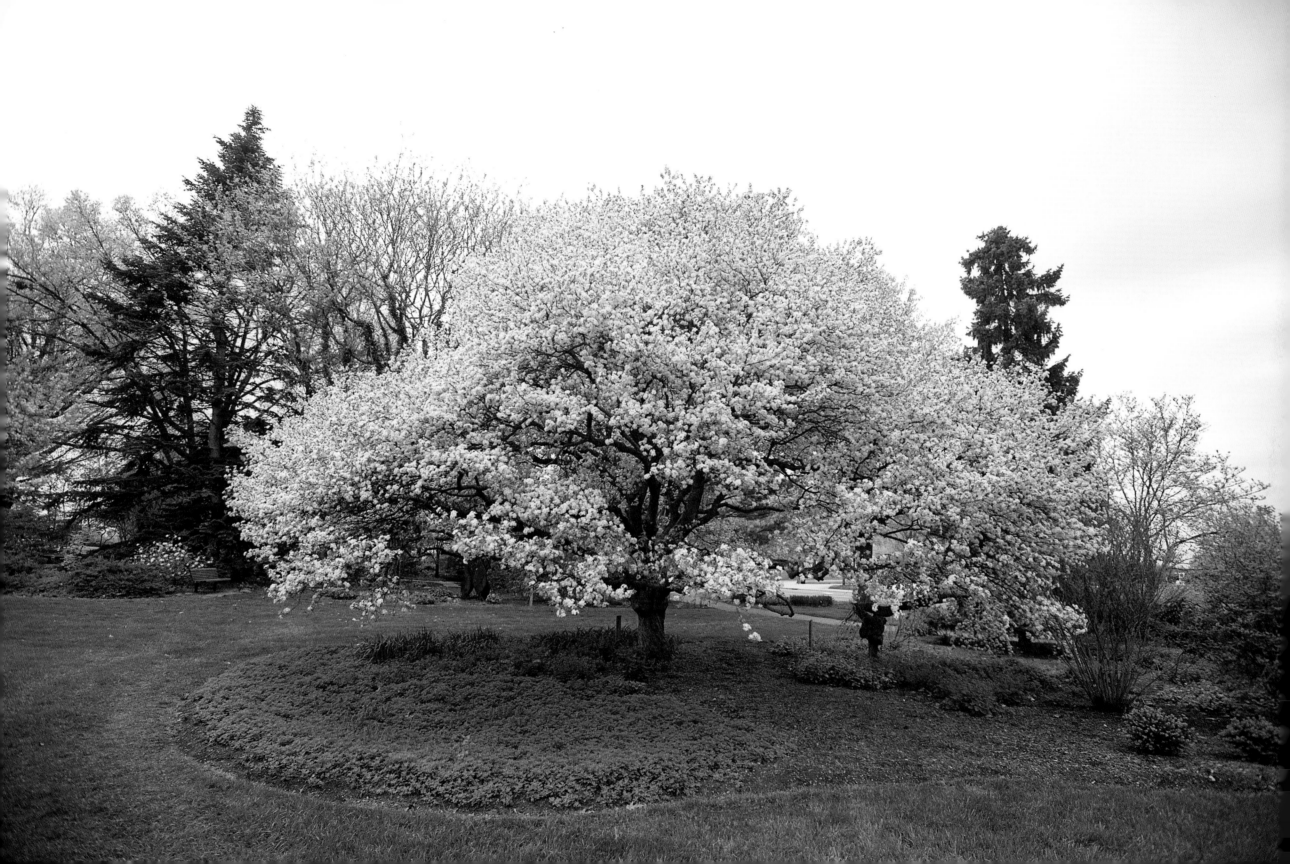

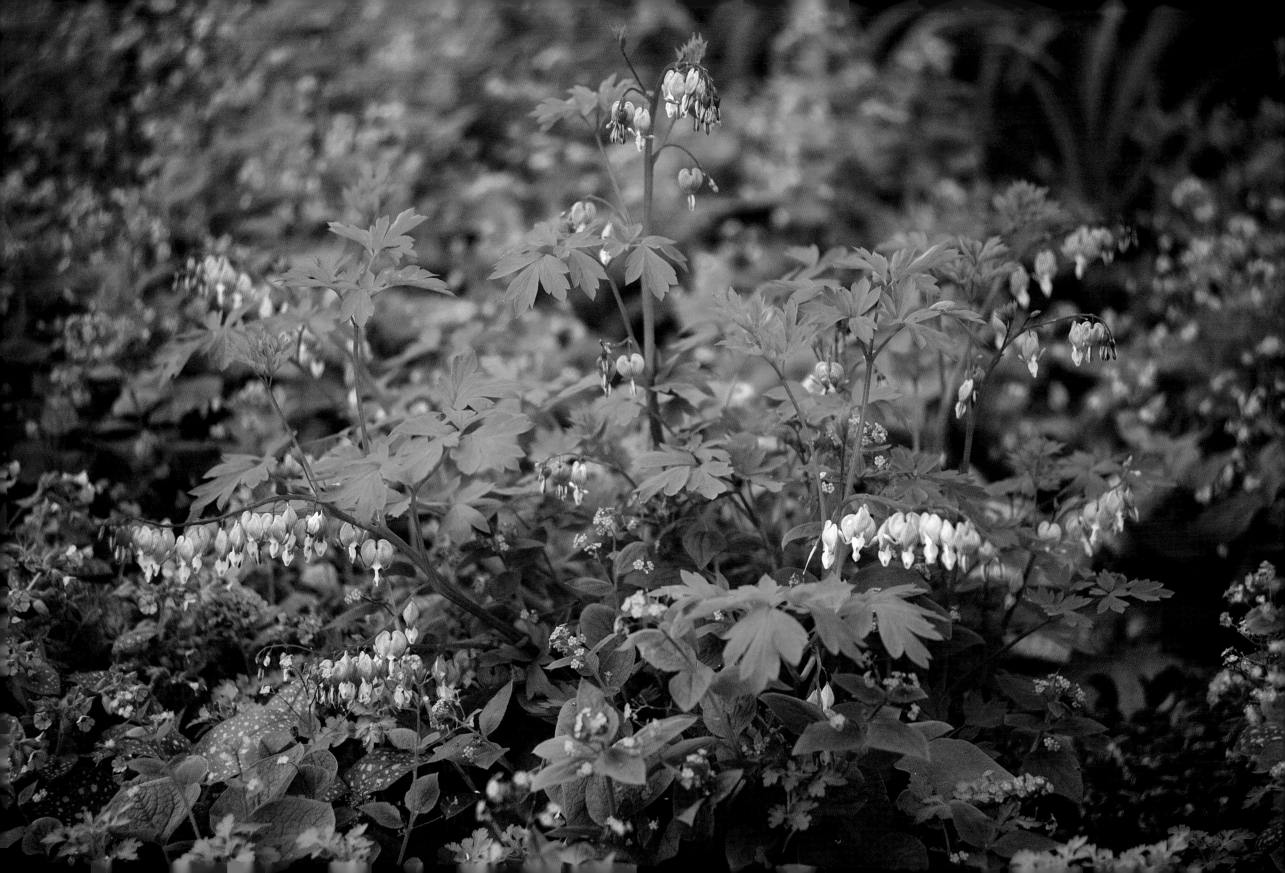

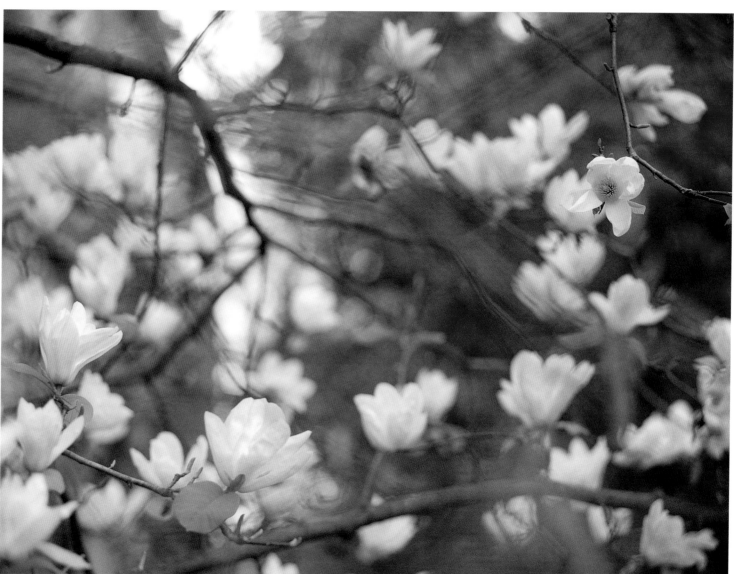

Bronze plaque honoring Dr. Lewis C.
Chadwick, at the Chadwick Arboretum.

Opposite page: Bleeding hearts and Siberian
bugloss in the shade of a magnificent
coralburst crabapple tree, Chadwick Arboretum.

Cucumbertree magnolia, Chadwick
Arboretum & Learning Gardens

The fact that a mature buckeye tree is tall, strong, and dignified is immediately obvious to even a casual observer. Less obvious is how that same tree has come to provide the iconic representation of the resolute, steadfast cultural identity of the citizens of Ohio. Like The Ohio State University, which proudly displays the buckeye nut and leaf on its official crest, sports uniforms, and architecture around campus, the buckeye tree has a long history with the inhabitants of Ohio. According to legend, Native Americans named the tree, noticing that the dark brown nut with its small pale mark resembles a deer's (or buck's) open eye. The wood was light, strong, and easily carved, and the nuts were blanched and ground into meal. The buckeye nut was thought to be a lucky talisman.

Anyone who has visited Ohio during the holiday season has likely eaten a buckeye—though not one from a buckeye tree. It is a long Ohio tradition (and very popular at OSU football games in particular) to dip balls of peanut butter in chocolate, leaving a small "eye" of peanut butter uncoated. The treats look just like buckeye nuts.

From their use in architecture to desserts, the buckeye tree, nut, and leaf serve as reminders of the natural beauty of Ohio and instill pride in every Ohioan.

THE MAGNIFICENT BUCKEYE

53

Autumn still life with buckeye leaves.

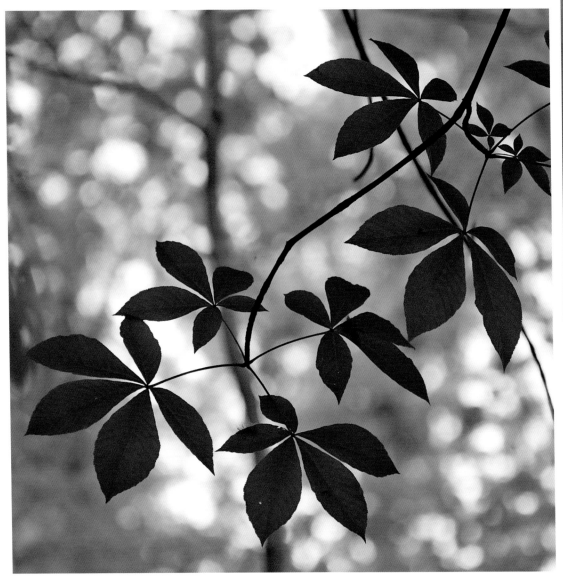

Buckeye leaves in silhouette.

Emerging shoots and flower
buds of an Ohio buckeye tree.

Opposite page: Detail of
a finely serrated leaflet.

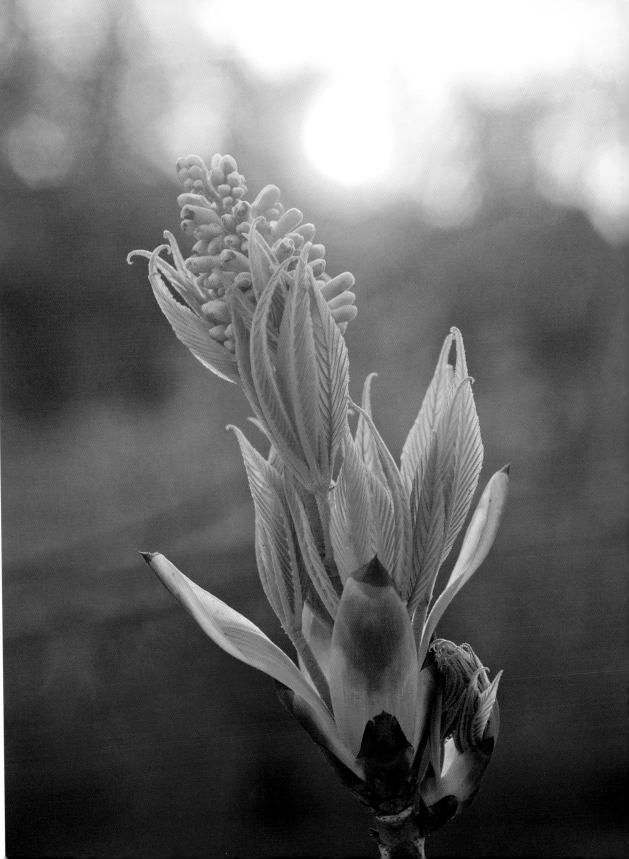

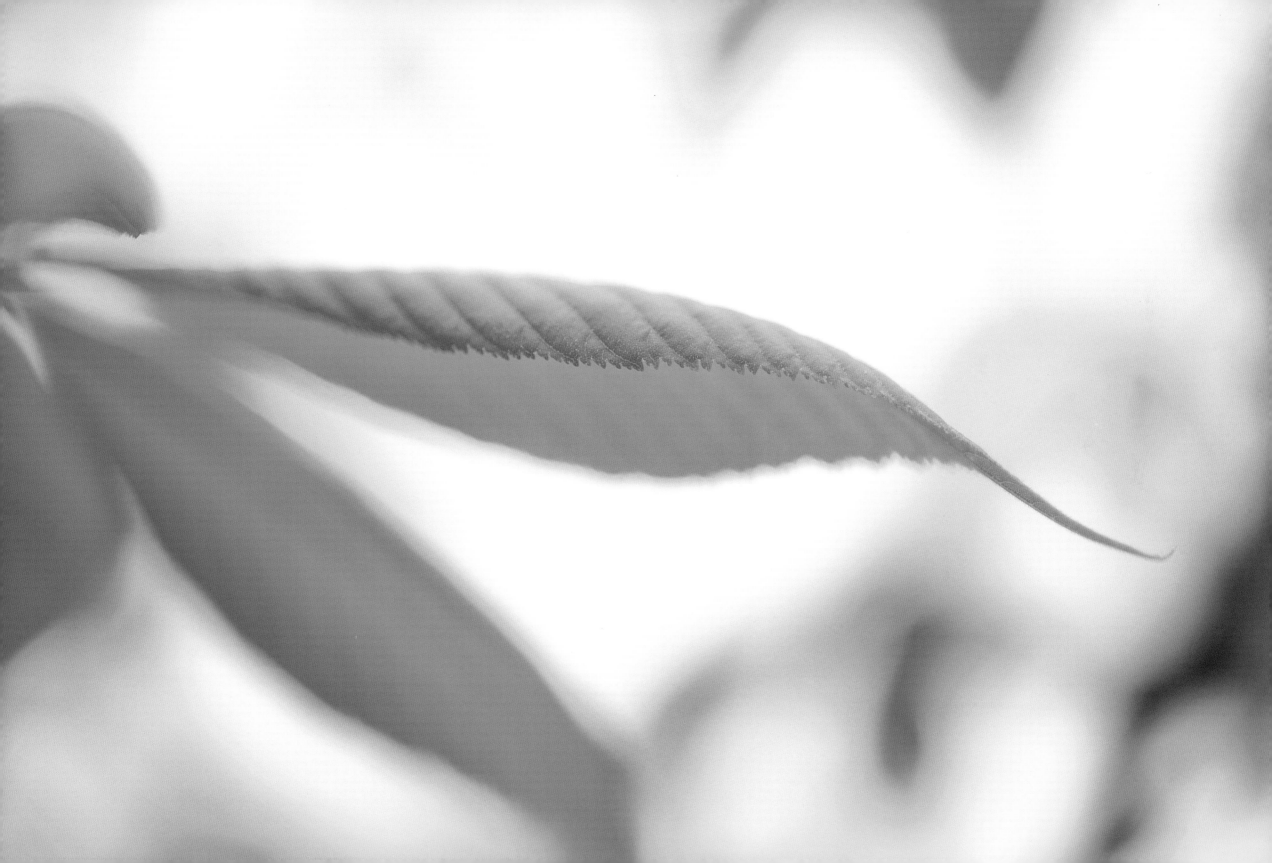

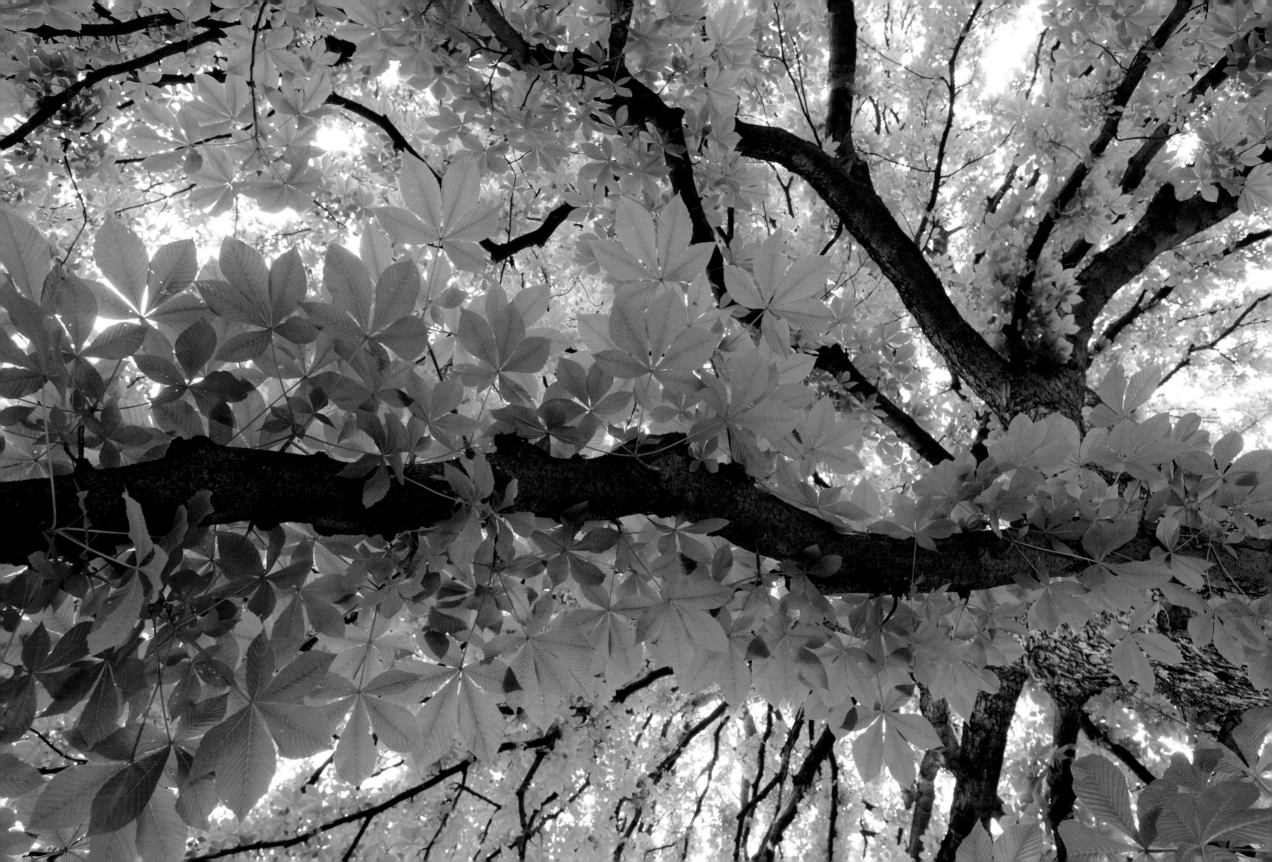

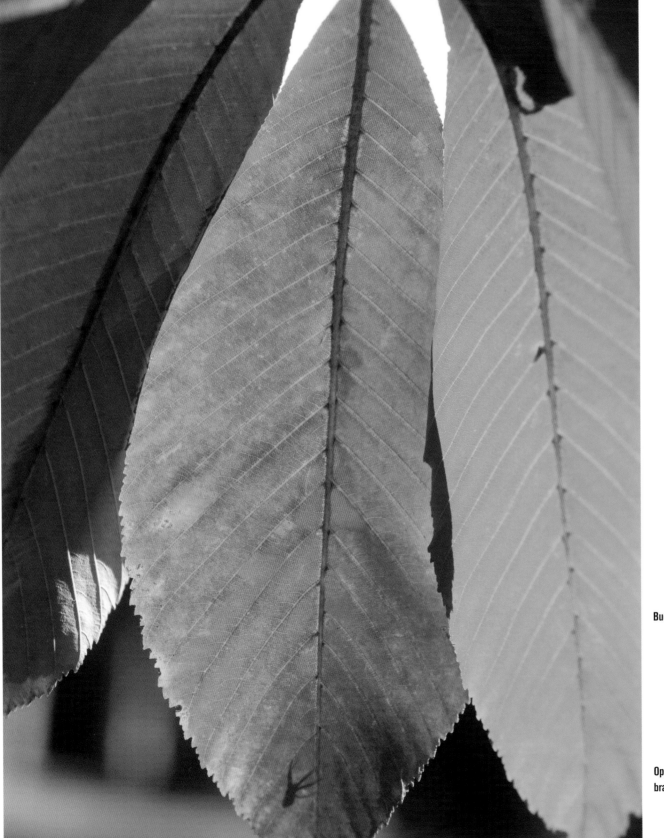

Buckeye leaf in transition.

Opposite page: The long, strong
branches of an ancient buckeye tree.

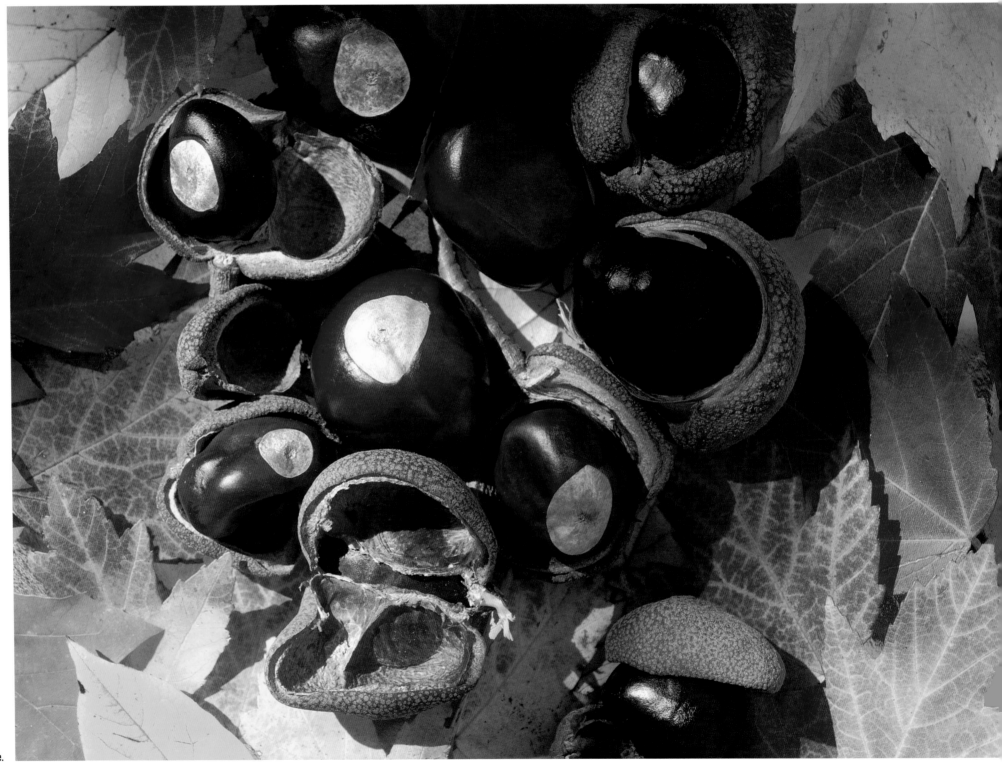

Buckeye still life.

A cluster of compound leaves.

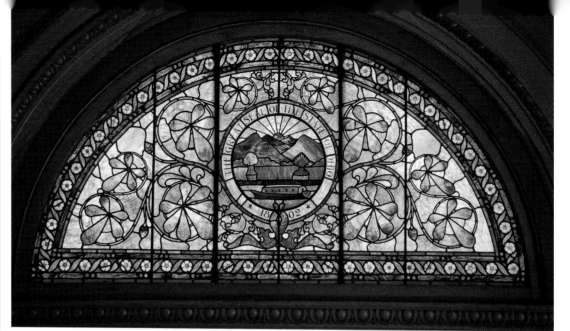

Top right: Stained glass window featuring the State of Ohio seal surrounded by buckeye leaves in Cincinnati City Hall's council chamber, 801 Plum Street, Cincinnati, Ohio.

Right: Detail of The Ohio State University's seal in terrazzo, lobby of Mershon Auditorium.

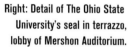

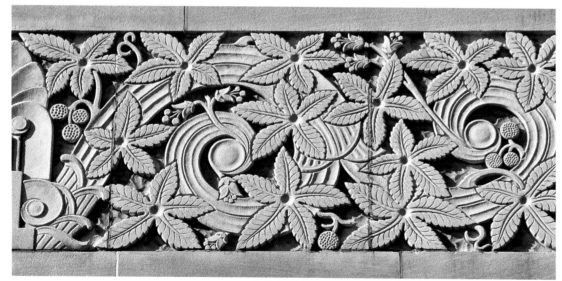

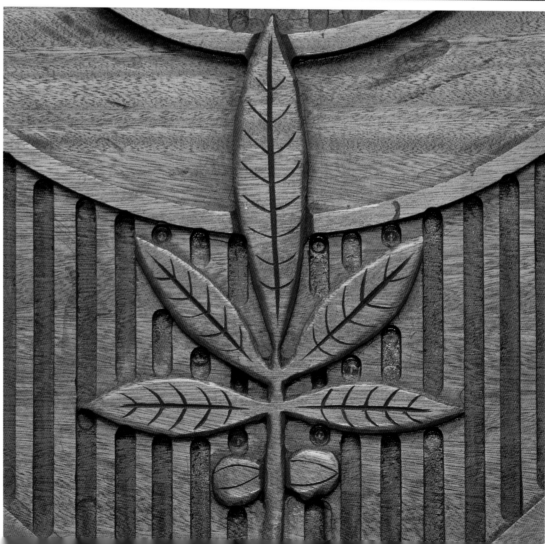

Carved limestone relief with buckeye pattern, façade of Western Southern Life Insurance Company, 400 Broadway, Cincinnati, Ohio.

Right: Detail of OSU's seal in carved wood, Fawcett Center.

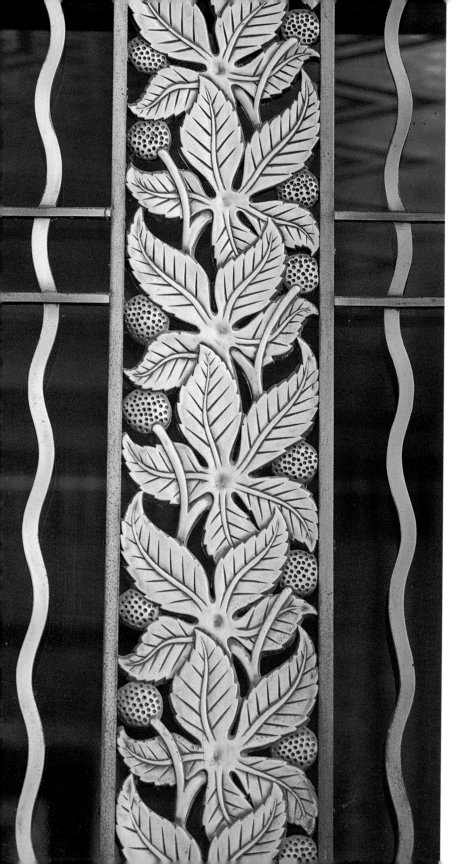

BUCKEYE IN ARCHITECTURE

Popularized at OSU in the 1950s, the use of the buckeye as an iconic association is just one of several instances throughout U.S. history where the nut has achieved national attention. In the 1840 U.S. presidential campaign, William Henry Harrison, an Ohioan and hero of the Battle of Tippecanoe, featured images of buckeyes on his campaign posters. His campaign centered on his folksy, down-home persona and his upbringing in the backwoods of Ohio. Of course, Harrison is also famous for his unfortunately coatless and lengthy inaugural address on a cold, wet March day. He contracted pneumonia and died approximately a month later. To this day he holds the record for shortest presidency (and longest inaugural address). Eventually, the association between buckeyes and Ohio resulted in the buckeye being named the state tree of Ohio—and the citizens of Ohio became forever known as Buckeyes.

The buckeye tree has not only a unique nut but also a complex compound leaf. The leaf typically has five leaflets that branch from the stem like fingers from a palm. This cherished botanical treasure has inspired OSU architecture and decoration and is also prominently featured in other settings around the state. Images of the buckeye tree, nut, and leaf can be found on the carved OSU seal in the Fawcett Center and brass reliefs upon campus lampposts, on the stained glass windows of the Cincinnati City Hall council chamber and the limestone relief on the Western Southern Life Financial building—only a few examples of the many that can be seen around our beloved state and campus.

Decorative panel in bronze bas-relief, façade, State of Ohio Supreme Court Center, 65 S. Front Street, Columbus, Ohio.

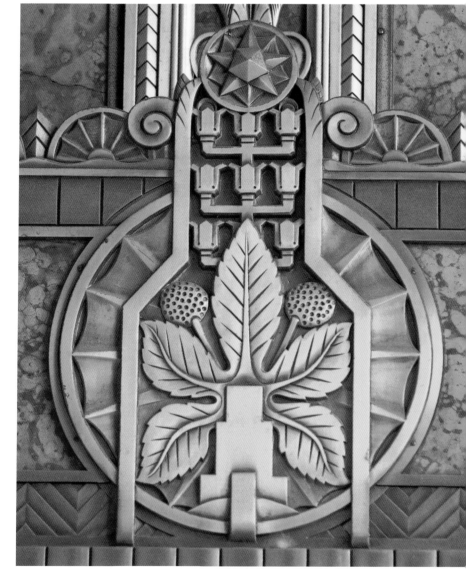

Buckeye leaf in bronze bas-relief decorates the exterior of the State of Ohio Supreme Court Center, 65 S. Front Street, Columbus, Ohio.

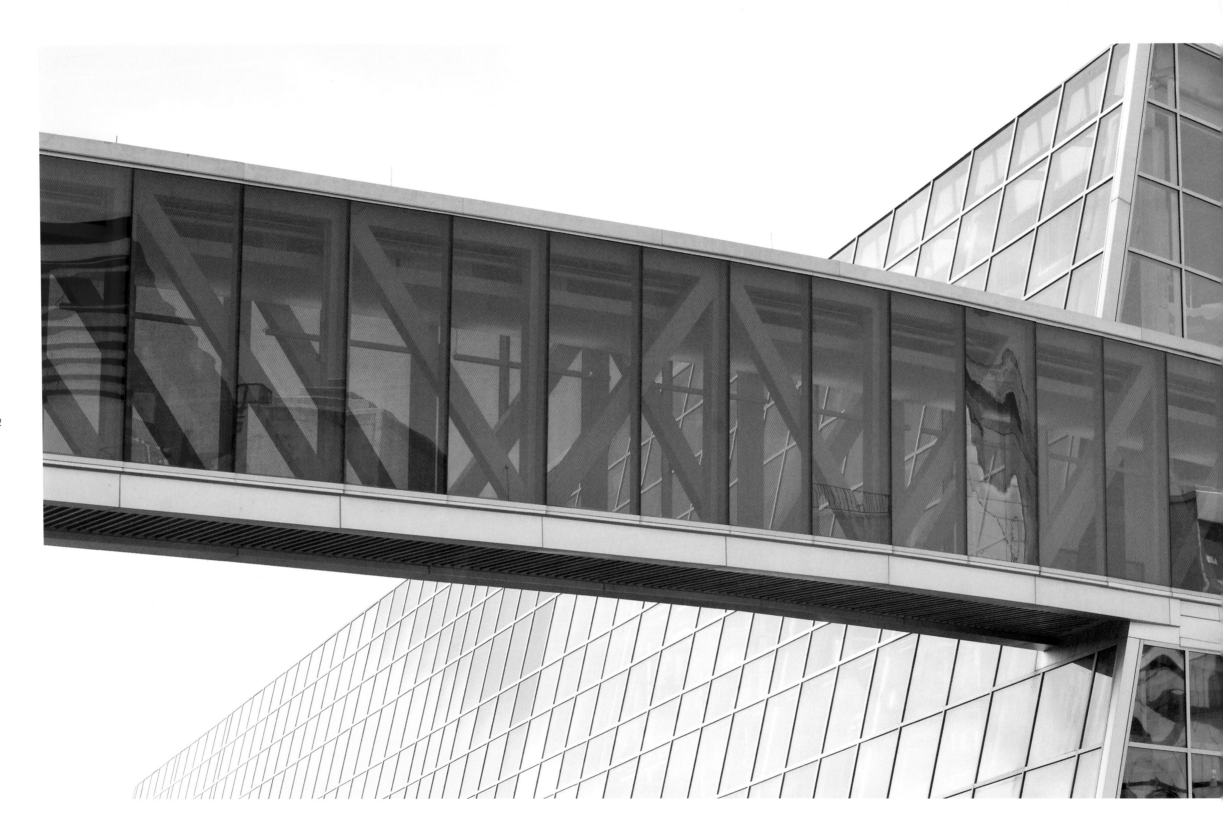

ART & ARCHITECTURE

The Ohio State University campus combines time-honored traditional architecture and eye-catching contemporary structures designed to inspire the poet and engineer in all of us. From the beautiful Beaux-Arts architecture of Ramseyer Hall to the post-modern masterwork that is the Wexner Center for the Arts, OSU's eclectic mix of styles successfully blends old and new. One might say this marriage of classic and modern is a subtle metaphor for the evolving world of higher education. In the photographs that follow, keep in mind that an enduring relationship exists between photography and architecture. As the photographer examines the inner play of structure, light, environment, and context, he also reveals the goals and insights of the architect.

THE ART OF ARCHITECTURE

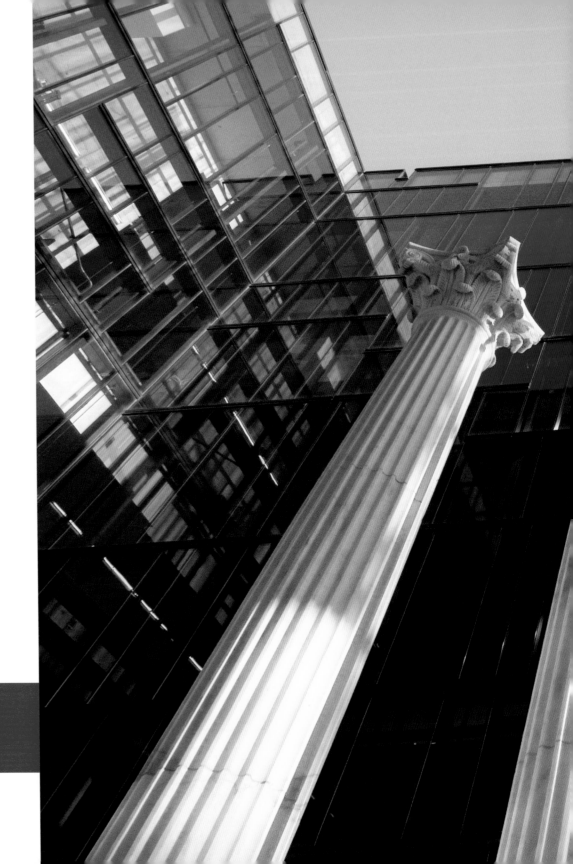

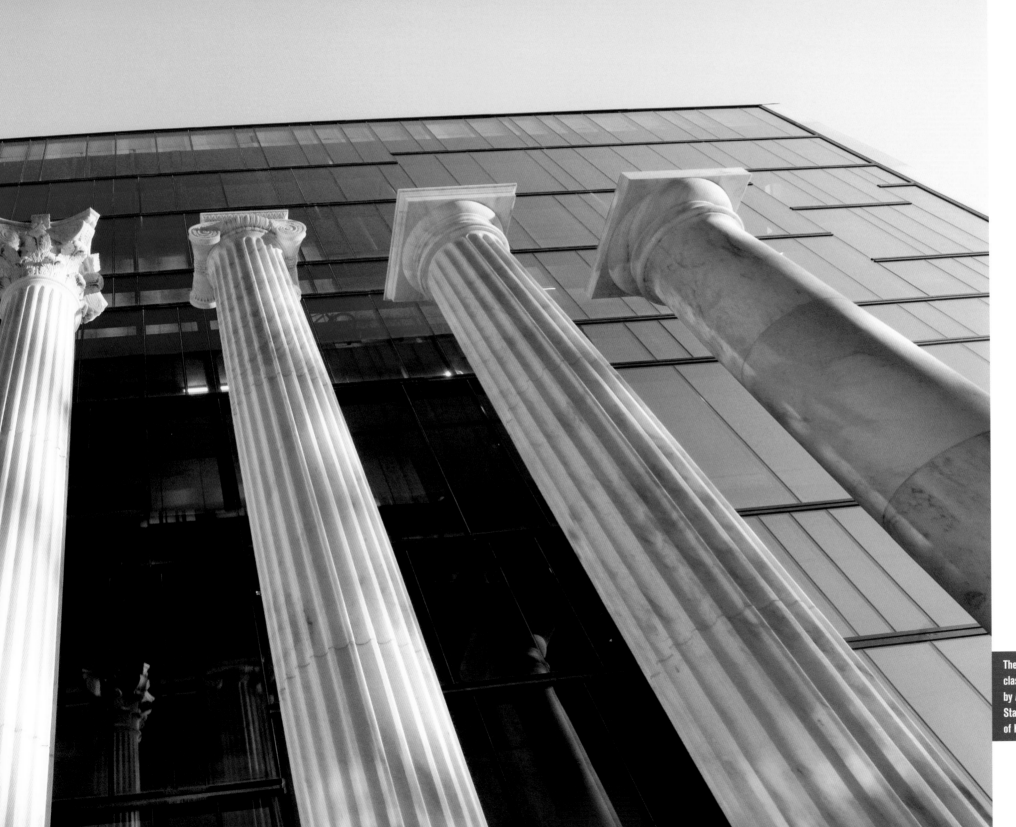

These five marble columns, which represent the
classical orders of architecture, were commissioned
by Austin Knowlton, a 1931 graduate of The Ohio
State University. They stand on the western side
of Knowlton Hall, OSU's School of Architecture.

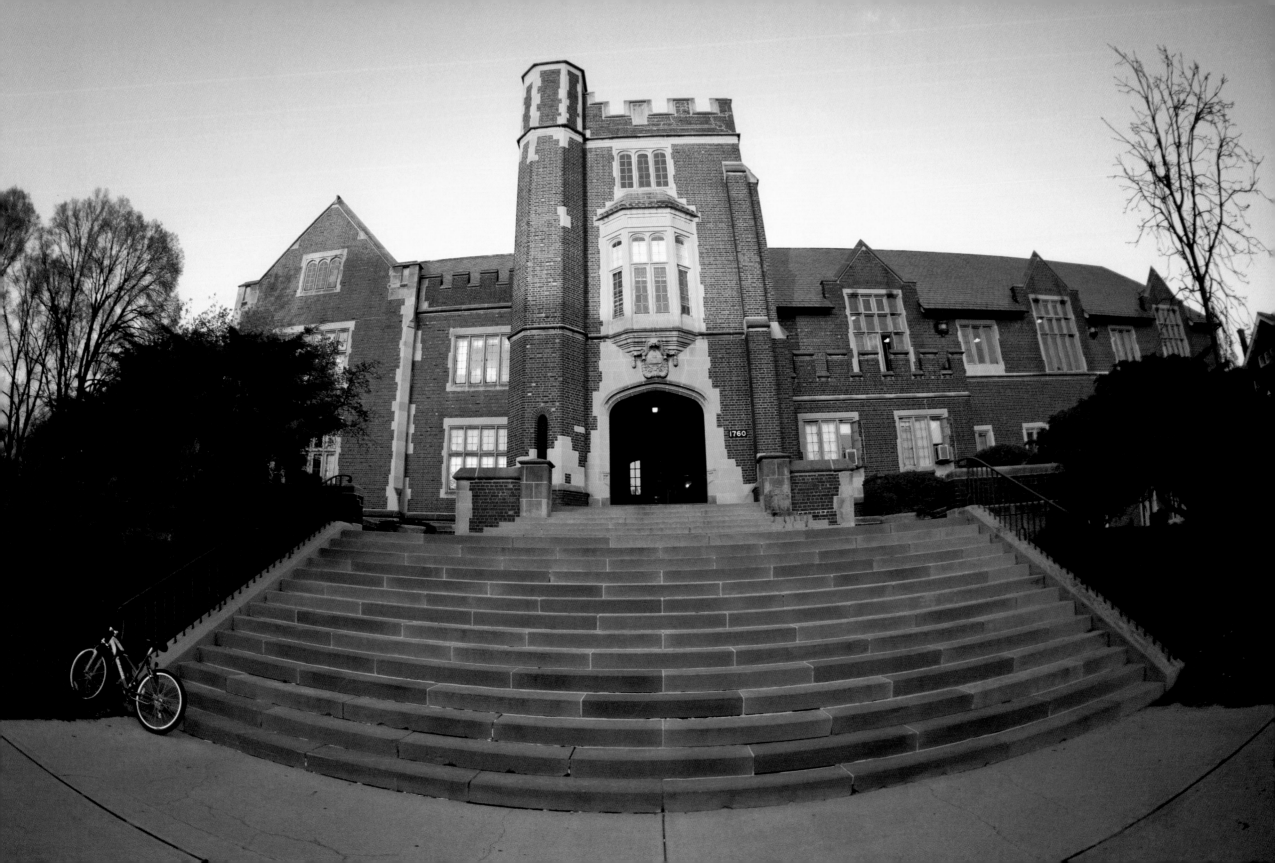

Spiral brick chimney atop Mack Hall.

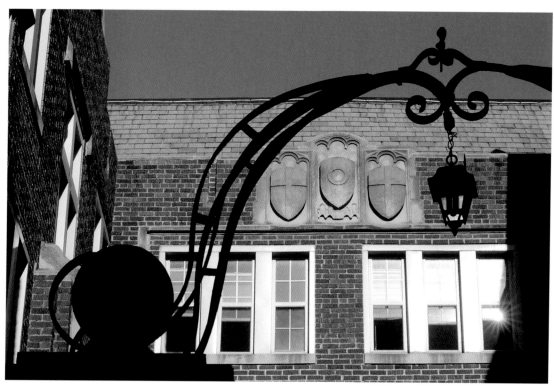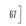

Scrolled iron archway framing
a view of Neilwood Gables, a
Jacobethan Revival dormitory.

Opposite page: View of Pomerene
Hall, an example of Jacobean Revival
architecture, Neil Avenue.

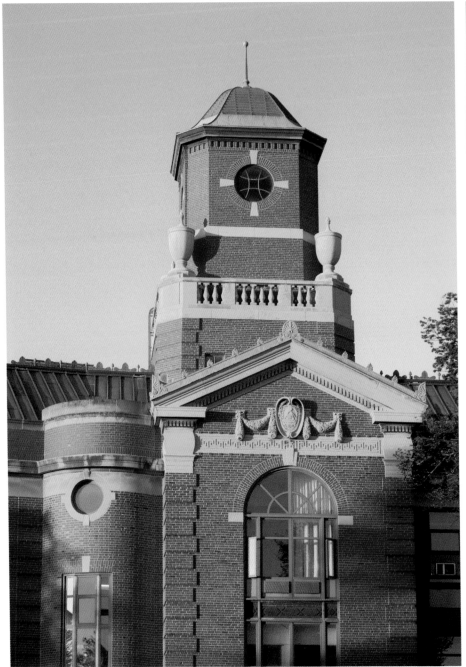

View of Ramseyer Hall, an example of
the Beaux Arts style of architecture,
West Woodruff Avenue.

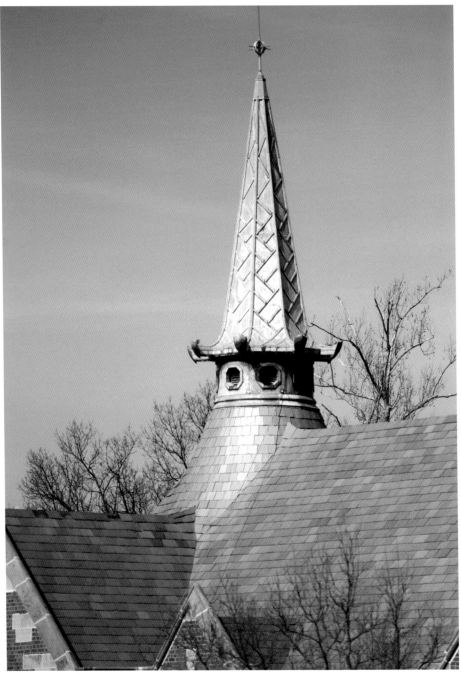

Metal fleche, French for "arrow," rises from
the steeply gabled slate roof of Mack Hall.

Opposite page: Classical entrance to
Old Brown Hall, demolished in 2009.

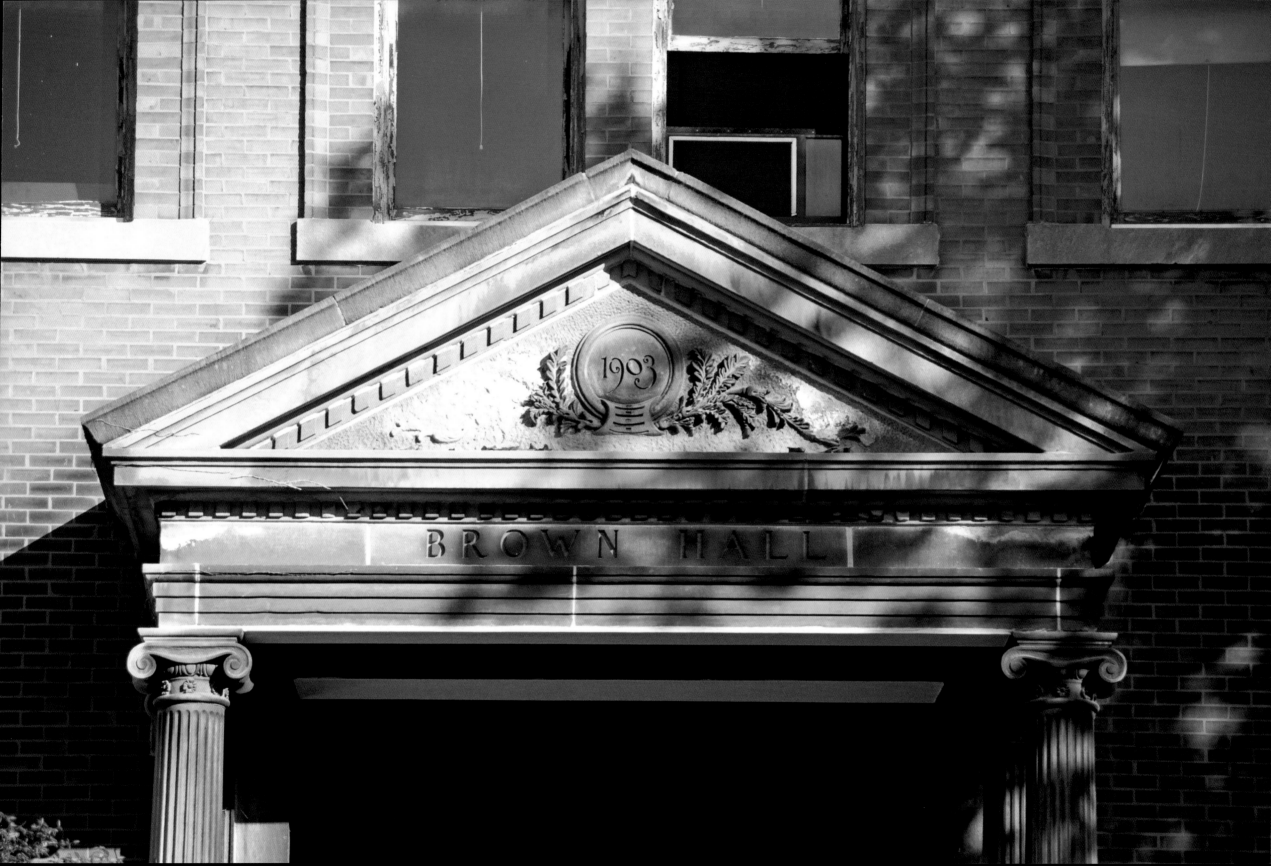

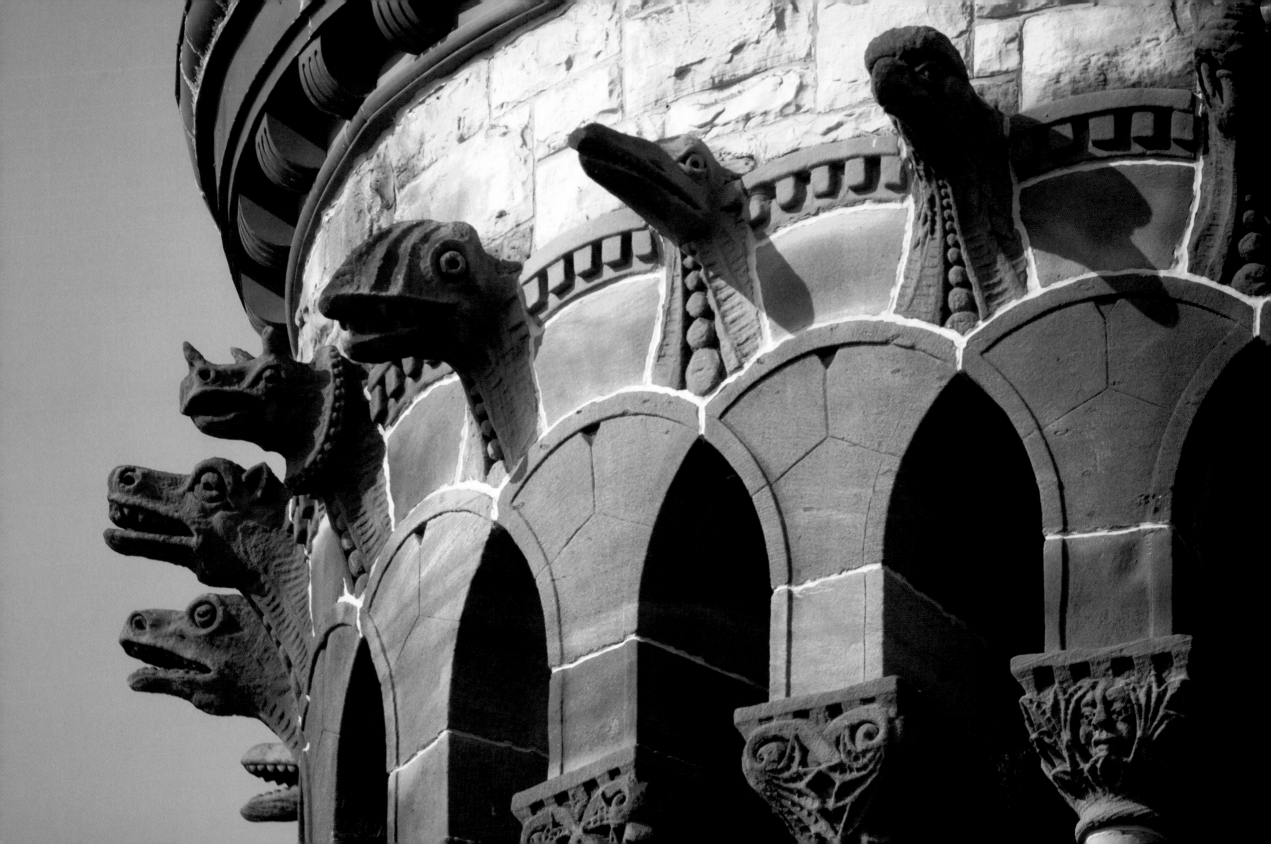

In 1891, The Ohio State University employed a local architect, J.W. Yost, to design a building that would set the university apart architecturally. Yost designed Orton Hall, which houses the Geology and Mineralogy Department, to naturally foster a sense of curiosity and learning. There is perhaps nearly as much to learn on the outside of the building as there is within. The many varieties of Ohio stone that comprise the exterior walls are arranged in proper geologic order, from the oldest stone at the base to the youngest stone high up on the walls. To the casual passerby, the animalistic faces at the top of the bell tower might appear to serve simply as protectors of the students within; however, a closer look shows that the images are much more closely aligned to the learning inside. Edward Orton, the building's namesake and first president of the university, designed the sculptures based on fossils of prehistoric animals that would have been found in the Ohio area. While there are sixteen creatures, only eight unique species are represented. A male and female of each animal appears, directly opposite its counterpart on the other side of the building. This sense of balance between the past and present is a common theme around The Ohio State University. The architectural spirit speaks to even novice observers. For those whose passion is architecture, Orton Hall is, simply, breathtaking.

71

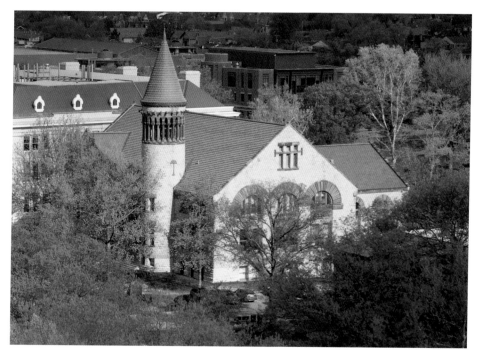

Opposite page: Series of extinct mammals
surrounding the Orton Hall tower.

Above: Orton Hall grotesque.

View of Orton Hall from the Reading
Room of Thompson Library.

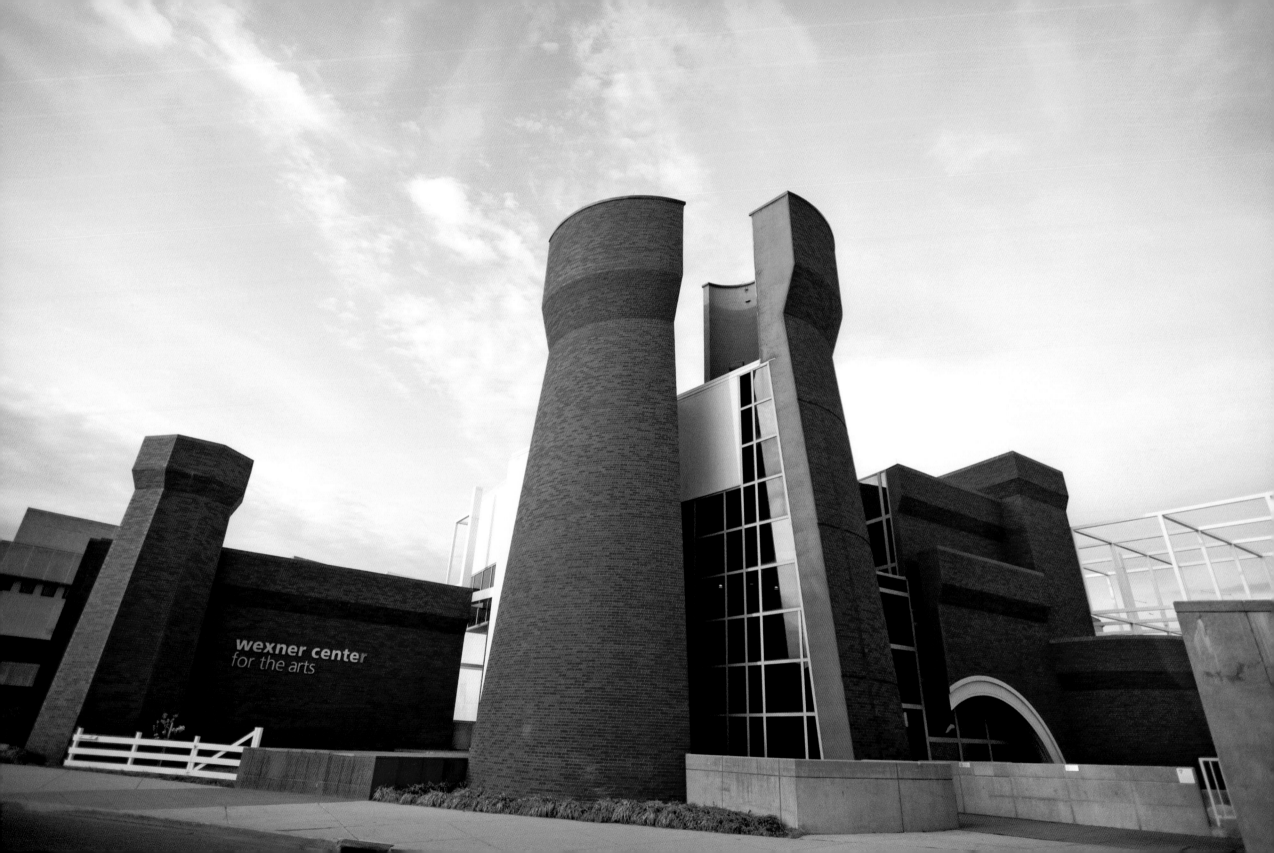

wexner center
for the arts

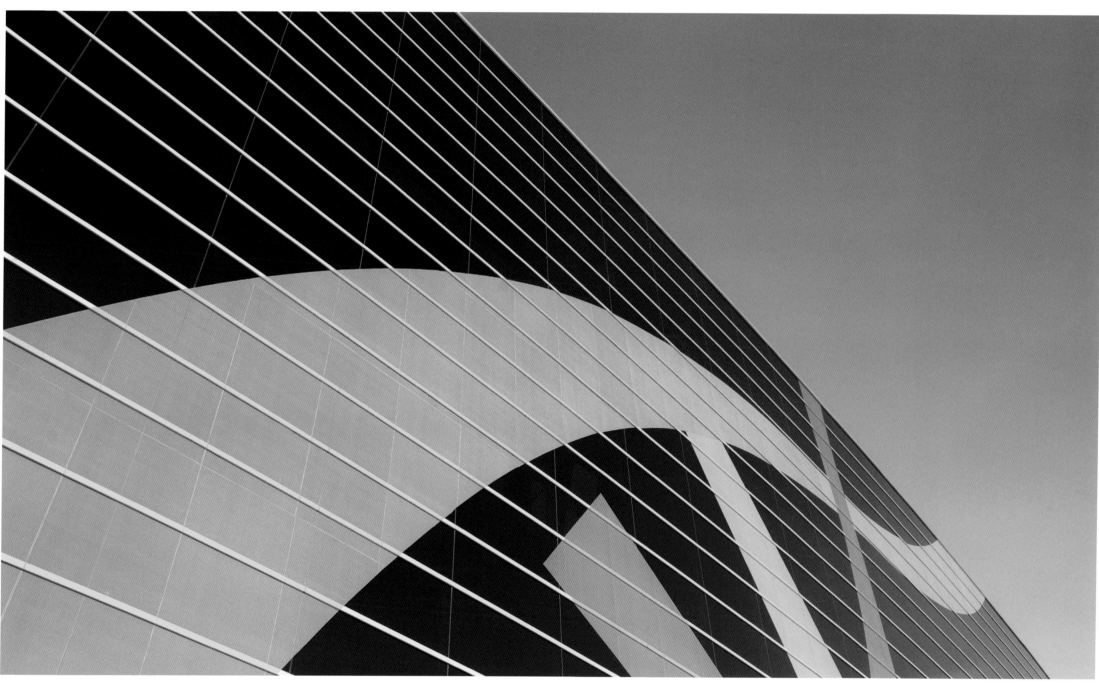

Opposite page: View of the Wexner
Center for the Arts, named in honor
of Harry L. Wexner, father of Leslie
H. Wexner, a graduate of OSU and
longtime supporter of the arts.

Above: View of The Ohio State
University Medical Center Eye and
Ear Institute, Wexner Medical Center,
located on Olentangy River Road.

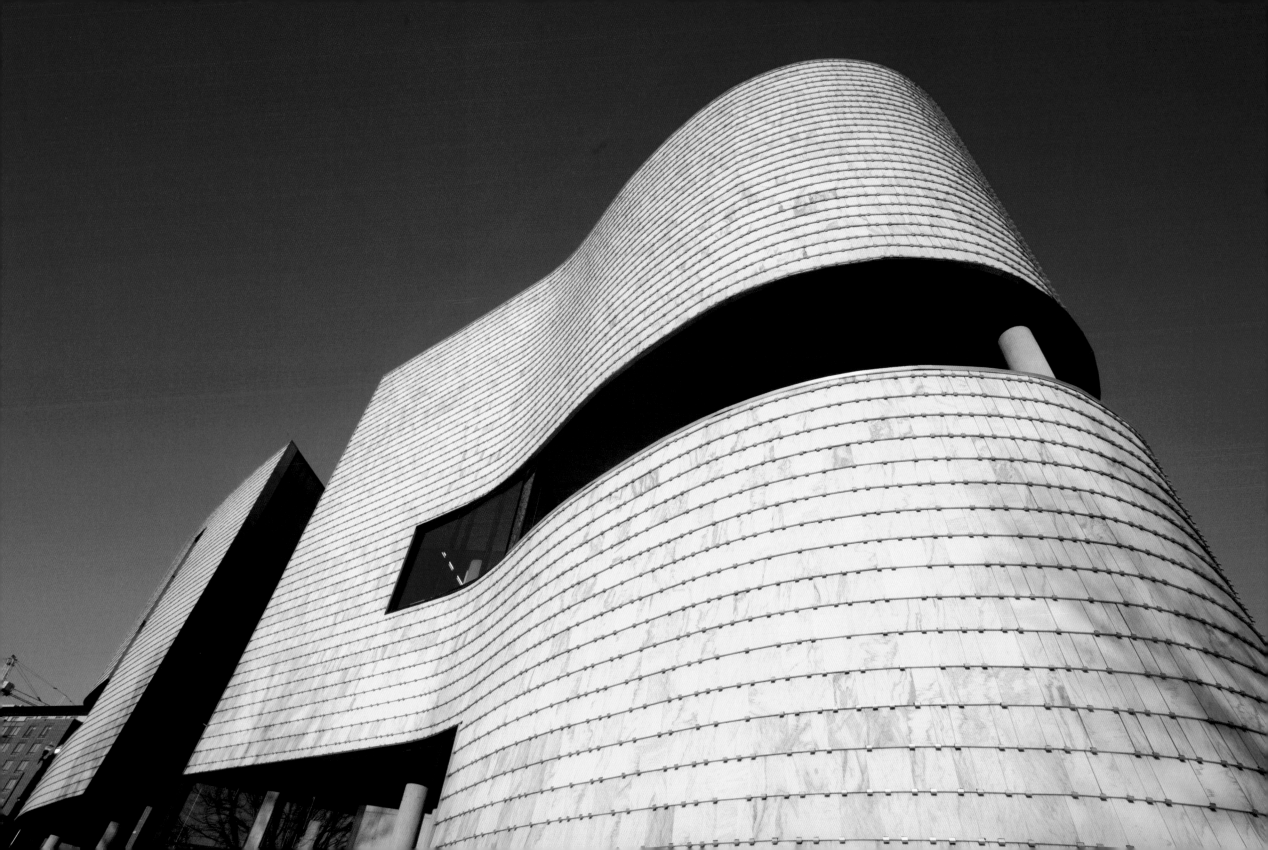

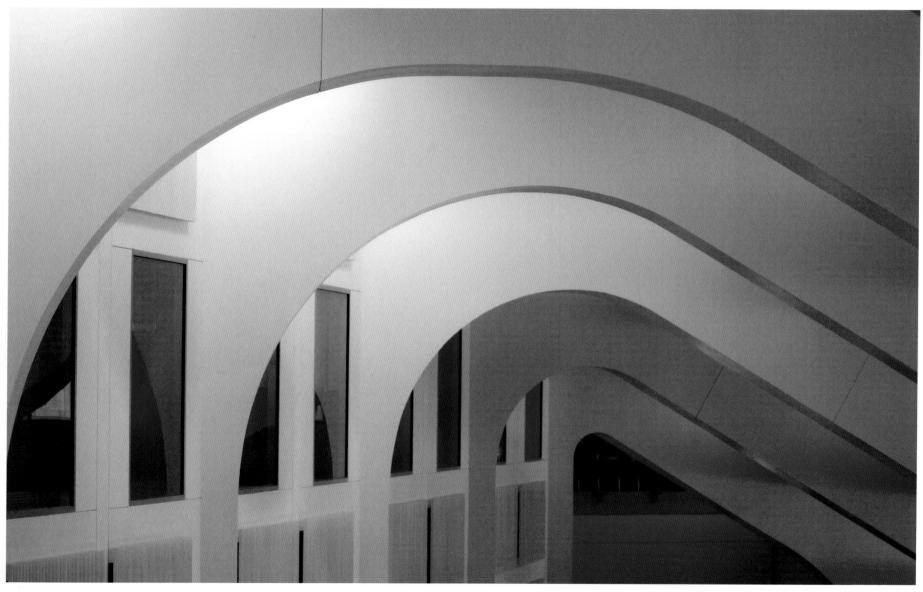

Opposite page: View of the Western façade of Knowlton Hall, School of Architecture, clad in marble shingles.

Above: Supporting arches in the main lobby of the Physics Research Building.

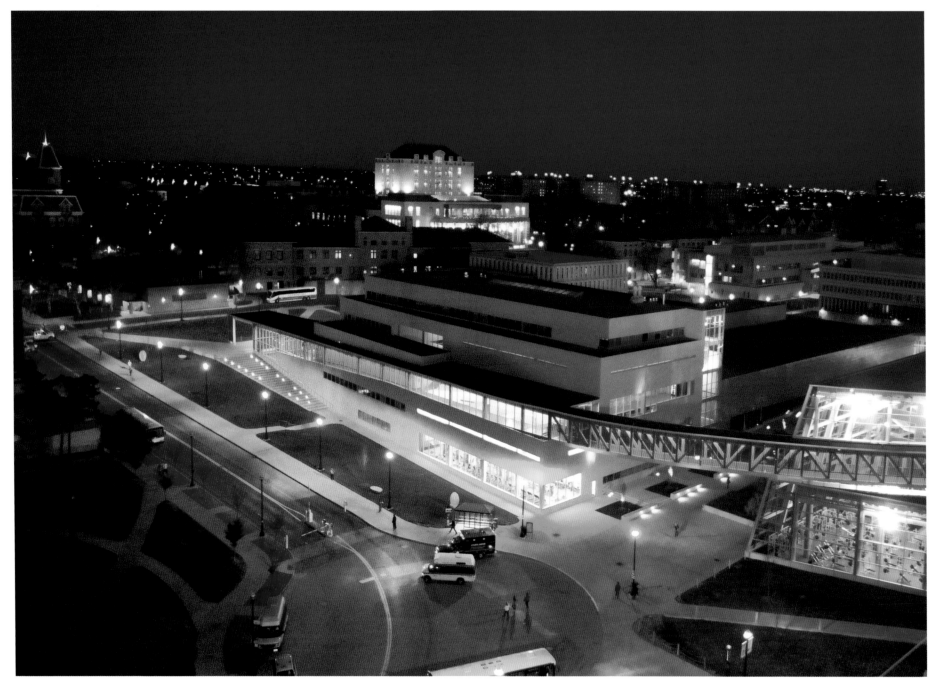

View of the Recreation and Physical
Activities Center, featuring a
scarlet glass walkway.

Opposite page: Northern façade
of Drinko Hall, home of the Moritz
College of Law on West 12th Avenue.

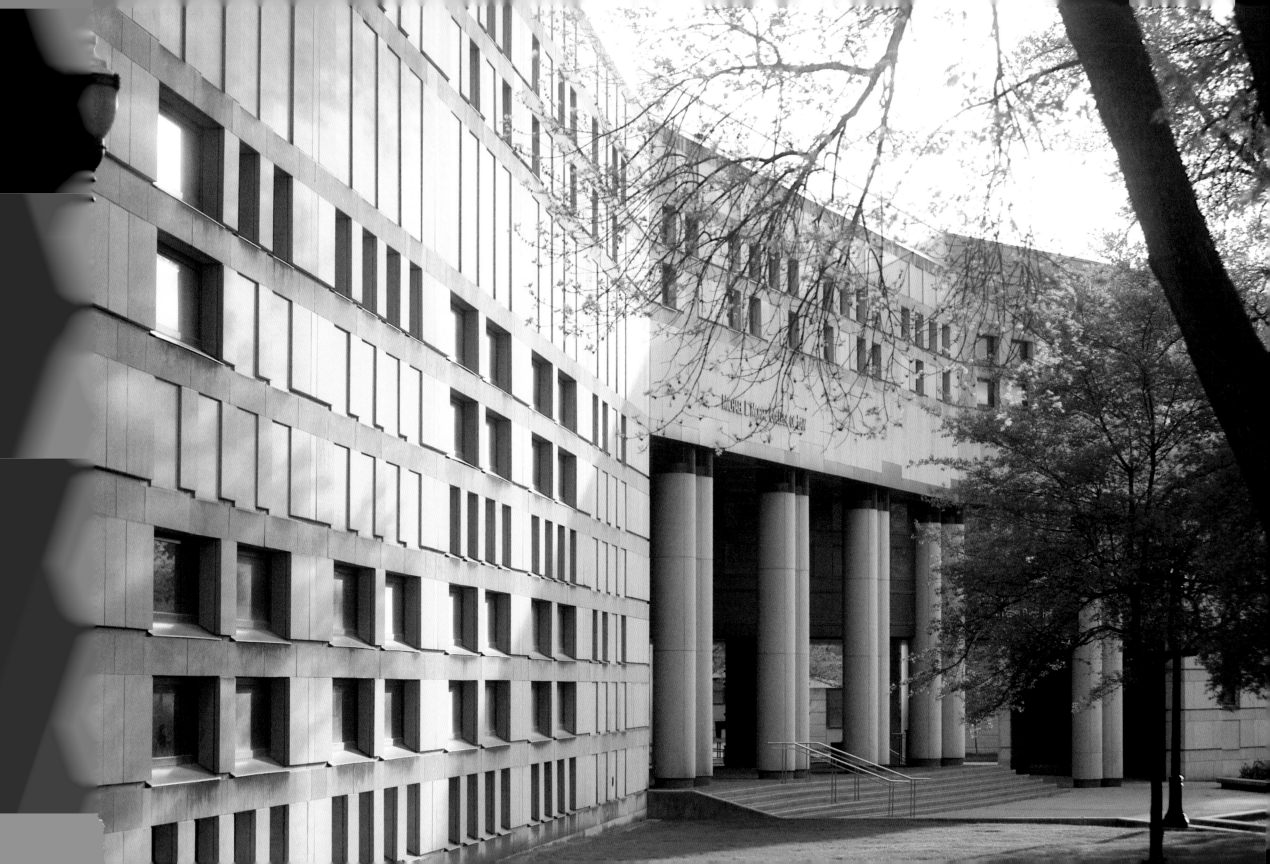

Art-deco inspired limestone and aluminum clock, northern façade, Mershon Auditorium.

Dramatic reflective glass and steel enhance the exterior of OSU's new South Campus Central Chilled Water Plant.

Opposite page: The prismatic blending of light enhances the concrete façade of the South Campus Central Chilled Water Plant.

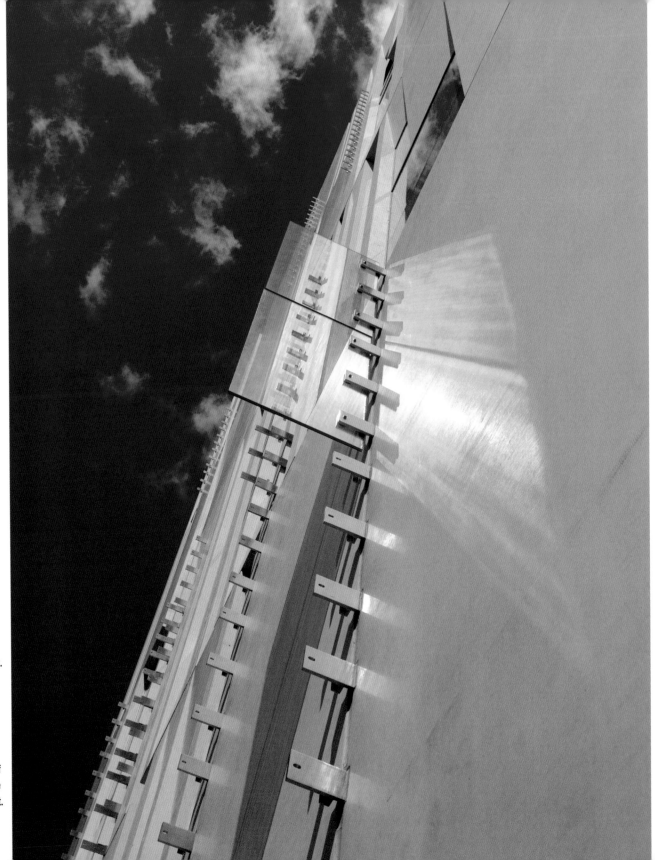

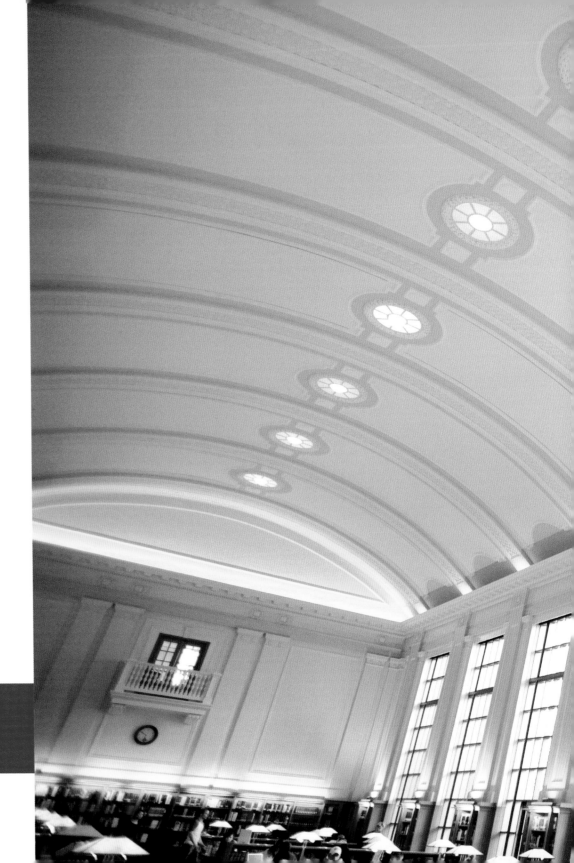

Modern or contemporary, moving or static, realist or abstract, sculptural works of art come in about as many forms as the humans that view and cherish them. Around the OSU campus appear representations of the entire spectrum of art history. As a student sits in the grand reading room of Thompson Library and gazes thoughtfully at a replica of the Winged Victory of Samothrace, it brings to mind Michelangelo's words, "Every block of stone has a statue inside it, and it is the task of the sculptor to discover it." What makes sculpture a fitting metaphor for a college campus is that students can be seen as the original material, while it is the job of the faculty and staff to help them mold their character, smooth rough edges, polish fine cracks, and uncover the treasure within. This is indeed the creative process.

SCULPTURE

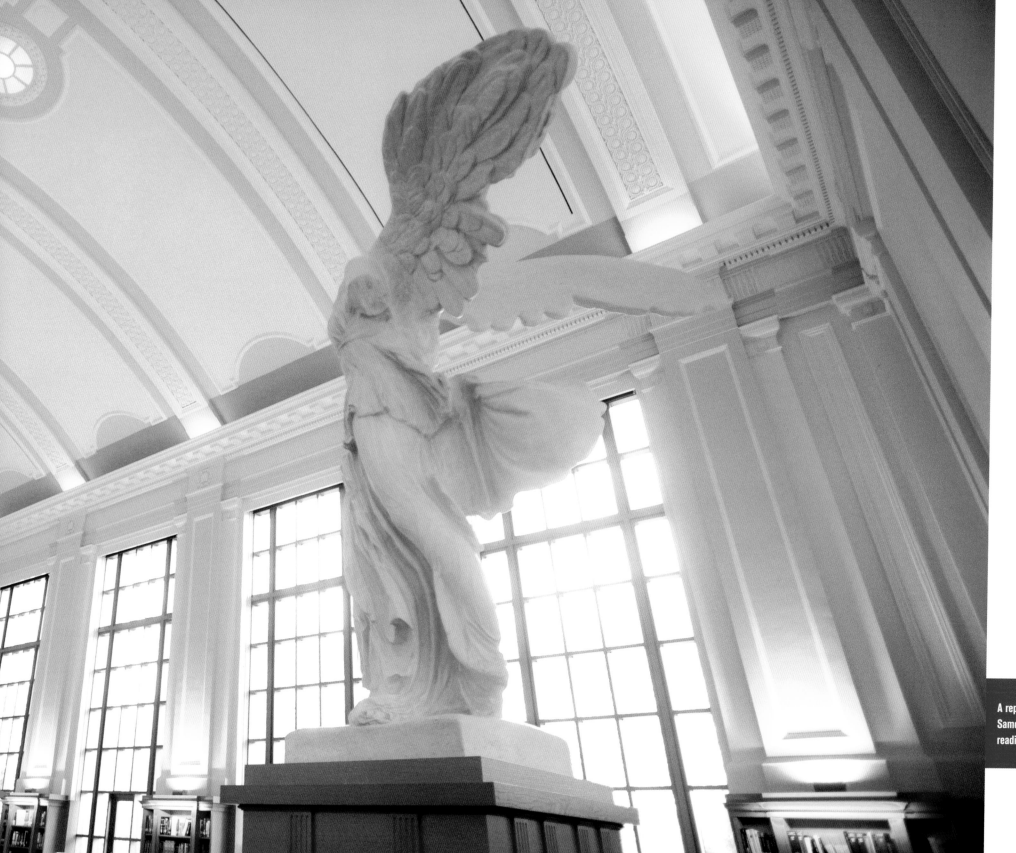

A replica of the Winged Victory of Samothrace dominates the grand reading room of Thompson Library.

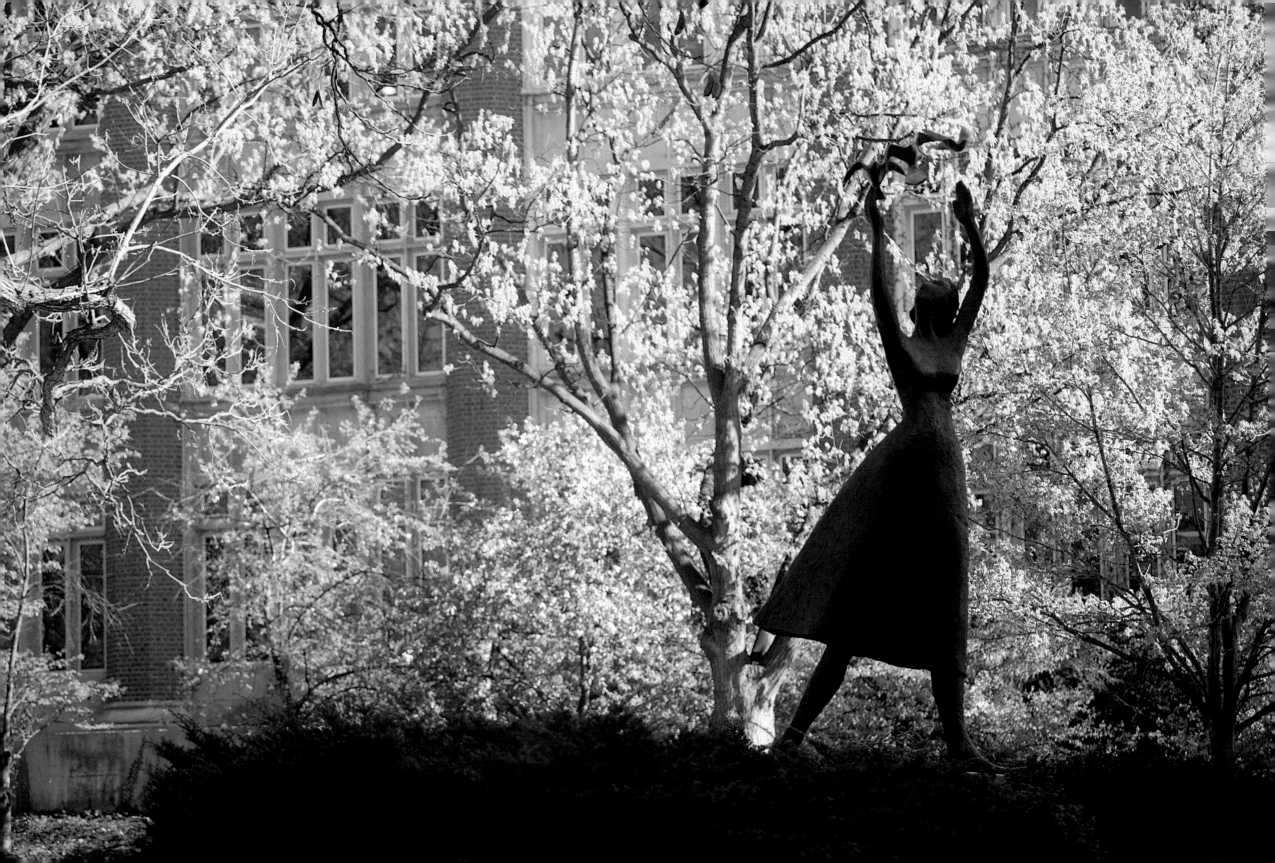

Hope: *"As a survivor of a great many hardships in my life, I never lost faith and I never gave up hope that tomorrow would bring a better, brighter, and more beautiful future for all."*

—ALFRED TIBOR, ARTIST

Dedicated to all people, offering hope and inspiration
Gift of Bernard R. and Florine C. Ruben – 1993

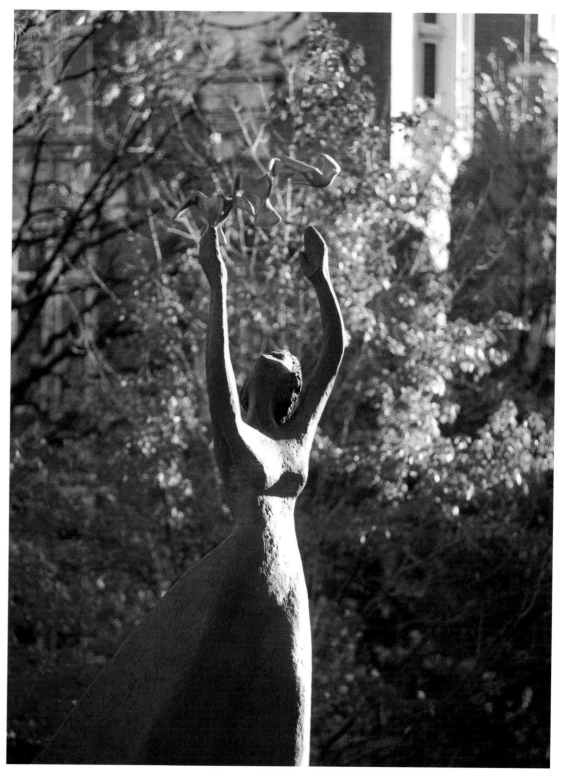

The Statue of Hope by Alfred Tibor,
dedicated in 1993, graces a courtyard
opposite the James Cancer Hospital.

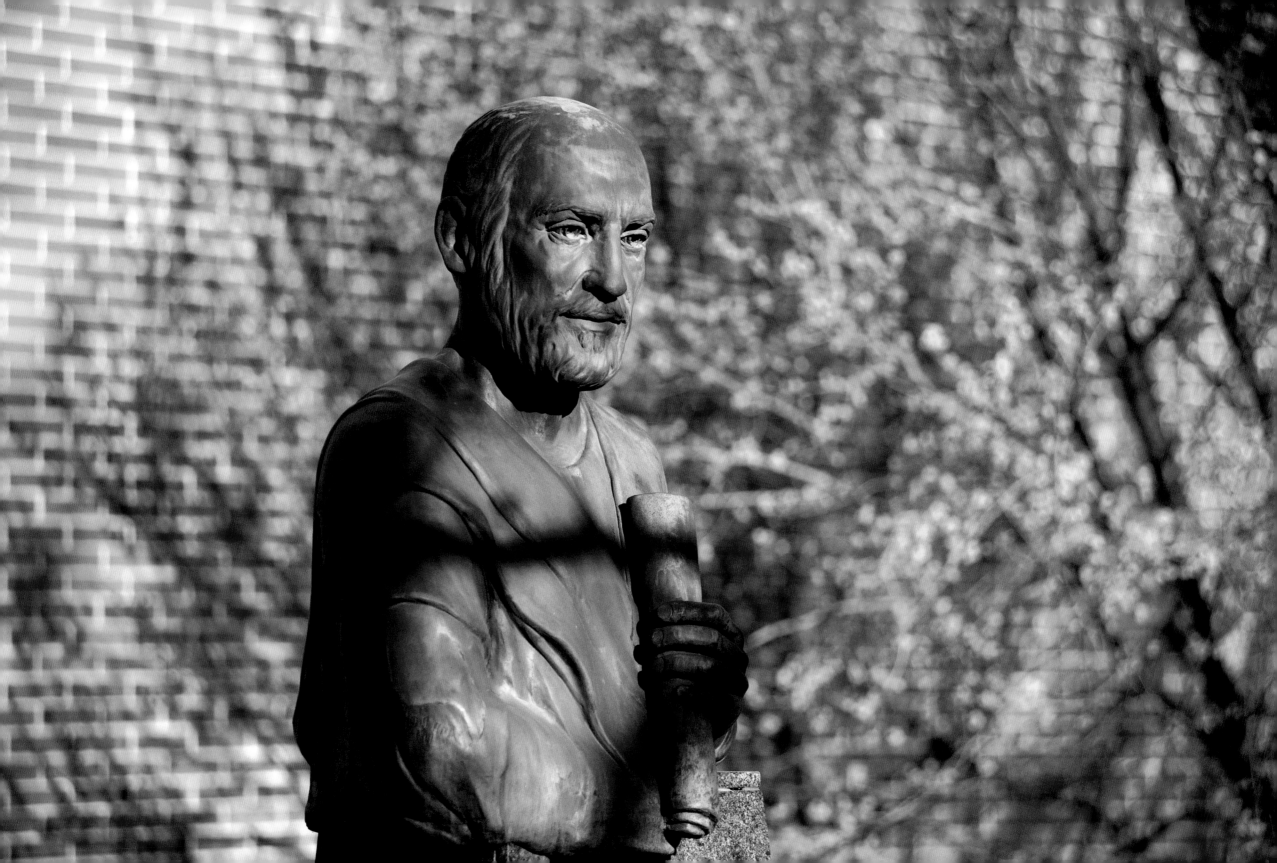

ΑΓΝΟΣ ΔΕ ΚΑΙ
ΟΣΙΟΣ ΔΙΑΤΗΡΗΕΩ
ΒΙΟΝ ΤΟΝ ΕΜΟΝ
ΚΑΙ ΤΕΧΝΗΗΝ
ΤΗΝ ΕΜΗΝ

Opposite page: Bronze bust of Hippocrates
by Ann Christoforidis, Hippocrates
Plaza, adjacent to Meiling Hall.

With purity and with holiness I will

pass my life, and practice my art.

—HIPPOCRATES

Carved marble inscription of a portion of the
Hippocratic Oath beneath a bust of Hippocrates

85

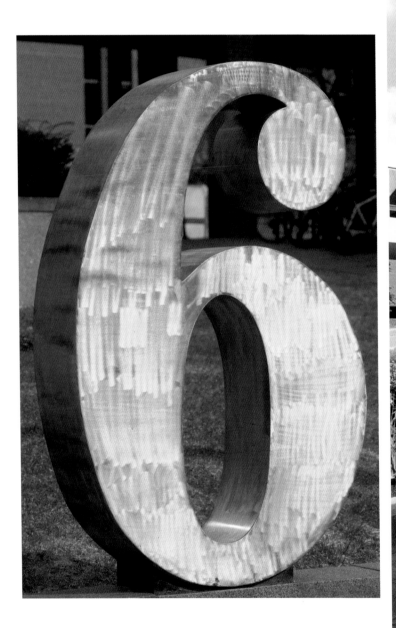

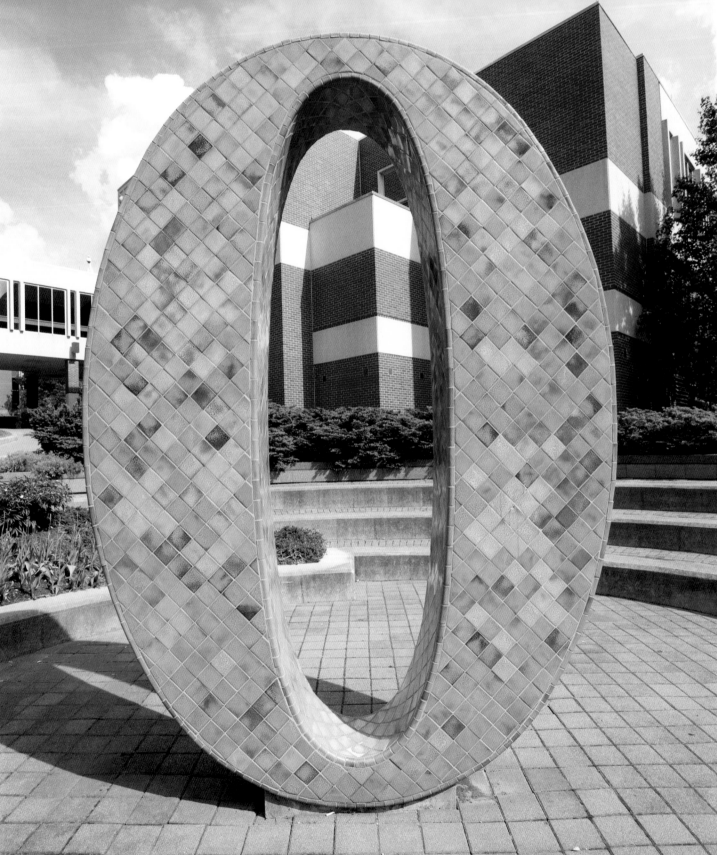

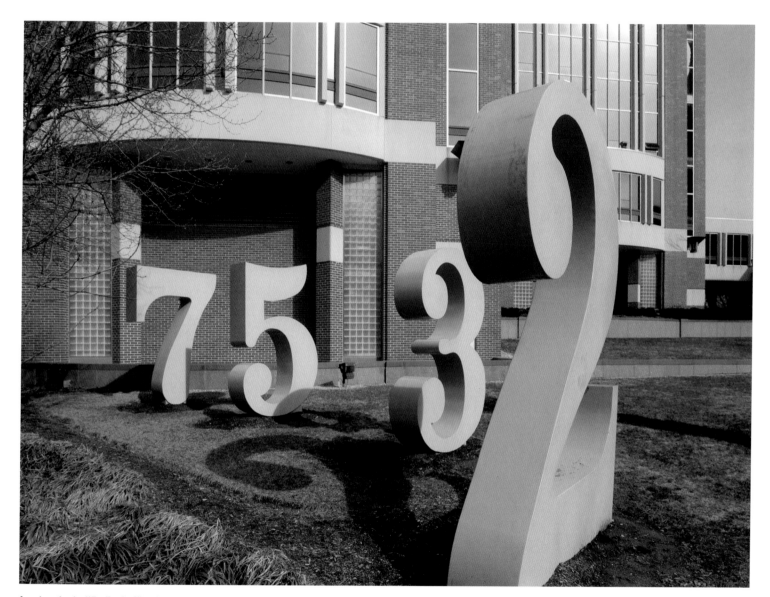

A series of scientifically significant numerical metal sculptures.

GARDEN OF CONSTANTS

One might not think to look near a science building for great artwork, but gracing the grounds near Dreese Laboratory is the Garden of Constants. Dreese Laboratory houses Computer and Information Science as well as Electrical Engineering. In 2004, artist Barbara Grygutis merged art and science seamlessly. The Garden of Constants consists of ten large numerical sculptures, as well as smaller scientifically significant numbers inlaid in the paths around the area. The inlaid numbers are formulas and symbols representing true constants, which are immensely important to the work being performed in the adjacent lab. This juxtaposition of art and science provides a mind-expanding experience that leaves the viewer impressed and inspired.

One of several concrete reliefs surrounding the Recreation and Physical Activities Center.

A sculptural installation by Maya Lin of shattered tempered glass recycled from auto windshields, located at the Wexner Center for the Arts.

Opposite page: This 5,000-pound granite ball is in the Bloch Cancer Survivors Park, named for Richard and Annette Bloch; part of a large sculptural installation by the late Victor Salmones.

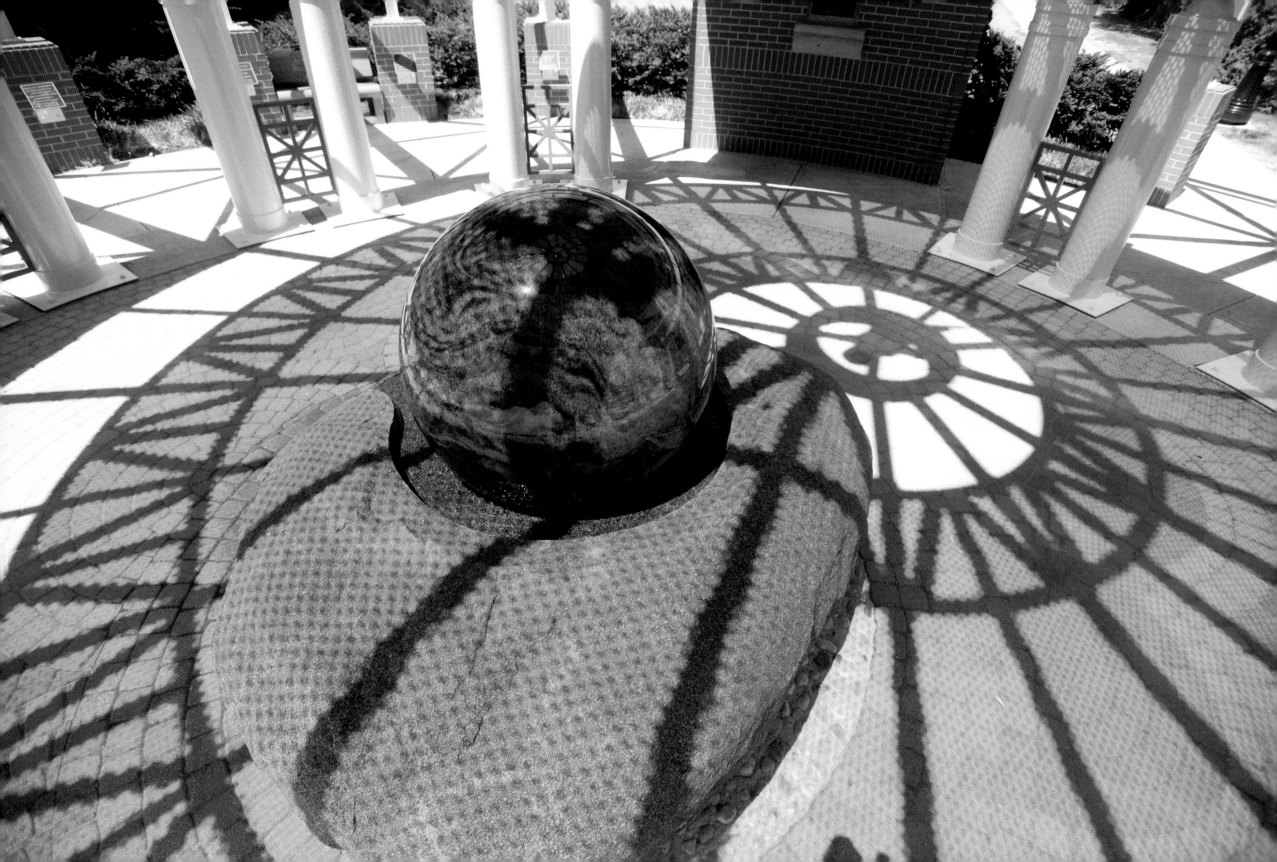

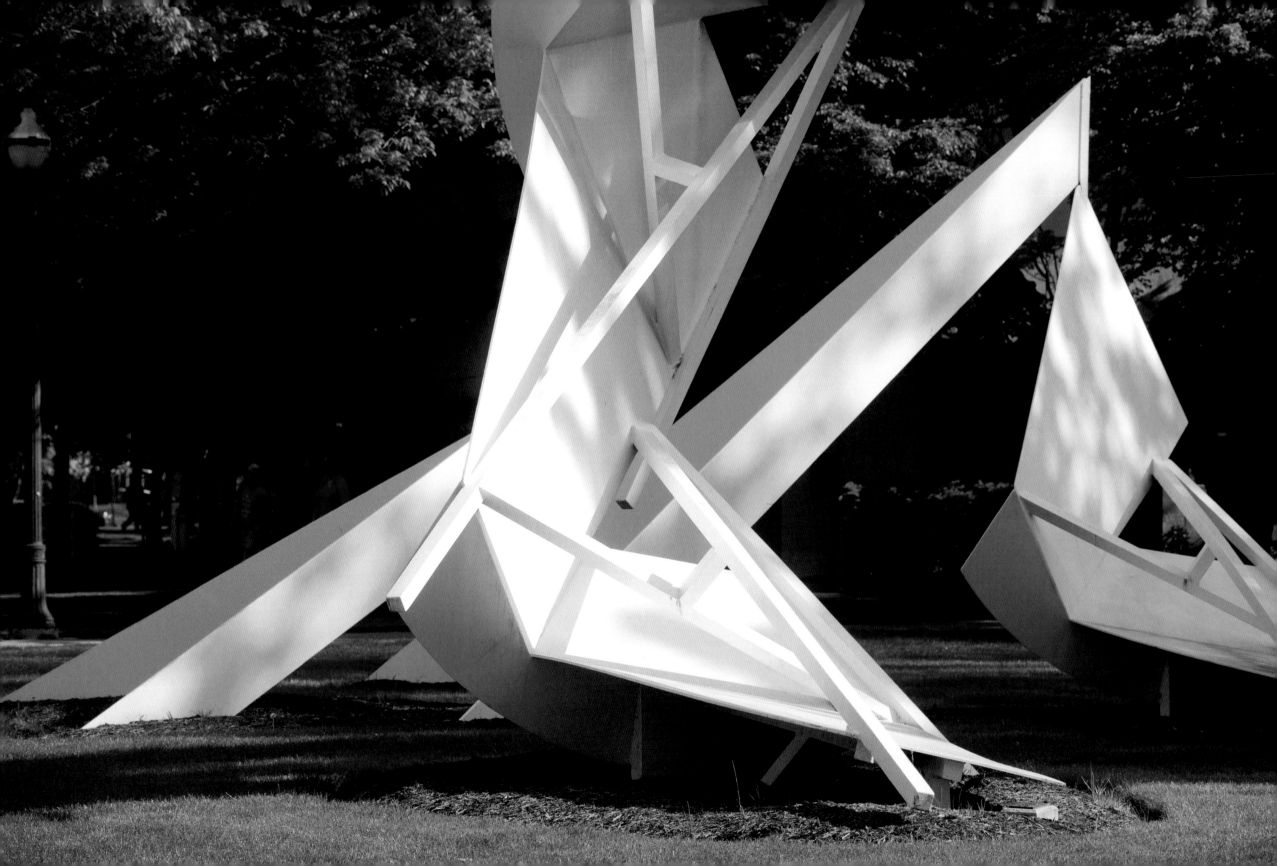

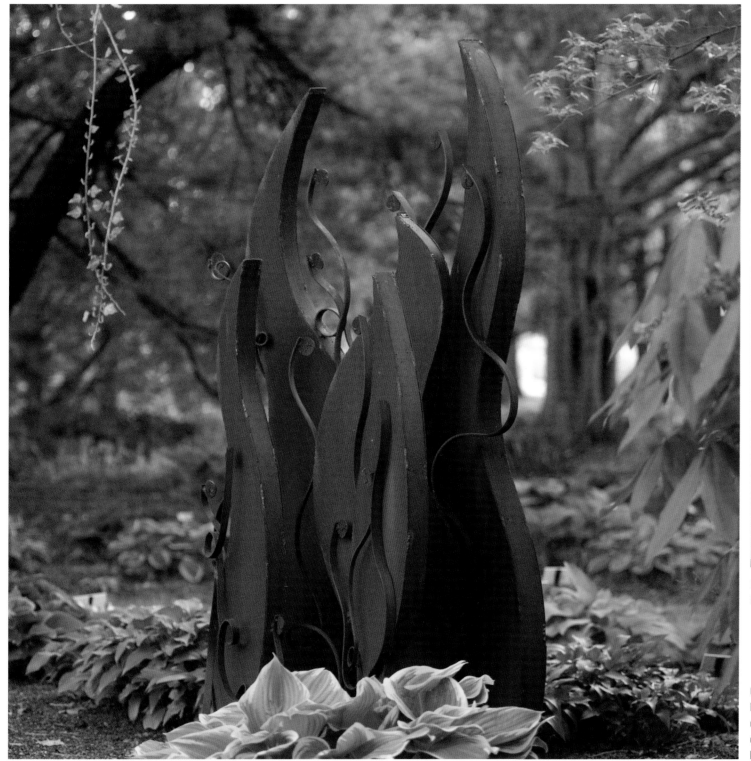

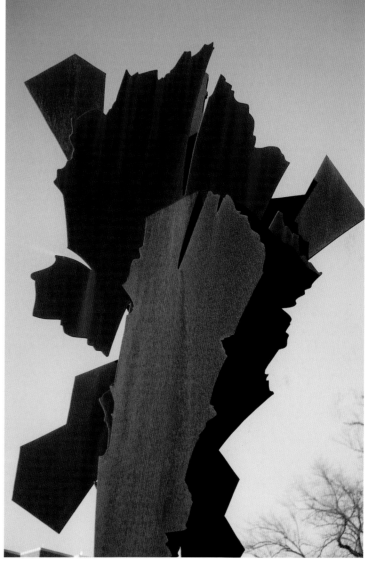

91

Left: Untitled metal sculpture by artist Pat Belisle, Chadwick Arboretum.

Above: Metal sculpture by Albert Paley, entitled "Gnomon," stands in front of Drinko Hall.

Opposite page: Geometric sculpture by David Black entitled "Breaker," dedicated in 1982, located on the lawn of Arps Hall. This piece was inspired by the motion of a breaking wave.

Doorways and windows attract metaphors like the moon pulls the tides. Nowhere, perhaps, is this truer than on a college campus. Both doorways and windows are passages to undiscovered worlds, new possibilities, adventures, and occasionally something as mundane (but important) as fresh air. Every new student knows the hesitation that accompanies that first turn of a doorknob into a new classroom. But, they also know that simple knob-turn is the initial step on their journey towards enlightenment.

DOORWAYS & WINDOWS

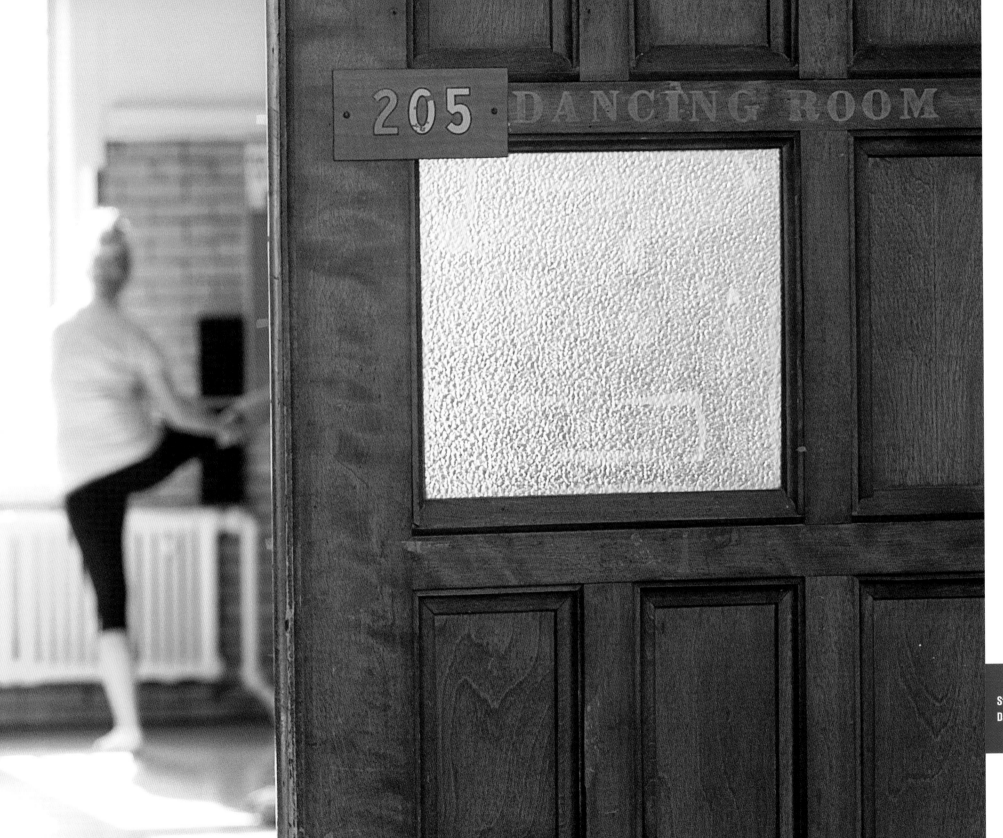

Students warm up in the
Dancing Room, Pomerene Hall.

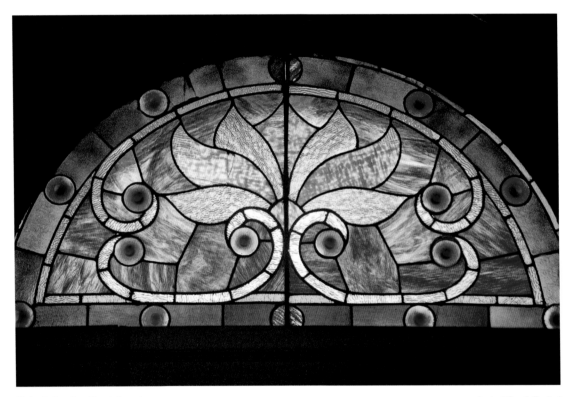

Stained glass lunette window above
the entrance to Orton Hall.

Arched Greek Revival
entryway to Bricker Hall.

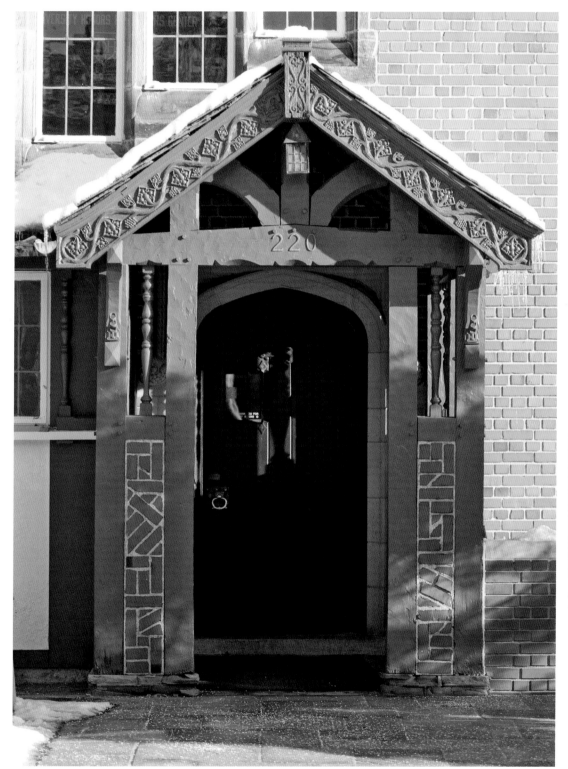

A Tudor Revival entrance greets visitors
to the Kuhn Honors and Scholars House.

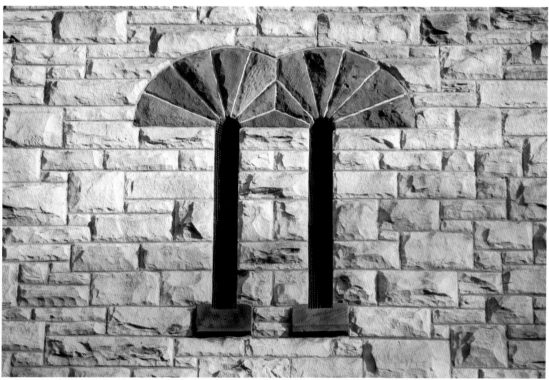

Stone windows with a semicircular
arch, a feature of Richardsonian
Romanesque architecture, at Orton Hall.

Classical balustrade and dormer
window atop Mendenhall Laboratory.

Window detail, University Hall.

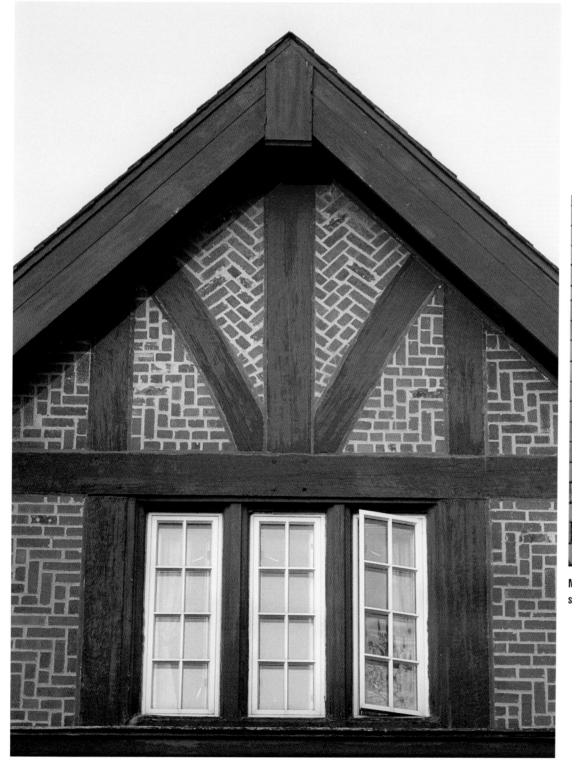

Mack Hall dormitory windows
surrounded by brick and timber.

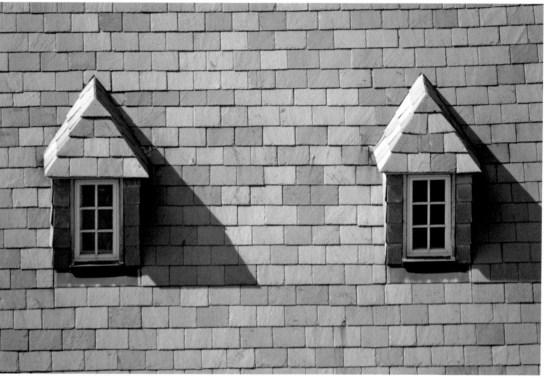

Slate-clad dormers on the
roof of Baker Hall.

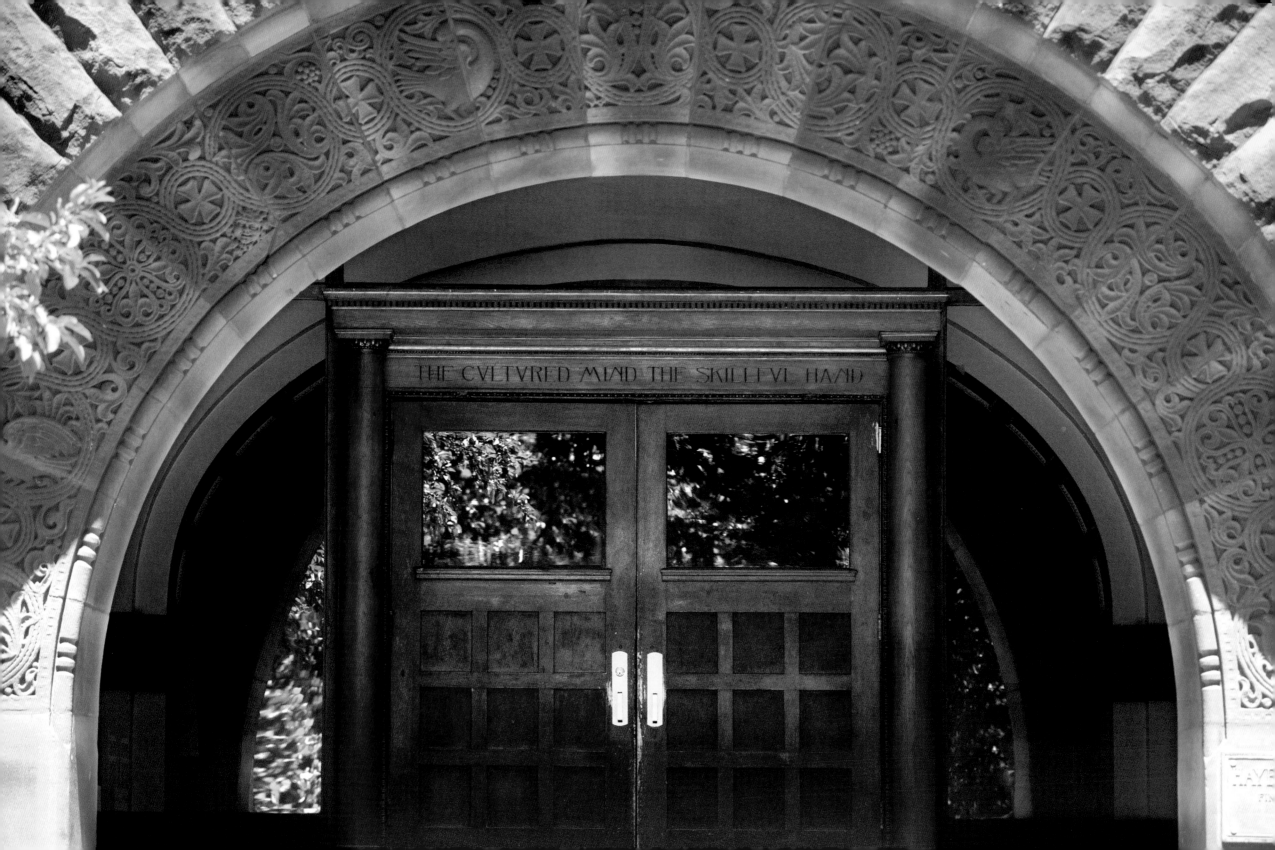

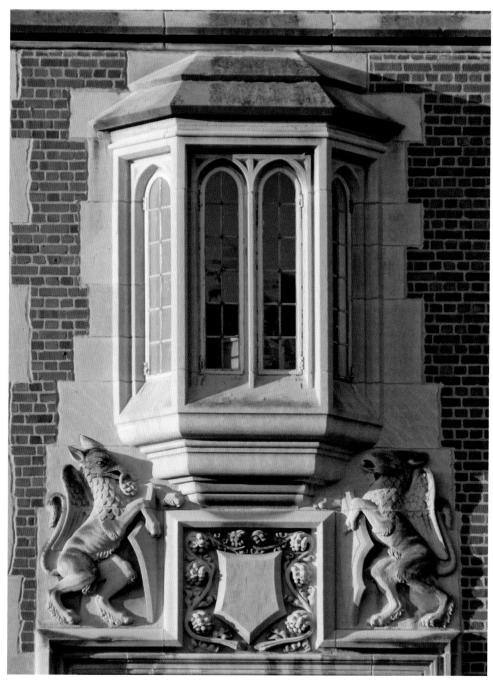

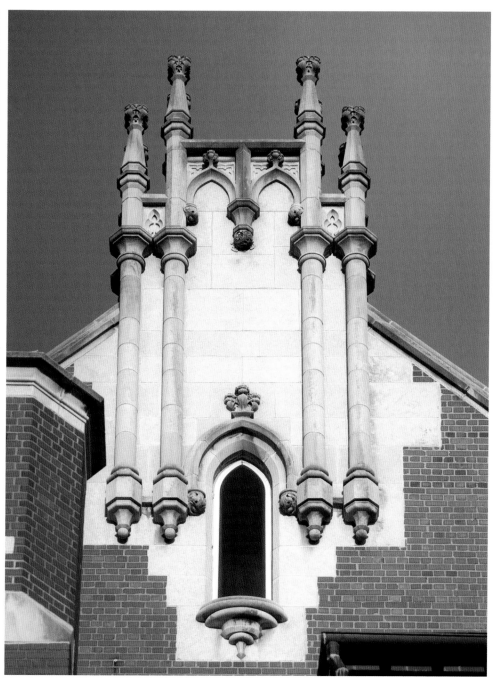

A decorative limestone bay window at
Pomerene Hall overlooks Mirror Lake.

Opposite page: Richardsonian Romanesque
entrance to Rutherford B. Hayes Hall.

A Jacobethan Revival brick gable with
clustered pinnacles and crockets framing
a lancet window, Hamilton Hall.

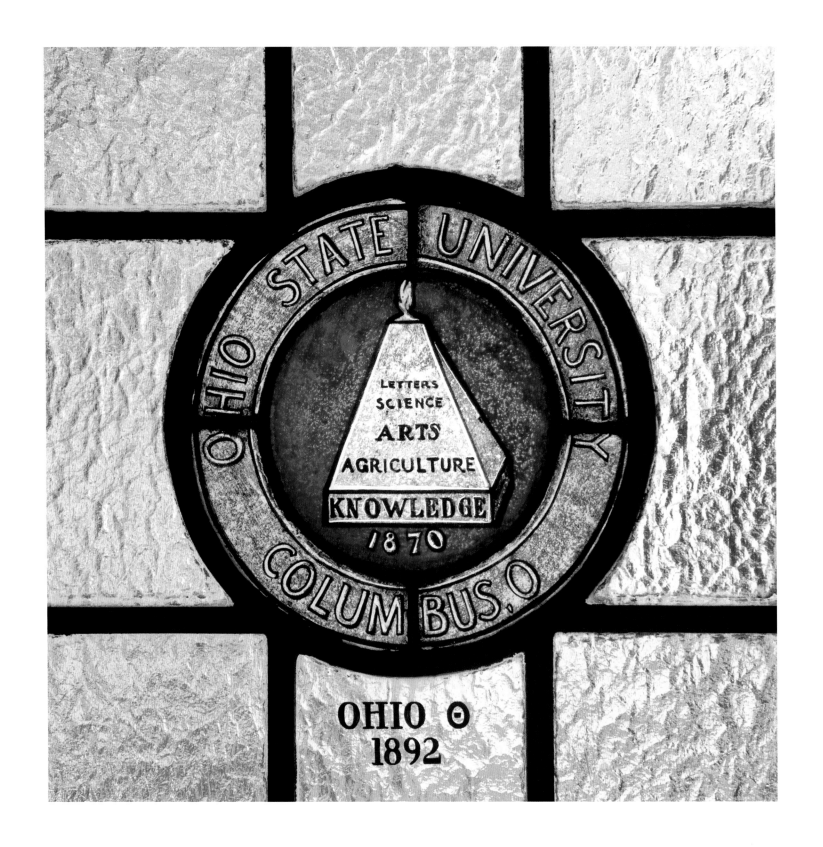

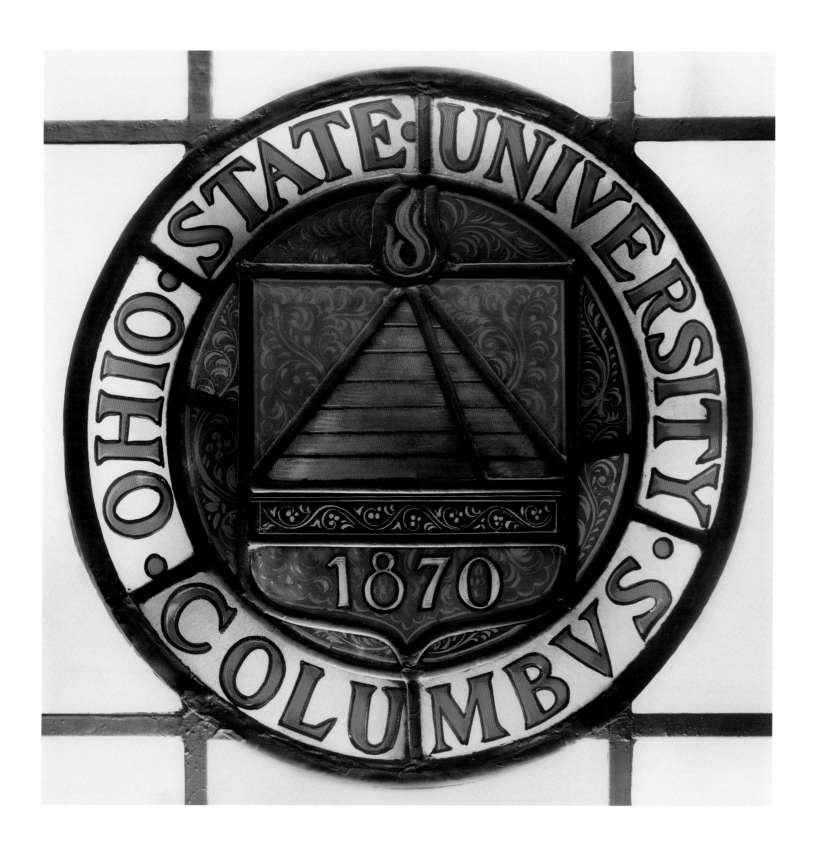

SEAL IN STAINED GLASS

The window on the opposite page, honoring The Ohio State University Sigma Alpha Epsilon fraternity chapter, is in the Walt Library, Levere Memorial Temple on the Northwestern University campus in Evanston, Illinois, location of the SAE national headquarters.

The window to the left was originally installed in Pomerene Hall and reflects the Jacobean style of architecture of that building. During a renovation, this window was removed, restored, and reinstalled in the basement of Pomerene Hall, where Mirror Lake Creamery & Grill is now located.

101

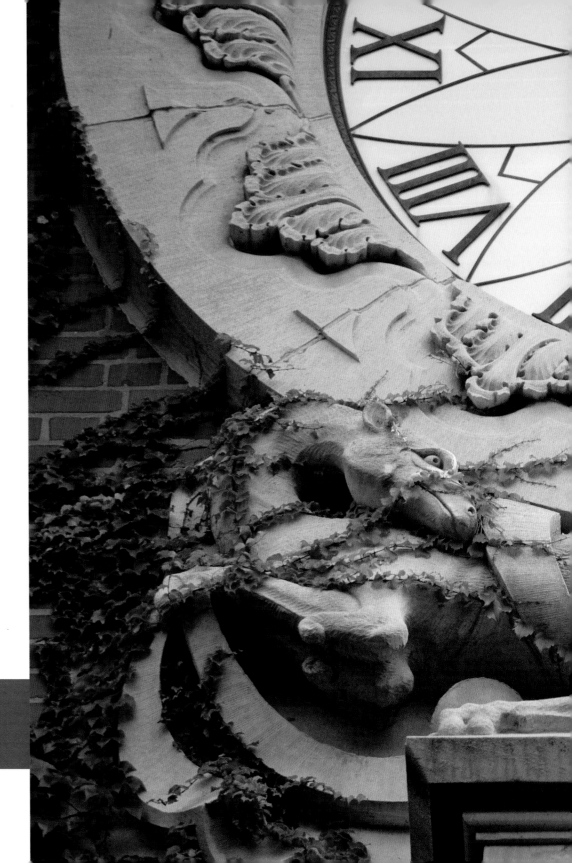

The daily routines of university life can give students and faculty a sense of security, control, and confidence. Unless your routine contains long walks around the campus, it is all too easy to miss much of the beauty around you. It is often said that "the devil is in the details," but one must not forget the untold beauty to be found there as well. From gargoyles and clocks to statues and art tile, architectural details and artistry are woven into the fabric of The Ohio State University.

CAMPUS IN DETAIL

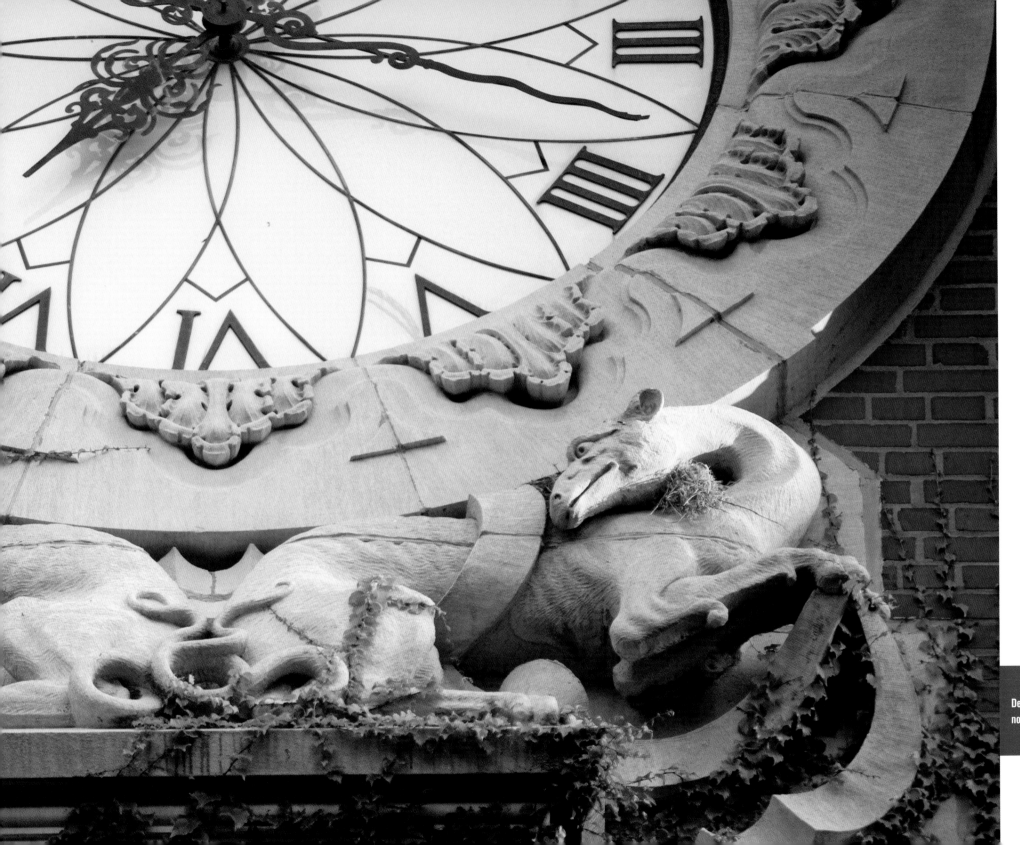

Decorative limestone clock,
northern façade of Hamilton Hall.

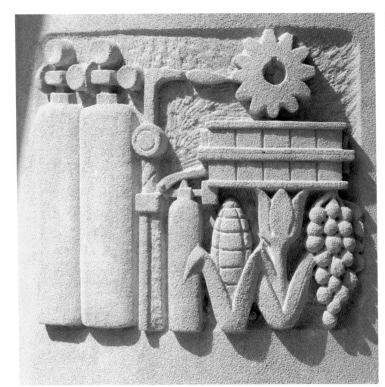

Carved limestone relief, Fontana Laboratories, W. 19th Street.

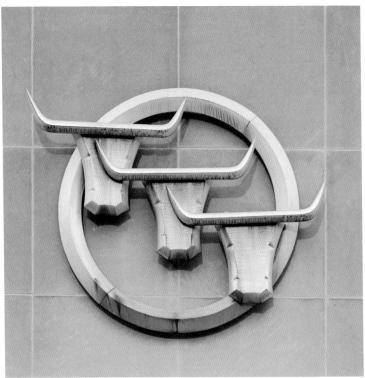

Aluminum sculpture above the main entrance, Animal Science Building.

Aluminum relief, Agricultural Administration Building.

·O·

OSU AND 4-H CLUBS

In the earliest years of the twentieth century Albert Belmont Graham began teaching lessons on plant cultivation and farm life in Ohio.

His group eventually became known as "Boy's and Girl's Agricultural Club"; today we know it as Ohio 4-H Club. The Ohio State University took an interest in the 4-H Club and became a strong partner in aiding the club's research. The members of the club had access to the university's Agricultural Experiment Station and the College of Agriculture. With OSU's influence, youth agricultural stations were established across the state.

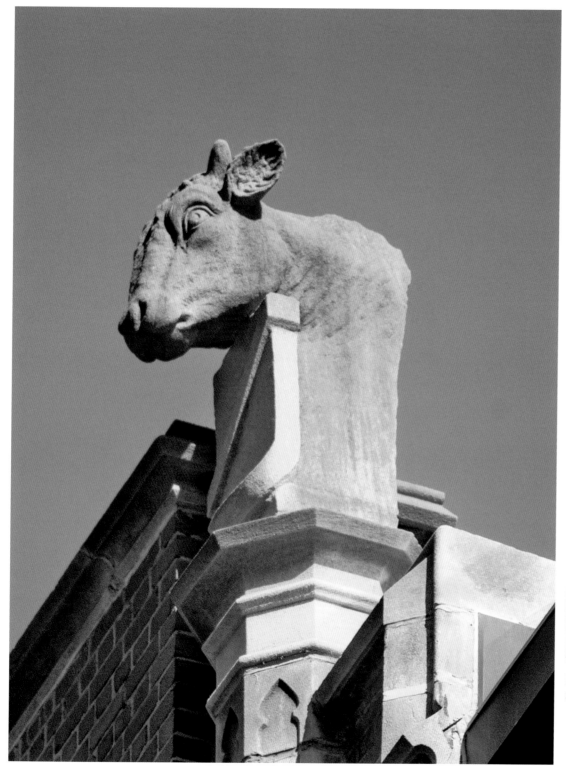

Left: Bovine grotesque atop
Starling Loving Hall.

Horn of Plenty above the south
entrance to Arps Hall.

O
GARGOYLES & GROTESQUES

The word *gargoyle* is etymologically linked to the Latin word meaning "to swallow," as in the sound one makes when gargling water. Gargoyles were originally designed to direct water away from the stone walls of a building, thereby protecting a building's structure from erosion and collapse. However, in architecture a "grotesque" is a fanciful figure carved out of stone—these two terms are often confused. Over the years, these architectural features have come to be seen as protectors of the building's inhabitants from outside evils. Orton Hall has a dramatic collection of these intriguing figures.

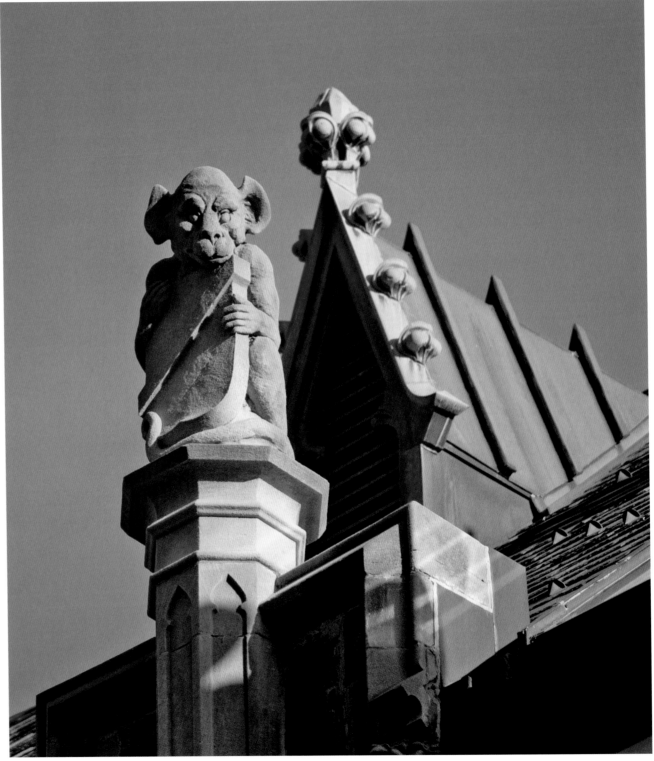

Grotesque atop Starling Loving Hall.

Opposite page: Classical gargoyle supporting a copper gutter.

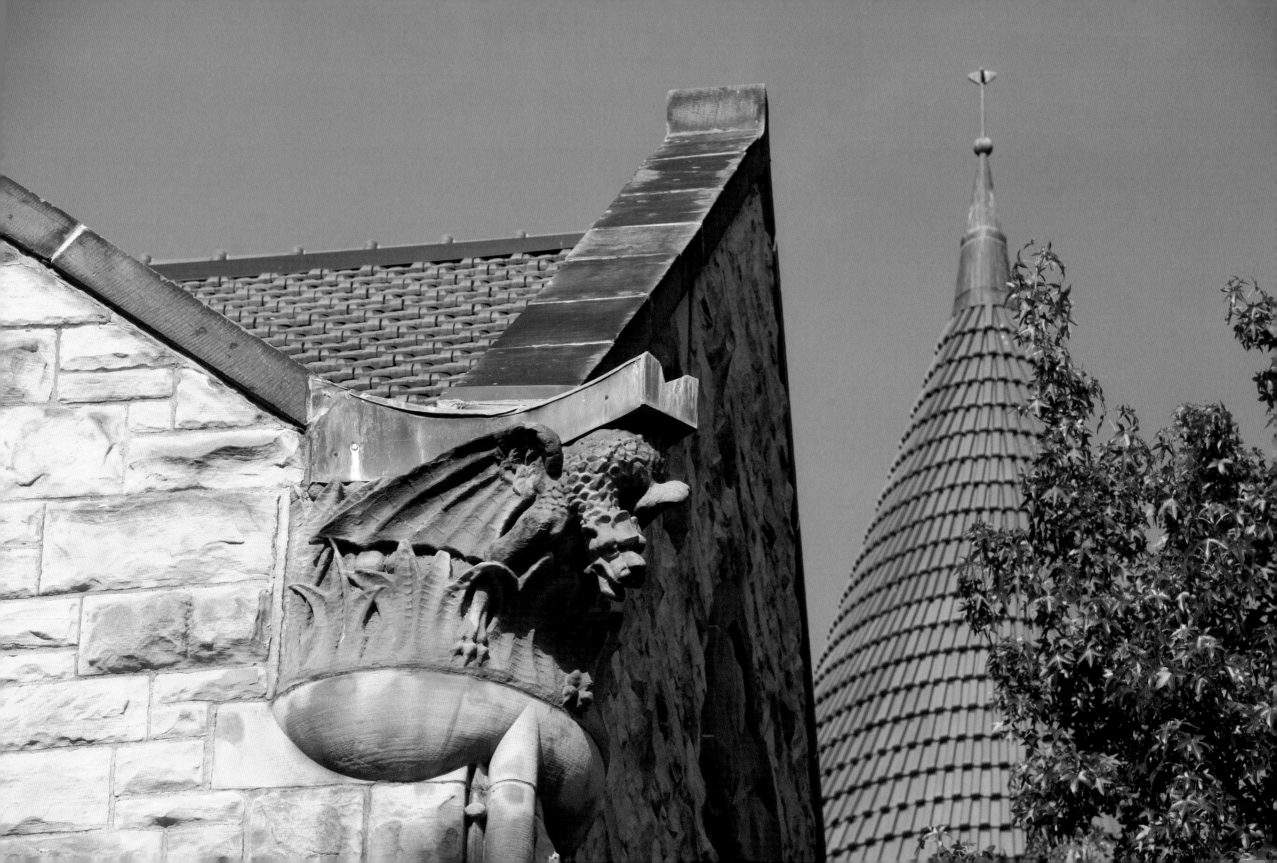

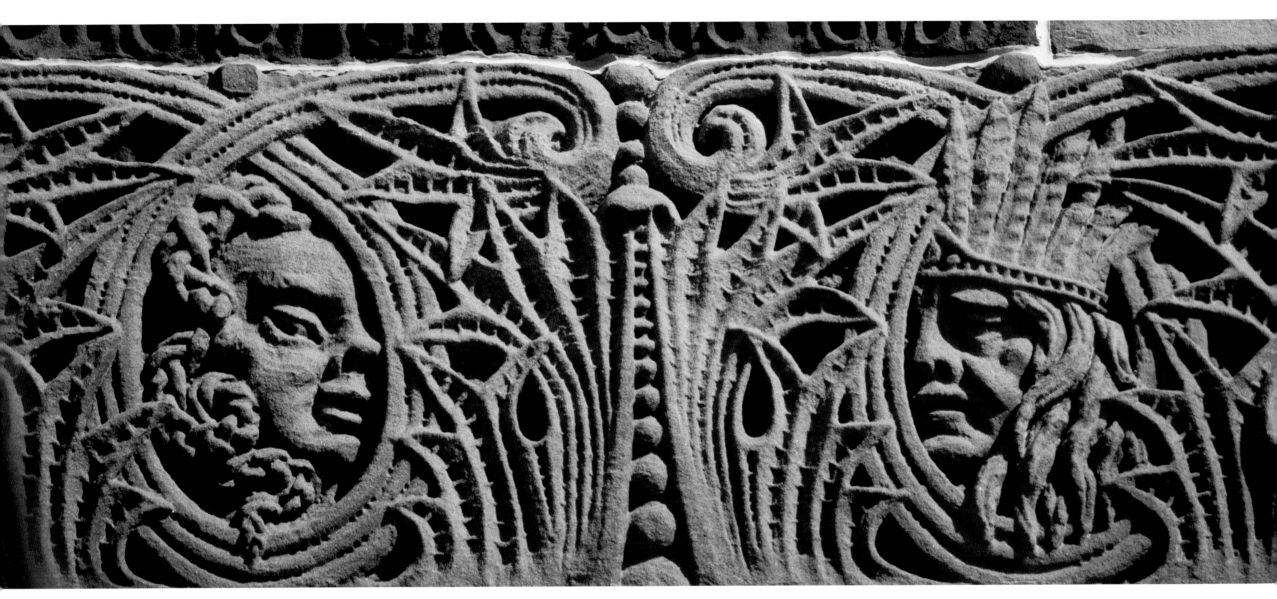

Elaborate sandstone relief, Orton Hall.

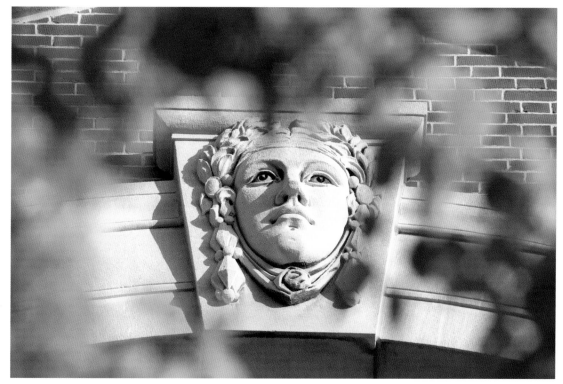

Classical keystone featuring a woman's
head in carved limestone above the
south entrance to Arps Hall.

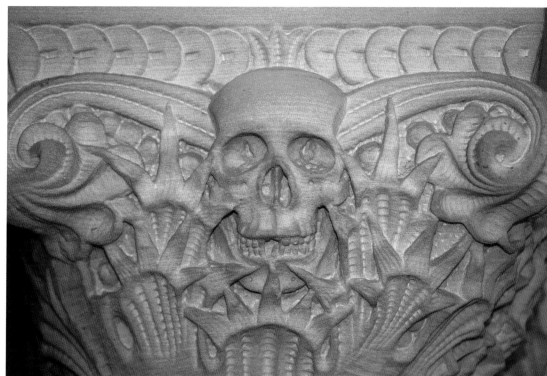

Carved capital featuring a human
skull, main lobby of Orton Hall.

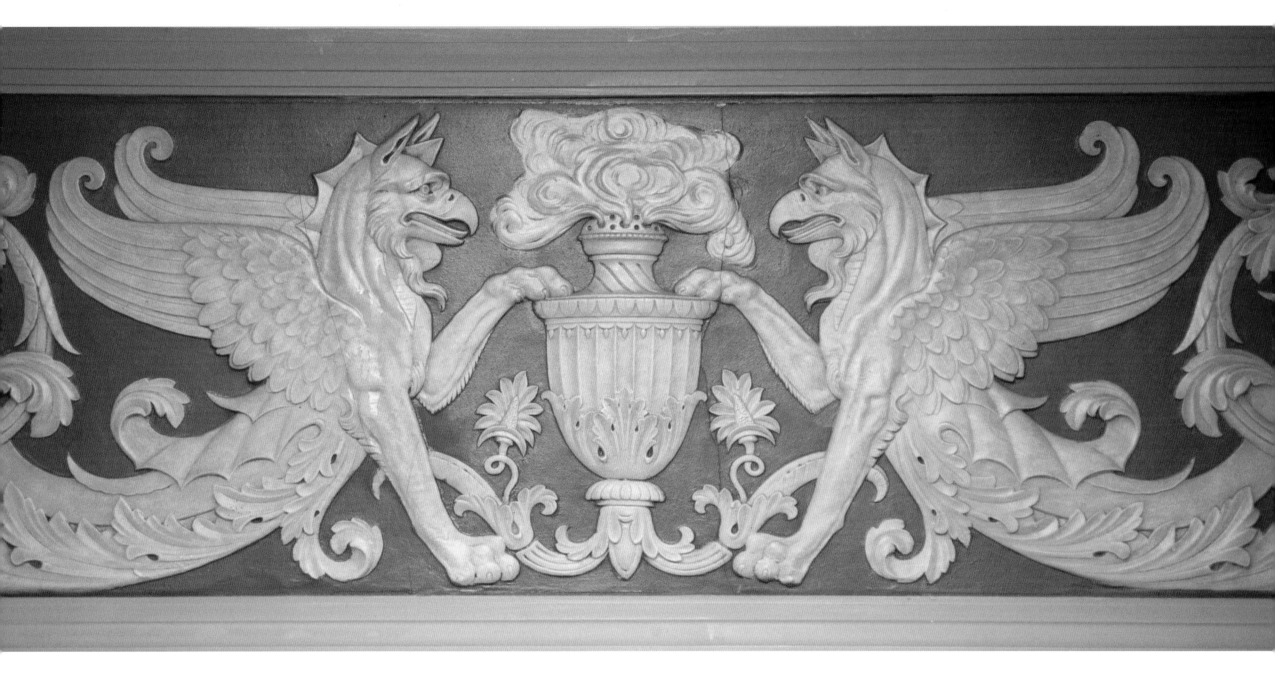

Decorative Greek Revival ornamentation,
interior of Bricker Hall.

A series of art tiles in the main lobby of Canfield Hall were created by the Mosaic Tile Company, Zanesville, Ohio.

Left: Decorative tiles by the Mosaic Tile Company surround the drinking fountains in Ramseyer Hall.

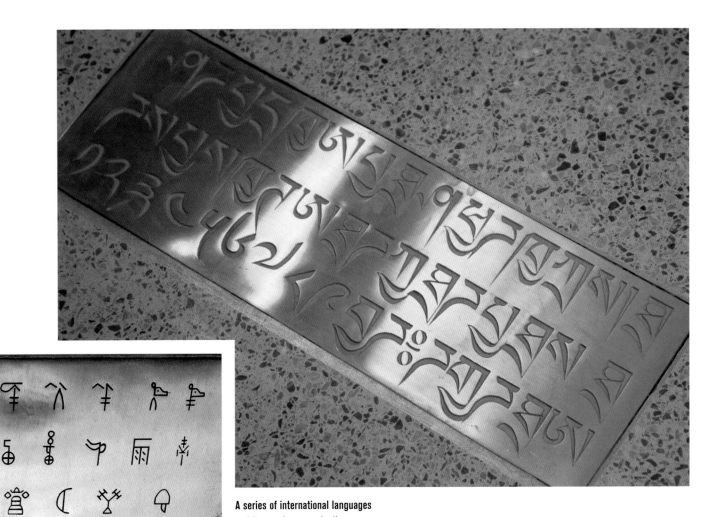

A series of international languages
and forms of communication are
the primary architectural decoration
throughout Thompson Library.

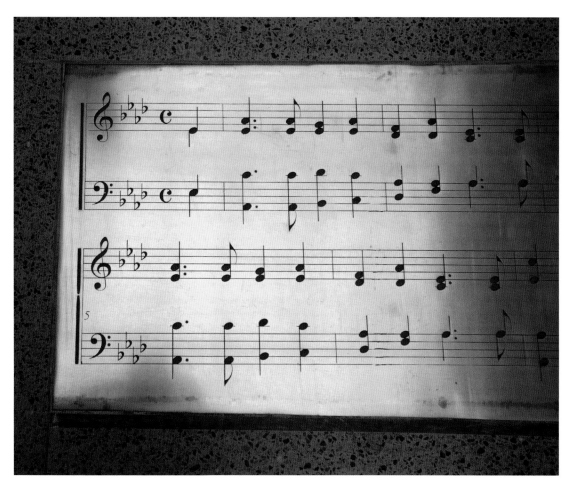

THOMPSON LIBRARY

If the pen is in fact more powerful than the sword, then perhaps the library can be seen as a proverbial armory. The Thompson Library houses approximately 1.25 million books and is an integral part of what makes OSU higher education so extraordinary. As a way of acknowledging the variety of languages stored in the library, the developers inlaid plaques into the floors. These plaques feature languages found in the library's collection. Examples include Latin, Braille, and Chinese, but also musical notation, pictographs, fictional script such as Tengwar, which was created by J.R.R. Tolkien for his Lord of the Rings trilogy, and untranslated languages such as Rongorongo, which was found on Easter Island. The inlaid markers of the Thompson Library are a wonderful display of how fundamental language is to learning and culture.

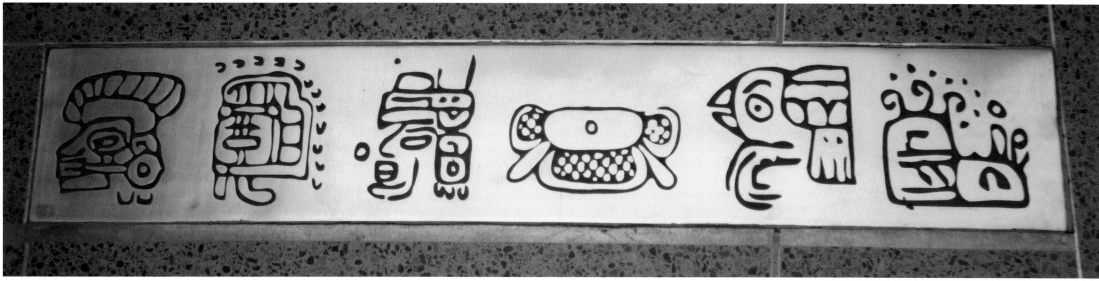

AND YE SHALL KNOW THE TRUTH AND THE TRUTH SHALL MAKE YOU FREE

JOHN 8-32

Instructive and inspiring quotations
carved in marble adorn the exterior
of the Moritz College of Law.

LANGUAGE ARTS

Words have the power to inspire, motivate, and drive creativity. Over the years, The Ohio State University has placed around campus influential words and phrases from philosophers, statesmen, educators, and even the Bible—some inconspicuously and some in plain sight. These messages are an attempt by the developers and planners of the university to encourage and enlighten students as they move past them daily. The forms are as varied as their locations: words can be found carved, chiseled, stamped, and engraved throughout the campus. Having students see and internalize these messages of empowerment instills confidence that is necessary not only for college life, but also for a successful life after college as well. Whether these messages play a subliminal role or a conscious one, their goal remains to uplift, motivate, and inspire creativity, and in that regard they are a success.

Floor marker designed by Barbara Kruger in marble, mosaic, and steel, in the Street Level Lobby of Fisher Hall, Fisher College of Business.

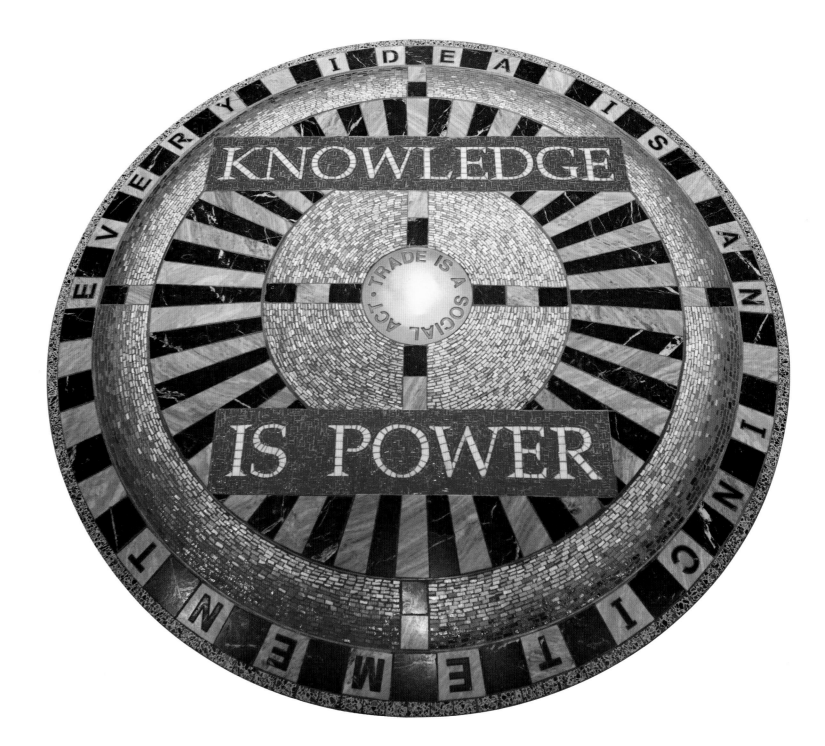

Limestone carvings featuring words
reflecting the values of education adorn
the eastern façade of Hughes Hall.

Opposite page: Mosaic tile with a
"Script Ohio" motif, Ohio Union restroom.

118

136 137 139 141 143
135 138 140 142 144
134 145

10 12 146
133 147
132 148
131 8 149
130 150
192 129 151
191 128 152
190 127 153
189 126 9 154
188 125 12 155
187 124 LFH 156
24 123 157
186 122 185 121 120 119 118 117 116 115 158
184 114 159
183 160
182 161
181 LFH 162
180 12 12 163
179 164
178 165
177 166
176 172 170 167
175 174 173 171 169 168

6
91 92 93
90 94
89 95
88 96
87 97 14
86 98
85 99
32 84 100
83 101
82 102
81 103
80 78 104
108 110 79 105 13
113 109 106 71
111 77 73 72 70 69
112 76 74 68
75 67
8 66
7 65
6 6 64
5 63
4 62
3 61 54
2 60 59 58 57 56 55 52
1 50 6

28
9
10
11 21
12 22
13 23
14 12 24
15 25
16 26
17 53 27 47
51 50 49 48

20 40 50 2 LFH 2

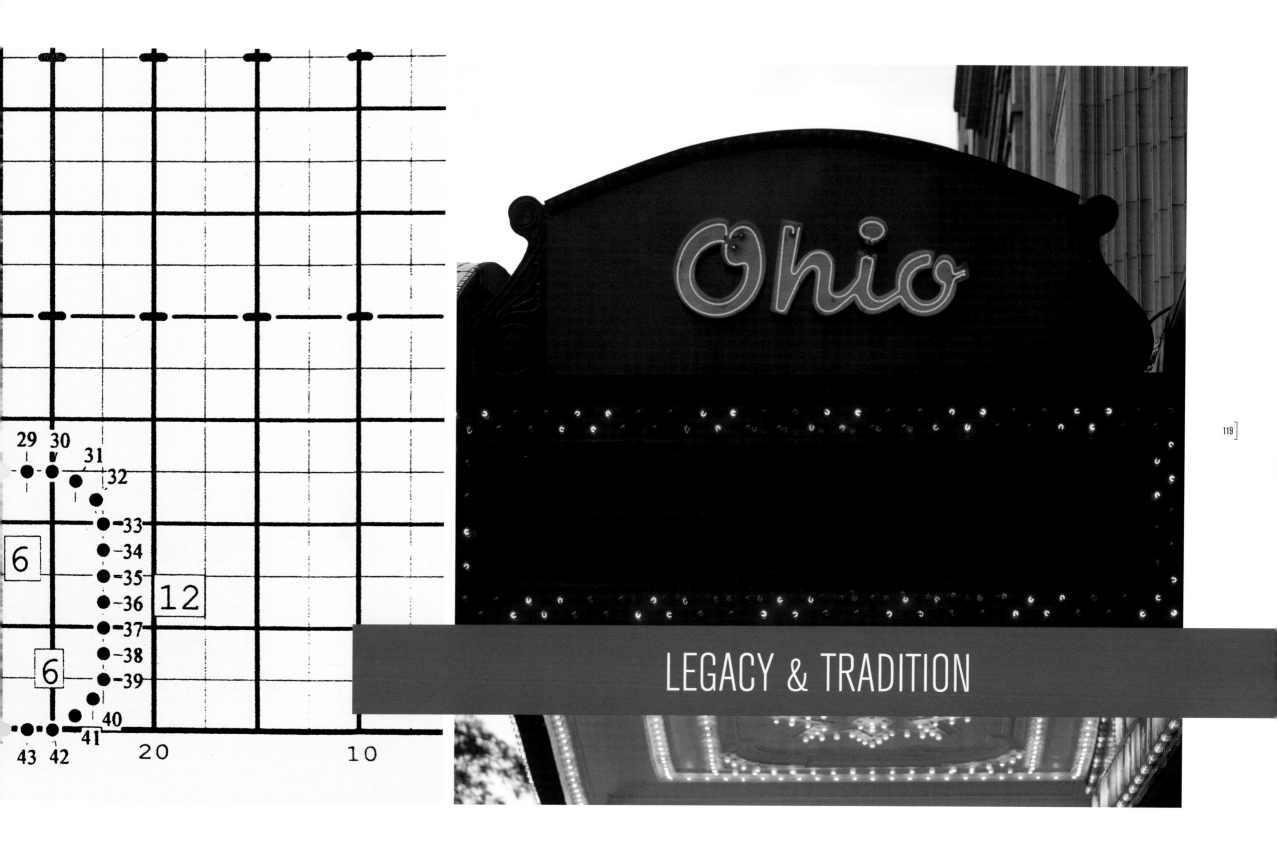

LEGACY & TRADITION

To the uninitiated, the field of sport might look like a shortcut to immortality. In fact, nothing could be farther from the truth. Endless hours of practice, conditioning, and training are prerequisites for even basic team membership in the modern age. The mere mention of names like Archie, Jack, Chic, Jesse, and Woody create an instant emotional response to the memory of their legendary feats. Yet the record books and trophy cases enshrine only a small yet highly visible portion of those athletes' accomplishments. Trophies are not awarded for getting out of bed at 4 AM to practice for two hours before your first class, and ribbons are not handed out for outstanding conditioning performance. By witnessing and remembering athletic triumphs, we cannot help but be motivated to strive for new heights in our own lives.

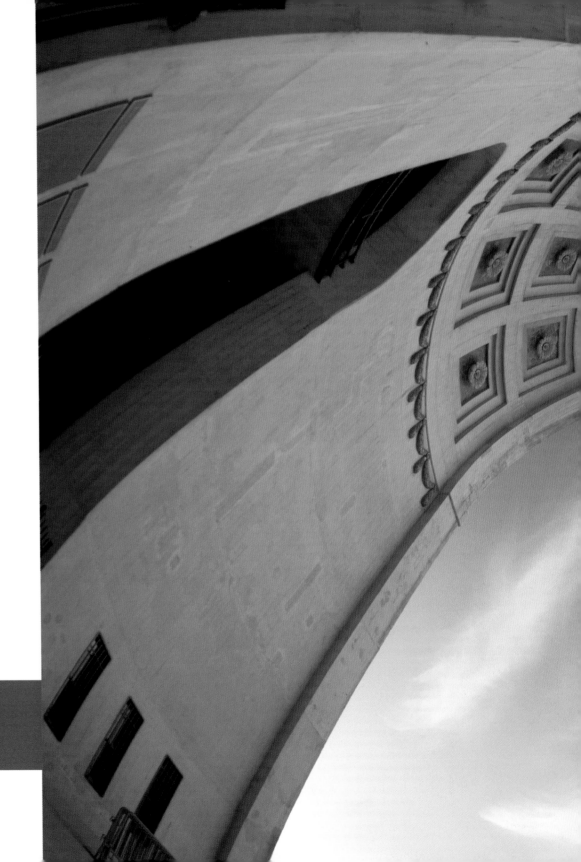

ATHLETIC HERITAGE

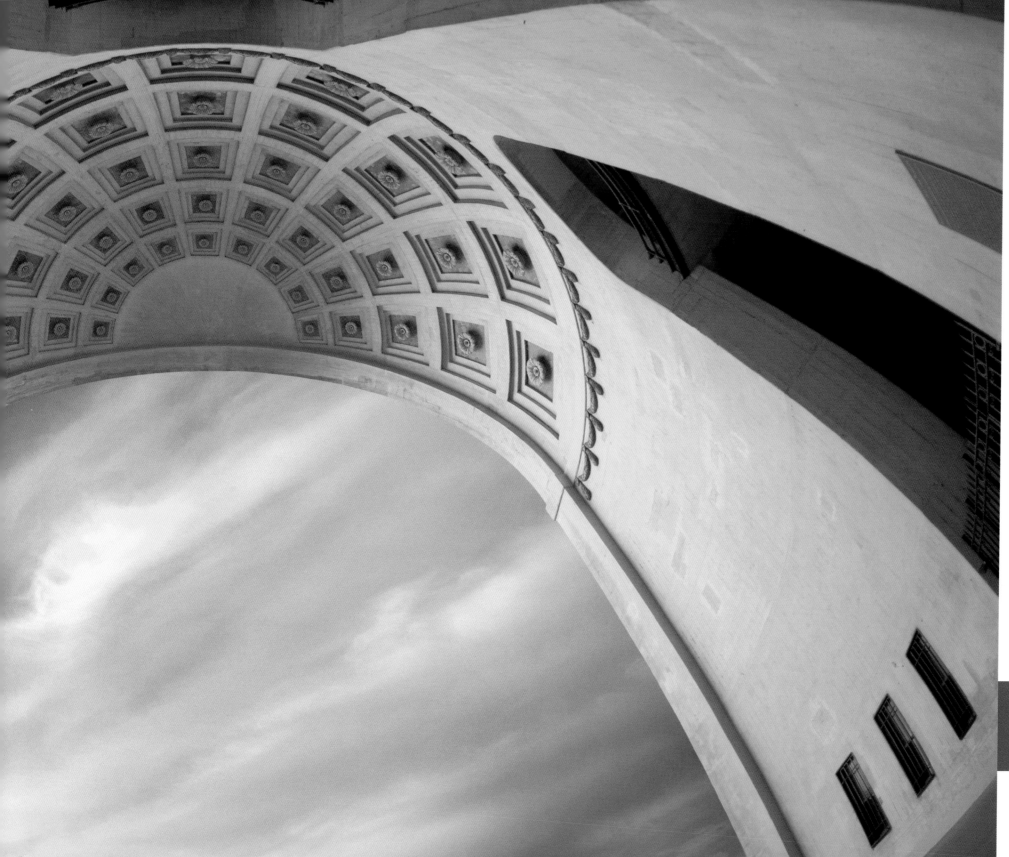

Grand entrance to Ohio Stadium.

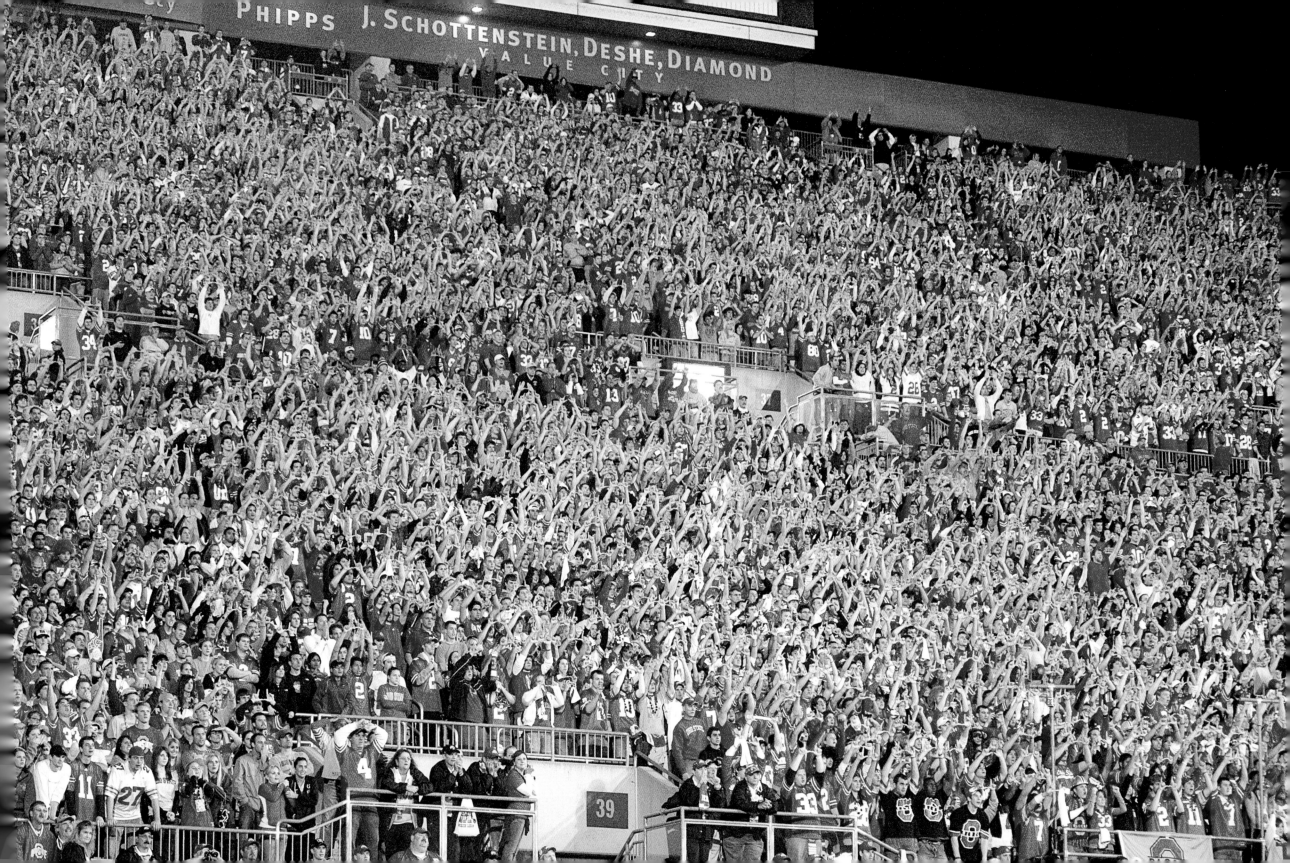

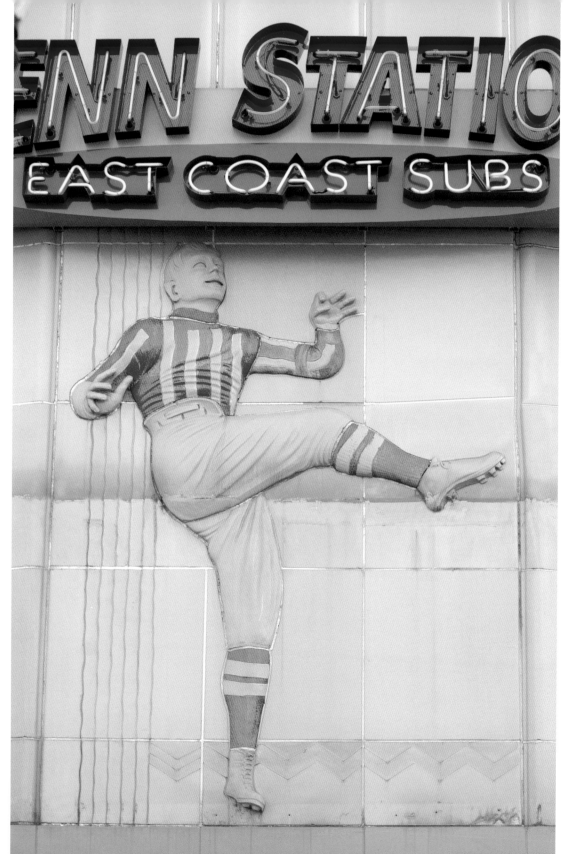

Ceramic relief honoring the legendary Chic Harley, who is credited with bringing the Ohio State University football program into national prominence, façade of Penn Station Restaurant, High Street.

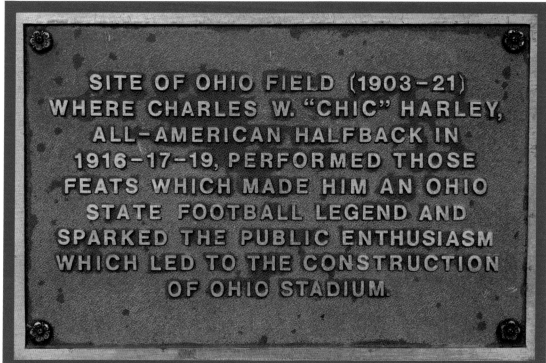

SITE OF OHIO FIELD (1903–21) WHERE CHARLES W. "CHIC" HARLEY, ALL-AMERICAN HALFBACK IN 1916–17–19, PERFORMED THOSE FEATS WHICH MADE HIM AN OHIO STATE FOOTBALL LEGEND AND SPARKED THE PUBLIC ENTHUSIASM WHICH LED TO THE CONSTRUCTION OF OHIO STADIUM.

Above: Commemorative plaque honoring Chic Harley on High Street adjacent to Arps Garage.

Opposite page: The legendary expression of support at Ohio Stadium ... O-H-I-O preformed to "Hang On Sloopy."

OHIO
HISTORICAL MARKER

COACH
WOODY HAYES

Over his 28-year coaching career, Woody Hayes (1913-1987) cemented The Ohio State University's tradition of football excellence while amassing one of the most impressive records in college football. Wayne Woodrow Hayes grew up in Newcomerstown and graduated from Denison University in 1935; after coaching two years at Denison and three at Miami, he began coaching at Ohio State in 1951. He led the Buckeyes to 205 wins, thirteen Big Ten titles, and five national championships. Passionate and committed to victory, Hayes fielded highly disciplined teams, characterized by his trademark "three yards and a cloud of dust" running offense and staunch defense. Off the field, he stressed academic achievement and taught history during the off-season.

THE OHIO BICENTENNIAL COMMISSION
THE VARSITY 'O' MEN'S ALUMNI ASSOCIATION
THE OHIO HISTORICAL SOCIETY
2003 84-25

Ohio Historical Marker honoring
Woody Hayes, adjacent to main entrance,
Woody Hayes Athletic Center.

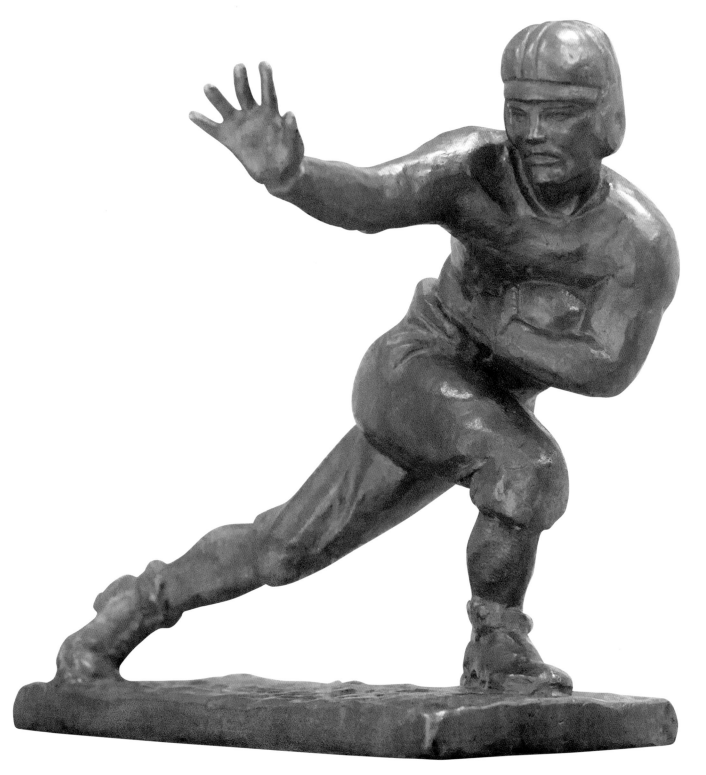

○
ARCHIE

Hayes gives West Coast reporters a now-famous quote about Archie Griffin:

"He's a better young man than he is a football player, and he's the best football player I've ever seen."

The 1975 Heisman Trophy awarded to Archie Griffin, on display at the Ohio Union.

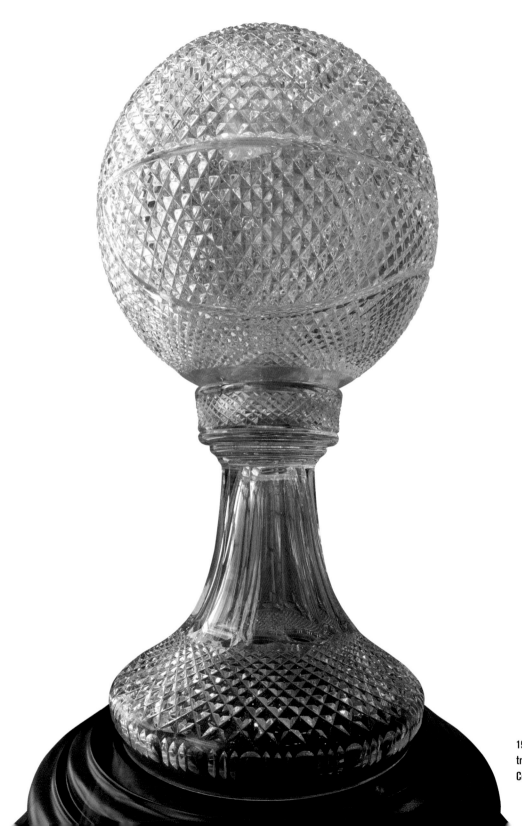

1960 DREAM TEAM

Jerry Lucas, a member of the 1960 National Championship team, was described by teammate Bobby Knight as *"the best player in the history of the Big Ten."* That group of basketball players went on to perform legendary feats in playing and coaching at the college and professional levels.

1960 NCAA Basketball Championship trophy, Woody Hayes Athletic Center trophy room.

Opposite page: Terrazzo mosaic of John "Hondo" Havlicek by Alexis Smith, Jerome Schottenstein Center.

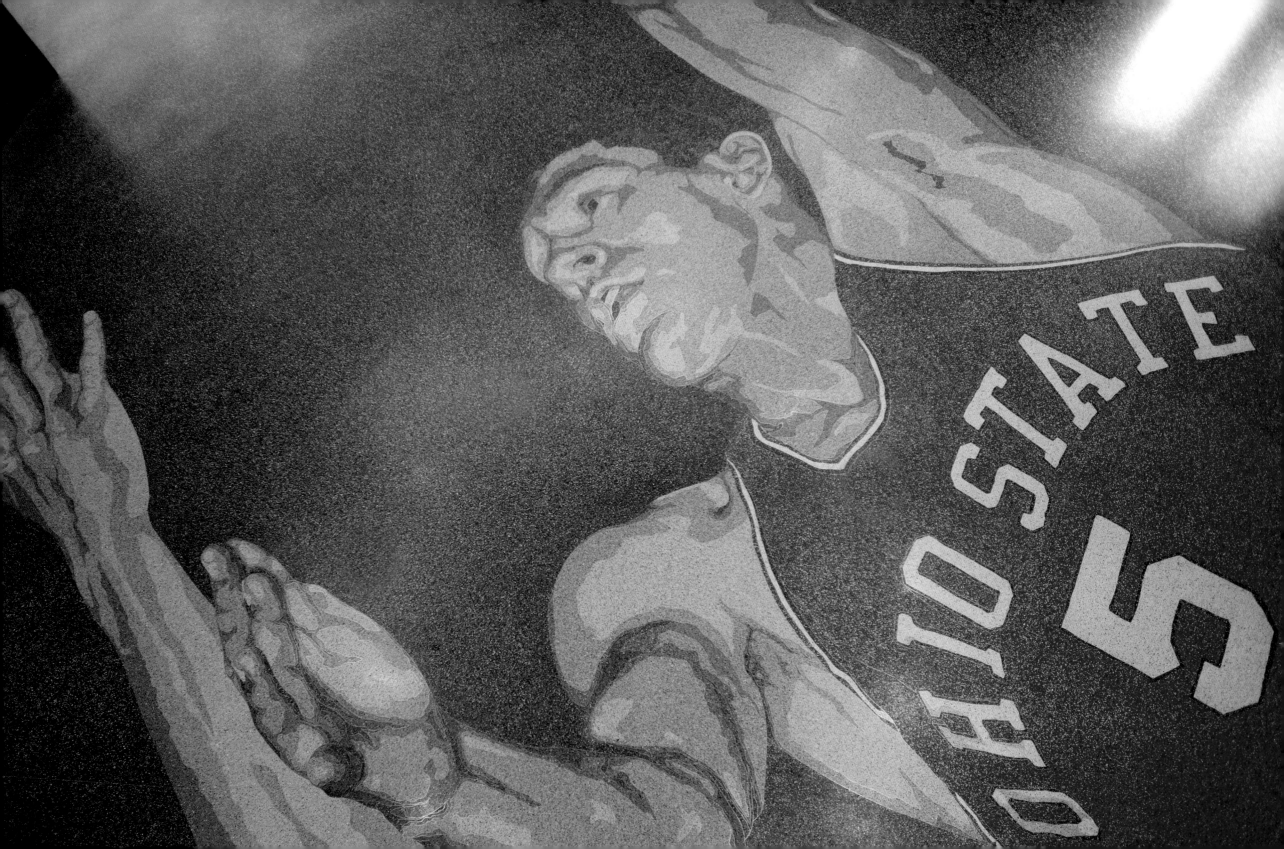

Opposite page and right: Terrazzo
mosaics by Alexis Smith celebrating
the athletic heritage of OSU,
Jerome Schottenstein Center.

Detail of a vintage baseball trophy,
Jerome Schottenstein trophy room.

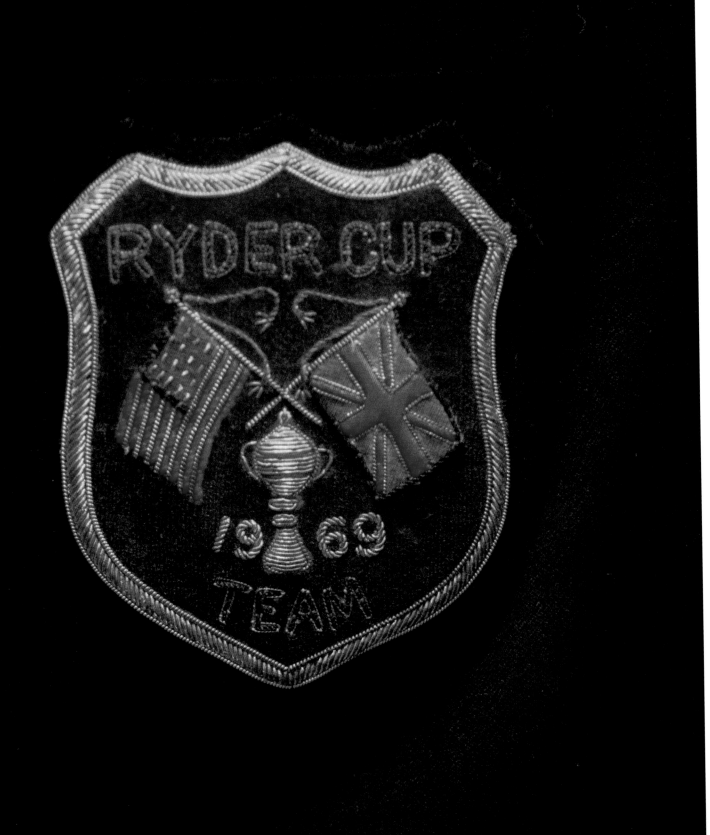

——————·O·——————
JACK

"Jack knew he was going to beat you.

You knew Jack was going to beat you.

And Jack knew that you knew that he

was going to beat you."

—TOM WEISKOPF, GRADUATED OSU 1962.

Jacket worn by Jack Nicklaus at
the 1969 Ryder Cup Championship,
Jack Nicklaus Museum.

Bronze sculpture of legendary golfer
Jack Nicklaus by Leicester C. Thomas,
dedicated in 1988, Nicklaus Museum.

Descriptive plaque and shoe worn by Jesse Owens in the Big Ten Track & Field Championship at Ann Arbor, Michigan on May 26, 1935.

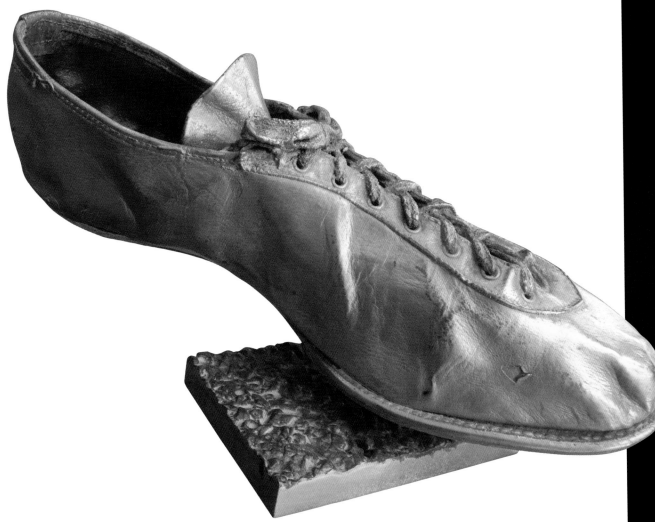

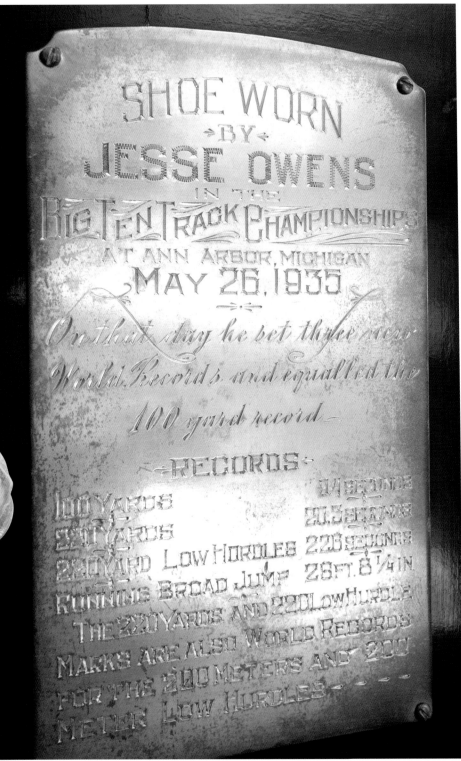

SHOE WORN
~BY~
JESSE OWENS
IN THE
Big Ten Track Championships
AT ANN ARBOR, MICHIGAN
MAY 26, 1935

On that day he set three new
World Records and equalled the
100 yard record

~RECORDS~

100 YARDS 9.4 seconds
220 YARDS 20.3 seconds
220 YARD LOW HURDLES 22.6 seconds
RUNNING BROAD JUMP 26 FT. 8 1/4 IN
The 220 Yards and 220 Low Hurdle
Marks are also World Records
for the 200 meters and 200
meter Low Hurdles

Opposite page: Detail of bronze sculpture of Jesse Owens highlighting his four gold medals won in the 1936 Olympics.

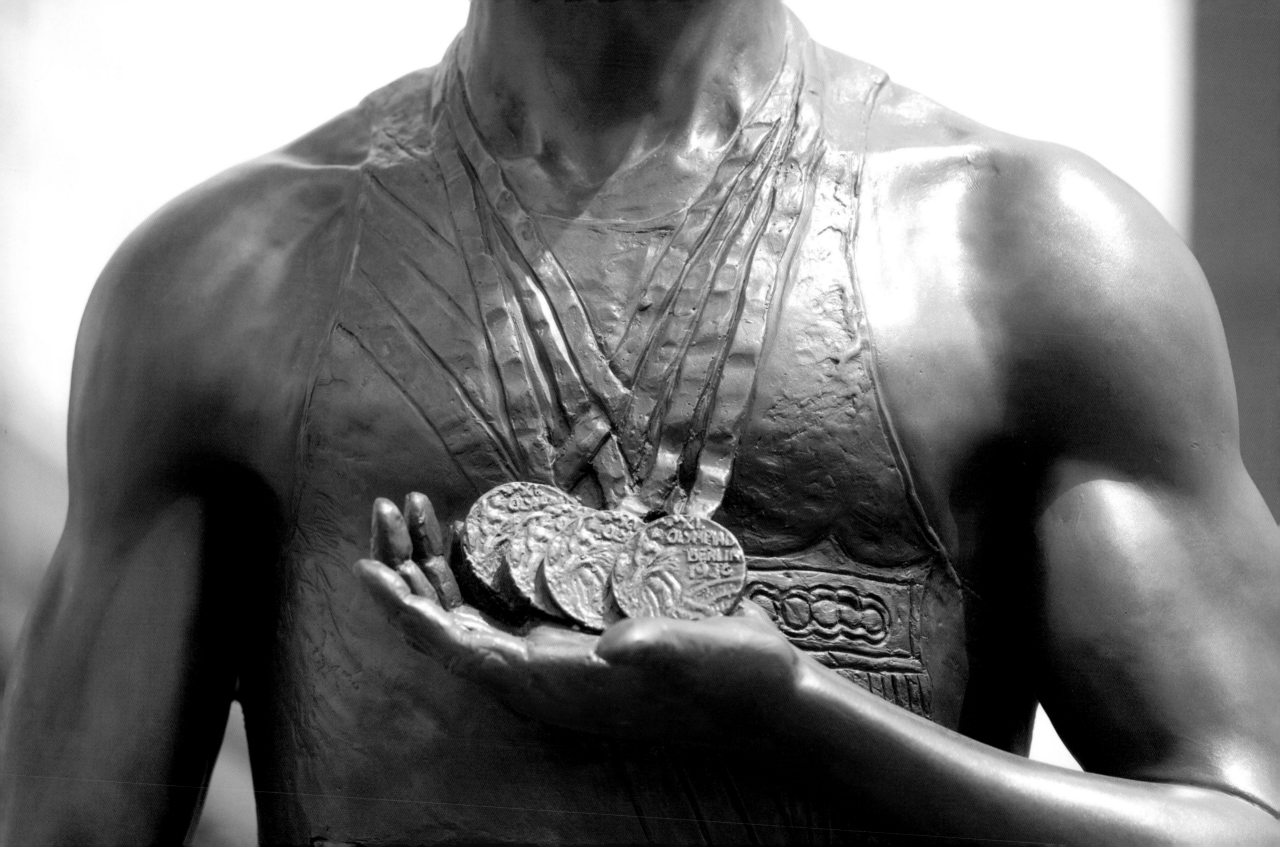

It is one of our most basic human desires to be remembered after we are gone. One way we have found to accomplish this is through the traditions we form with friends, family, and coworkers. The Ohio State University campus is alive with communities of many kinds, so it should come as no surprise that our campus is rich in such customs and rituals. There is something about the college experience that lends itself to the formation and preservation of these traditions. Perhaps it is that young students with a first taste of independence are eager to be a part of something larger than themselves. Perhaps it is that veteran students know it will be these traditions that will be talked about at their 50th reunion. Regardless of your personal reason for participating, it is obvious that traditions are the very essence of the college experience.

TRADITION

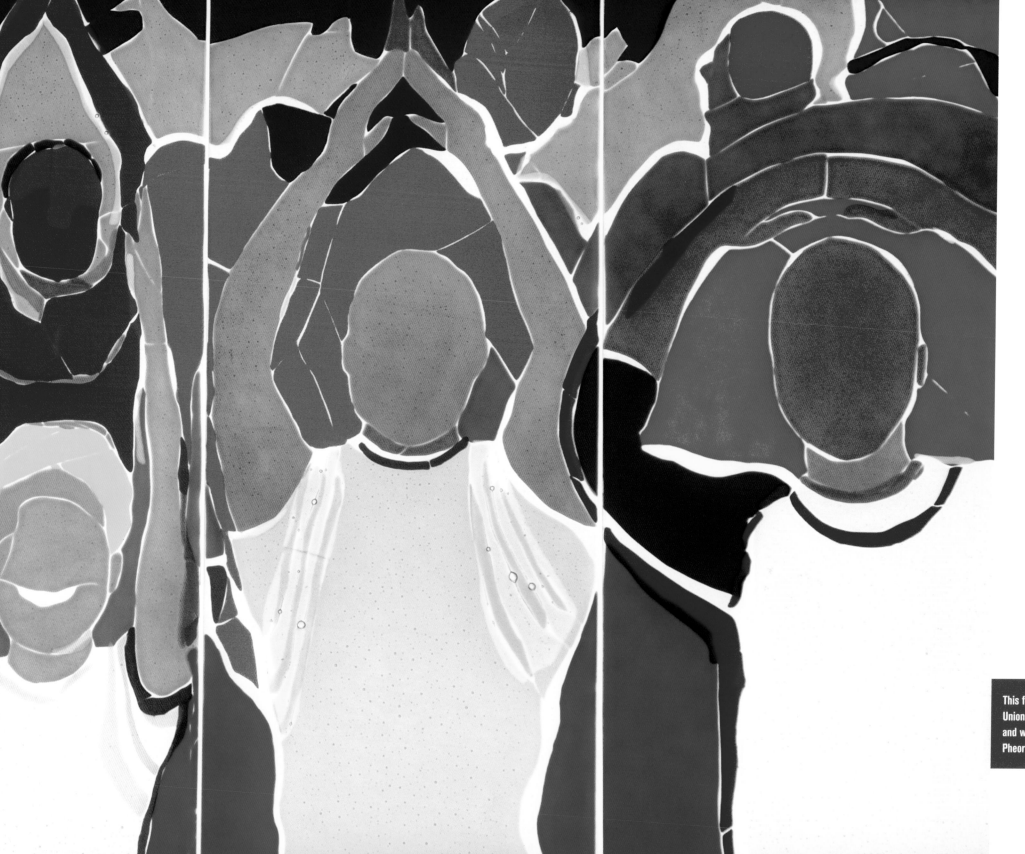

This fused art glass window in the Ohio Union depicts the famous O-H-I-O and was a collaboration by artists Pheoris West and Richard Harnet.

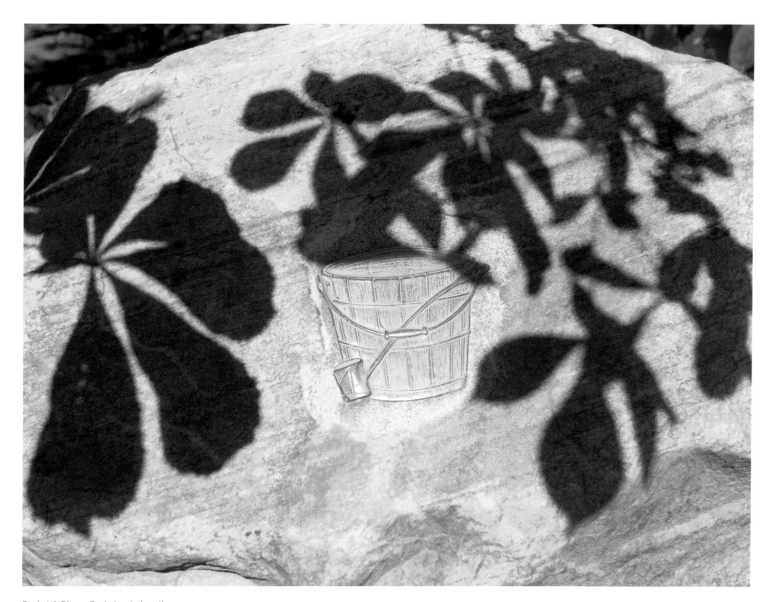

Bucket & Dipper Rock, located on the
northern walkway surrounding Mirror Lake.

Opposite page: Sphinx Plaza,
northwest corner of the Oval.

BUCKET & DIPPER

The Bucket & Dipper Rock is a symbol for the Bucket
& Dipper Honorary Society at OSU. Founded in 1909,
Bucket & Dipper is the second oldest honorary society
at The Ohio State University. Bucket & Dipper might
be best known as the originators of the Illibuck Pass,
a football tradition started in 1925. The rock itself is
steeped in tradition, much like the society it symbolizes.
During construction of The Ohio State University
Library, a large boulder was discovered just north of
the building. The Board of Trustees authorized the
honorary society to place a bronze plaque on the bolder
making it forever The Bucket & Dipper Rock. In 1949
the Library needed room for expansion and the rock
was moved from the north side of the Library to Mirror
Lake, where it remains today.

137

⬤
THE BELLS OF ORTON

Through an arch of leaves, screened

softly by nature, her turrets show, rising

from gray old walls and grassy lawns.

The sun has drawn a pattern of light

and shadow in the roughness of her

stone. As twilight falls, sound the bells

of Orton Hall.

– MAKIO 1936

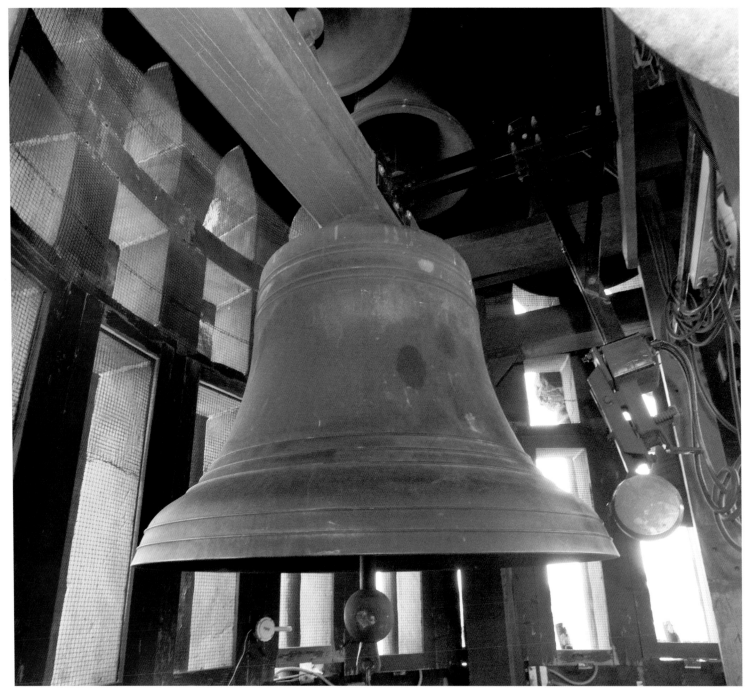

One of the Orton Hall chimes,
installed in 1914.

Opposite page: Limestone relief
of the seal of The Ohio State
University, Faculty Club façade.

Block O chandelier in the Archie
Griffin Grand Ballroom, Ohio Union.

Elaborate leather cover of the 1929 **MAKIO**,
yearbook of The Ohio State University.

This art glass panel in Ohio Stadium was a gift to OSU football players and fans from the Motorists Insurance Group and was dedicated in 2001.

Brick relief on the western façade of Smith Hall.

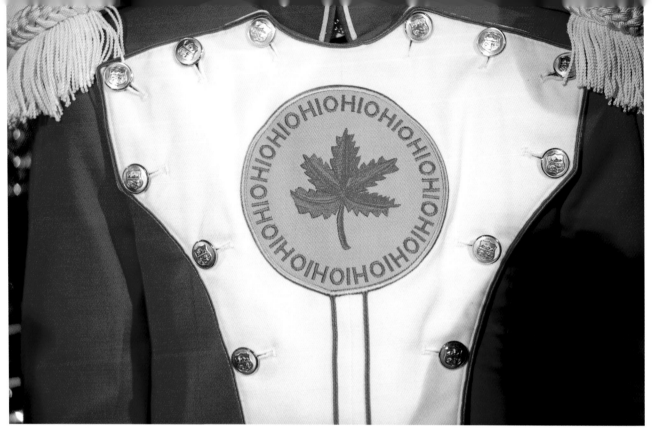

O
TBDBITL

To someone outside the university, the reference to the OSU Marching Band known as TBDBITL may be somewhat mysterious. The origins of this famous acronym are as follows: Director Dr. Jon Woods claims, "Supposedly at a pep rally one year, Woody Hayes stood up after the band played a song and said, 'That's the best damn band in the land!' That's all it took. When Woody says something, it's law."

Top: Detail of drum major uniform, The Ohio State University Marching Band.

Right: Detail of cymbals, OSU marching band.

Opposite page: OSU band salutes the victorious football team in its thrilling victory against Iowa, November 2009.

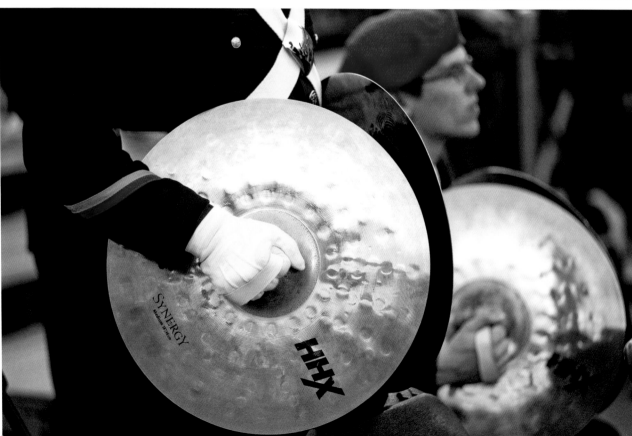

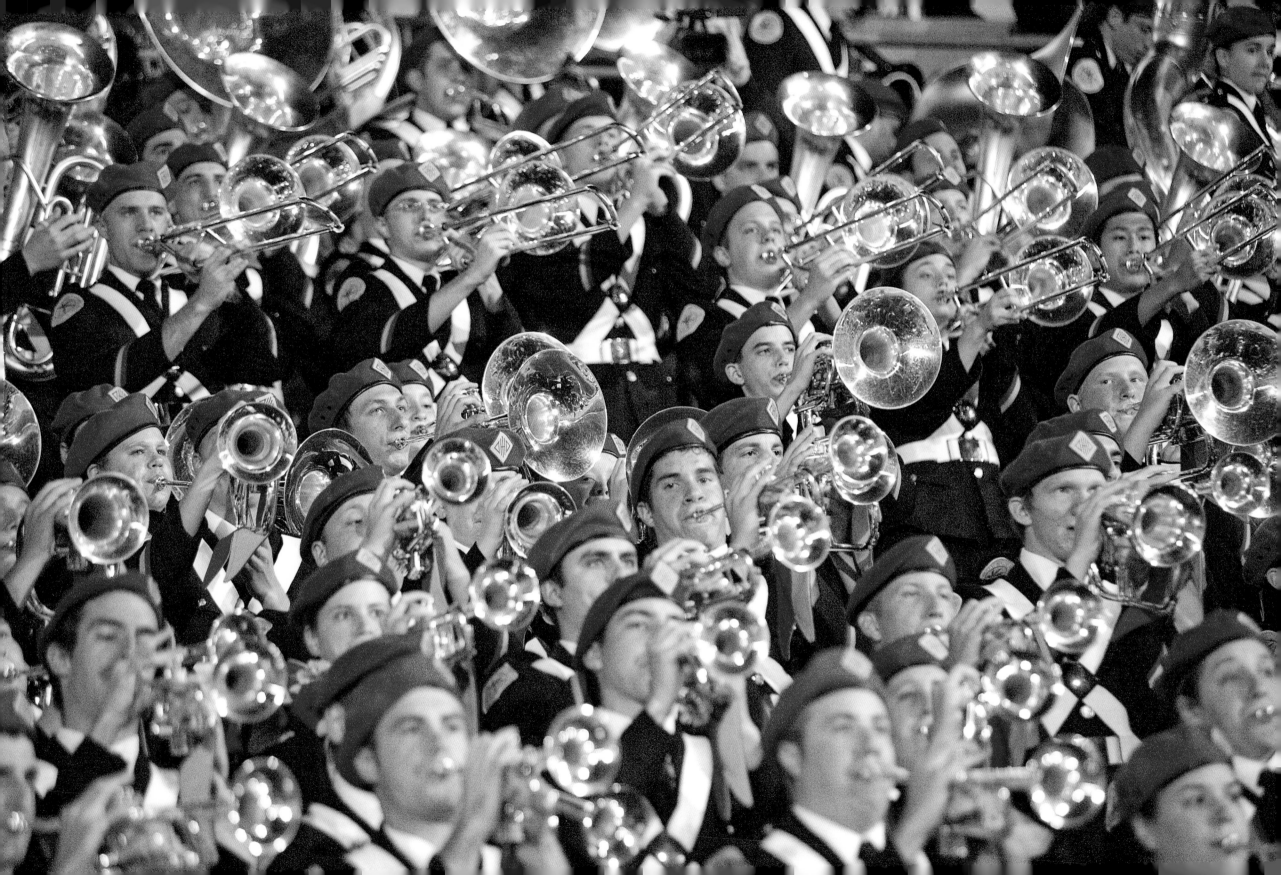

Buckeye sculpture by L.C. Shank in honor of J. Ralph Shank, Professor of civil engineering at OSU, Longaberger Alumni House.

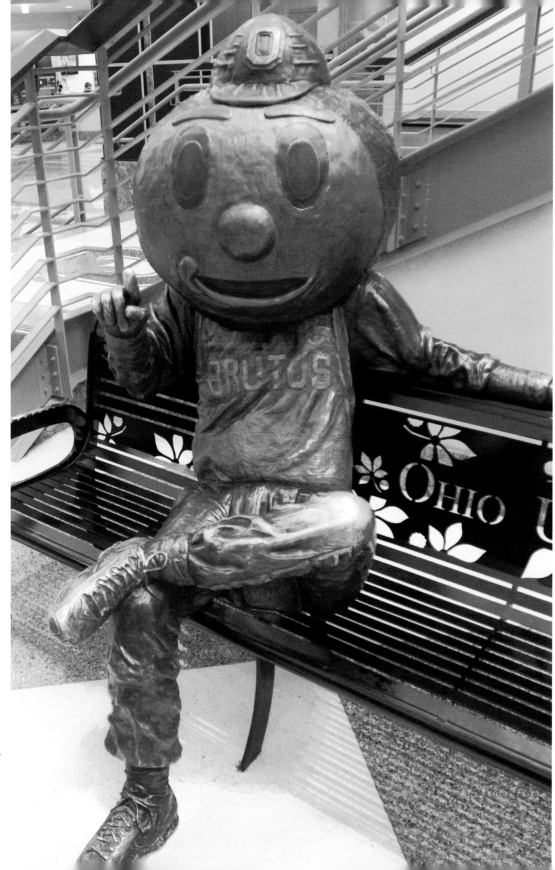

Brutus in bronze holds court in the Ohio Union.

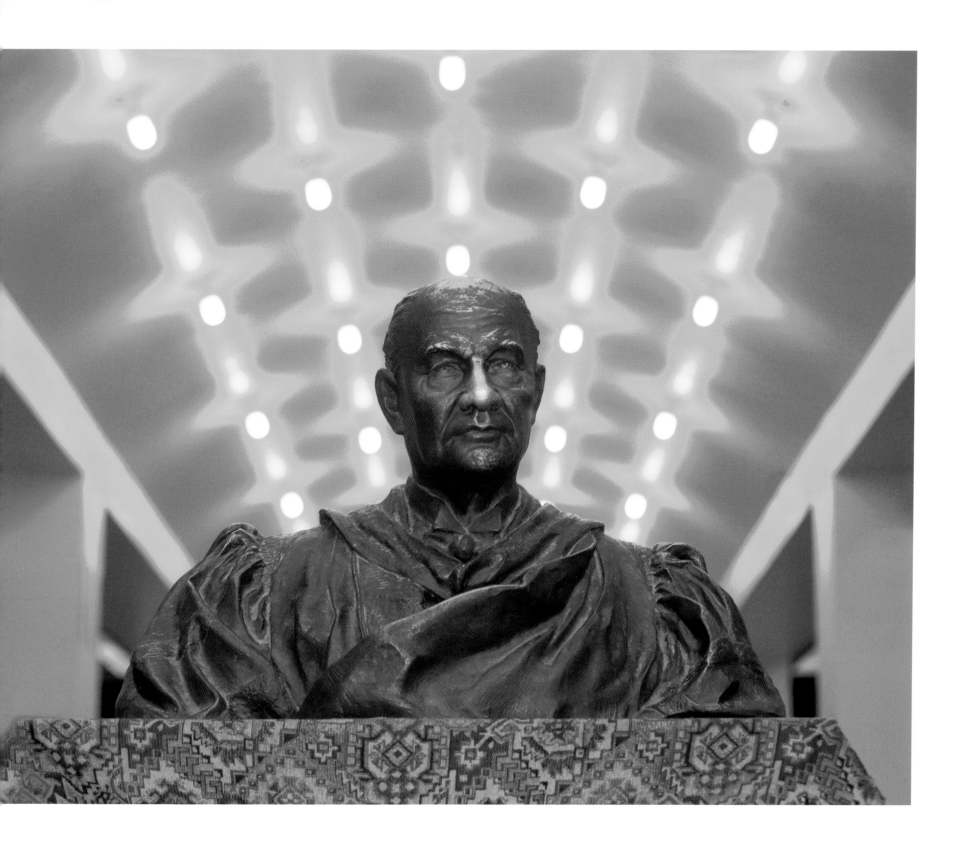

RUBBING THE BRONZE

The worn bronze bust of OSU's 5th President, William Oxley Thompson, is steeped in tradition. Generations of students have rubbed the nose and forehead of this sculpture, hoping for luck on their upcoming exams. Of course, this tradition results in frequent restorations but it is a small price to pay for an endearing custom.

Archimedes famously said, "Give me a place to stand and with a lever I will move the whole world." The Ohio State University was originally founded, and still exists today, to provide the tools for building a better tomorrow. The tools that OSU provides are the metaphorical levers needed to accomplish this goal. The university has a legacy of developing leaders and innovators in all fields who are willing and able to make a difference. All students recognize from the first time they step on our historic campus that this is the "place to stand"—and they will move the world.

In addition we must always remember the men and women who devoted their personal and professional lives to this University and, as a result, created a worldwide force for good.

LEGACY

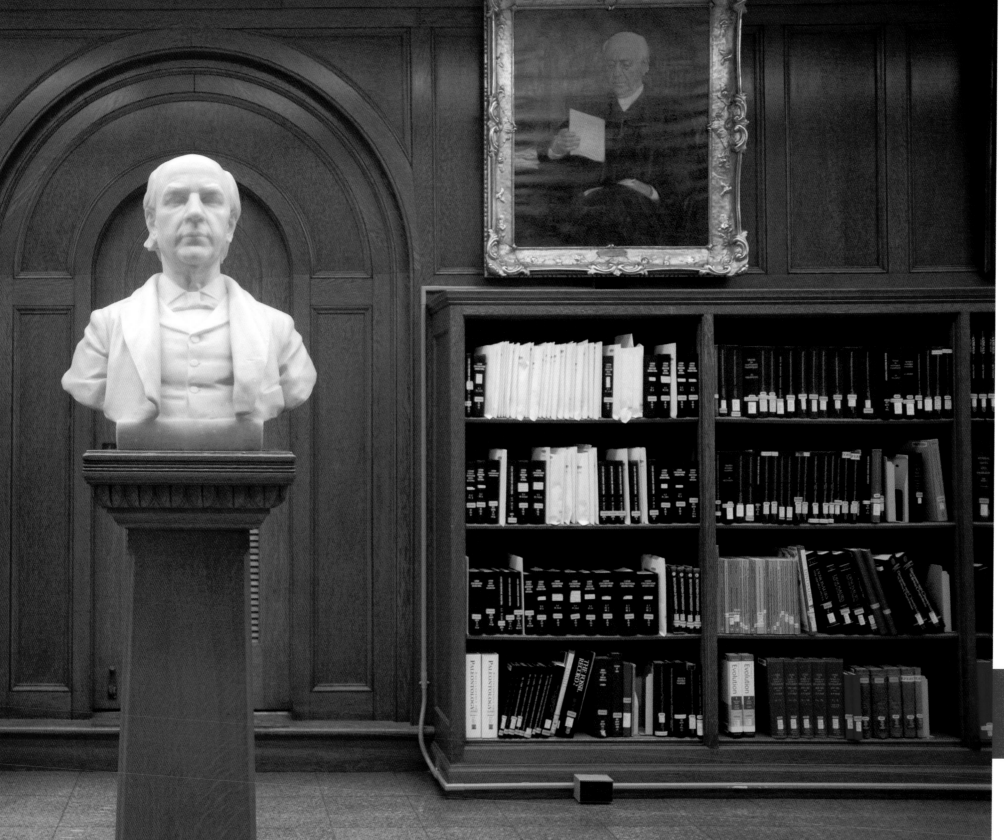

Bust of Edward Orton, Jr., in the
Geology Library, Orton Hall.

THESE FIVE OAK TREES WERE
PLANTED TO REPLACE THE
FIVE BROTHERS" ELM TREES
THAT WERE LOCATED
APPROXIMATELY -75 METERS
NORTHEAST OF HERE.
A ROCK NOW MARKS THAT SITE.
OHIO STATERS INC.1976

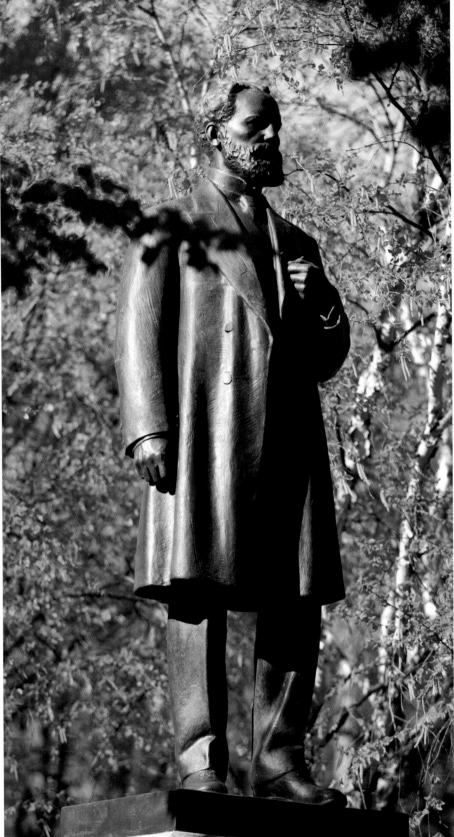

Left: Memorial fountain and sculpture of Samuel Mitchel Smith, gift of his sons, 1880.

Right: Sculpture of Willoughby Dayton Miller, acknowledged as a pioneer in modern dentistry, courtyard of Postle Hall.

Opposite page: Memorial plaque honoring the "Five Brothers" elm trees.

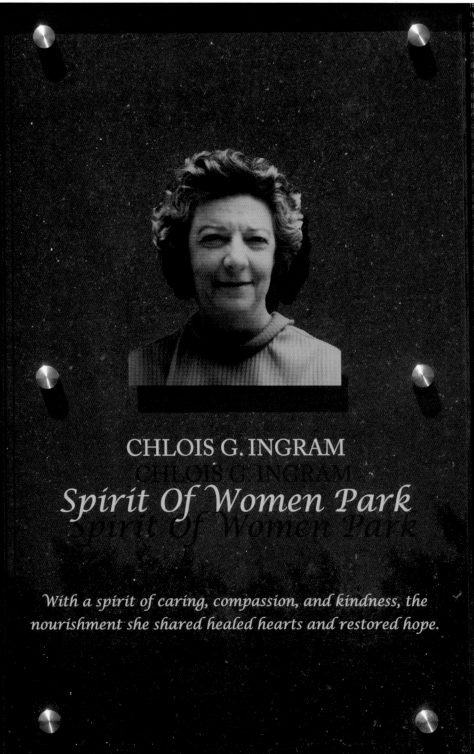

CHLOIS G. INGRAM

Spirit Of Women Park

With a spirit of caring, compassion, and kindness, the
nourishment she shared healed hearts and restored hope.

sister

compassion

kindness

daughter

best friend

caring

loving

partner

heart

aunt

wife

friendship

strength

grandmother

SPIRIT OF WOMEN PARK

After celebrating more than a decade in its former location, the Chlois G. Ingram Spirit of Women Park was relocated in 2012 to its current home at the corner of Medical Center Drive and Ninth Avenue. This park is dedicated to the loving memory of long-time Red Cross Gray Lady volunteer Chlois G. Ingram. The new park features a calming crescent-shaped pool designed to provide an oasis for patients, visitors, and staff. Although the original hand-painted tiles were lost during the renovation, many of them have been remade into etched glass tiles that are integrated into the water feature. These tiles, shown above, were created by alumni to honor the women who inspired them.

Glass and marble memorial honoring Chlois G. Ingram.

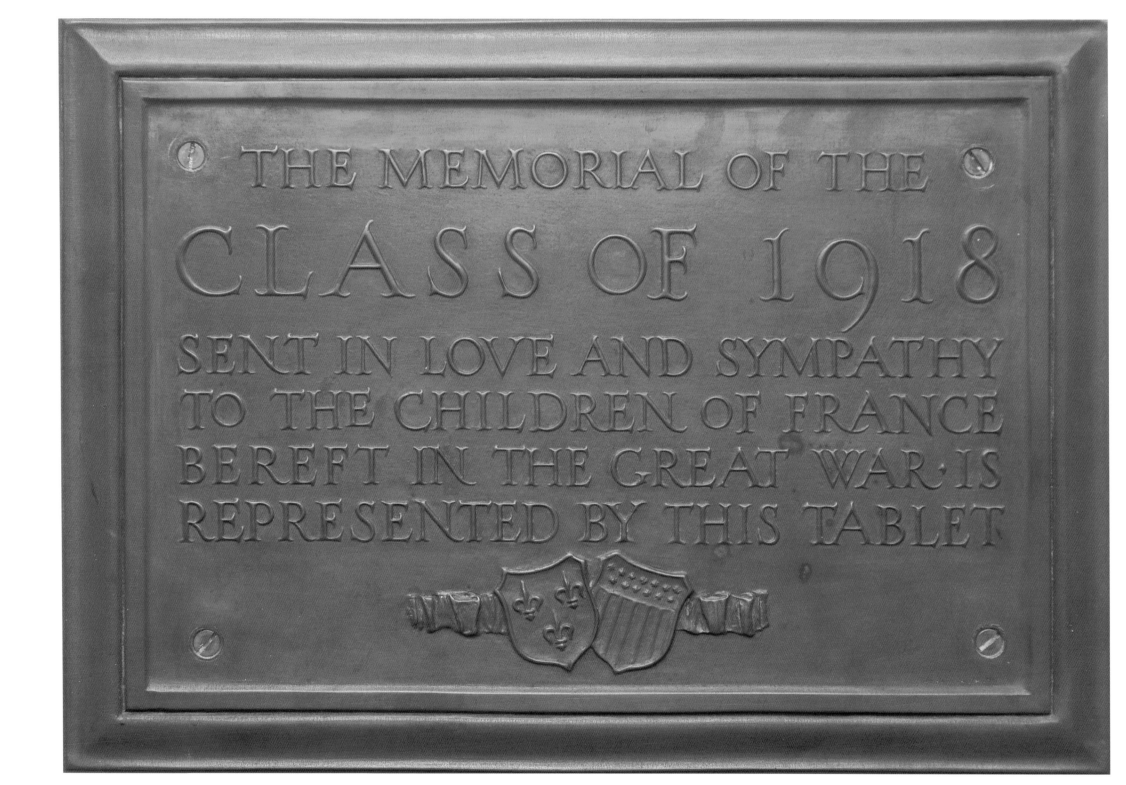

THE MEMORIAL OF THE
CLASS OF 1918
SENT IN LOVE AND SYMPATHY
TO THE CHILDREN OF FRANCE
BEREFT IN THE GREAT WAR·IS
REPRESENTED BY THIS TABLET

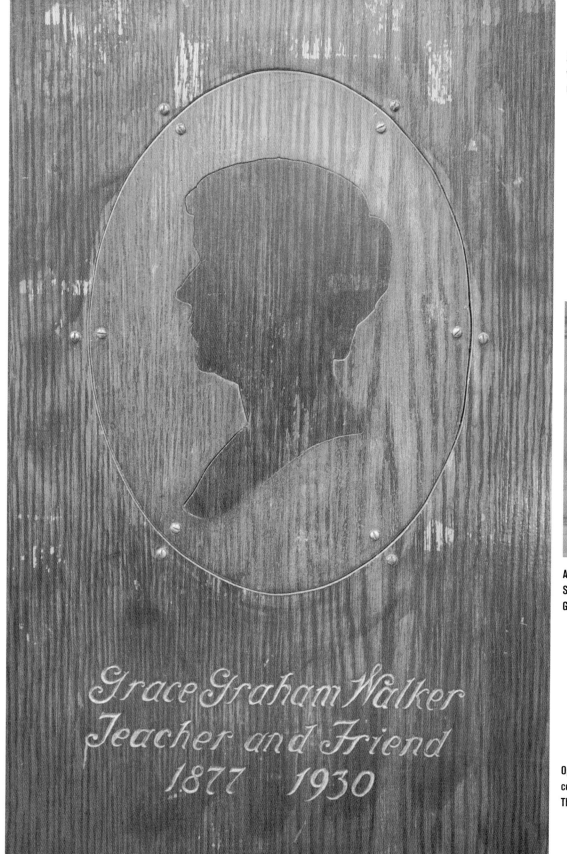

A simple remembrance in carved
wood of beloved teacher Grace
Graham Walker, Campbell Hall.

Above: Commemorative relief of John
Strong Newberry, Ohio's 2nd State
Geologist, 1869-1882, Lobby, Orton Hall.

Opposite page: Brass plaque
commemorating the 1918 class gift,
Thompson Memorial Library.

O

OHIO HISTORY

As one drives past the southern façade of the Ohio Union, one can't help but notice the remarkable collection of limestone reliefs. The original carvings, executed by Marshal Fredericks, were rescued from the previous union, which was demolished in 2008. To enhance this collection, sculptor William Galloway was commissioned to create additional reliefs. Both the older and newer works convey the history of Ohio.

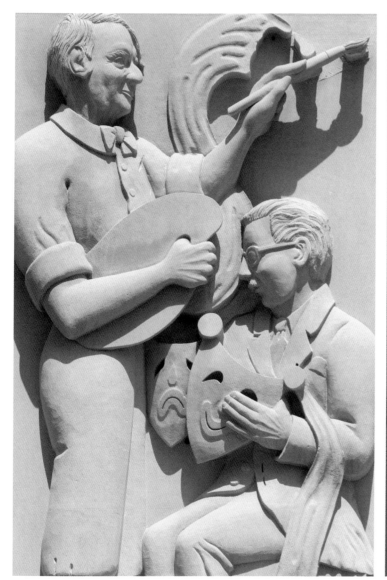

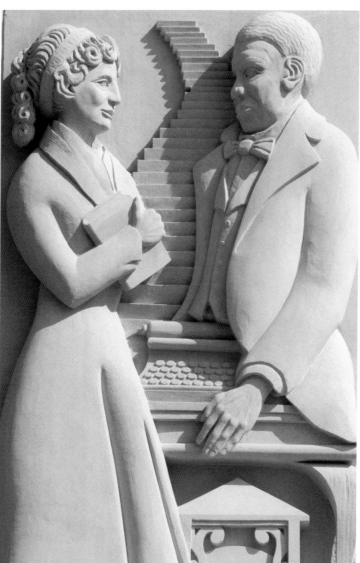

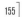

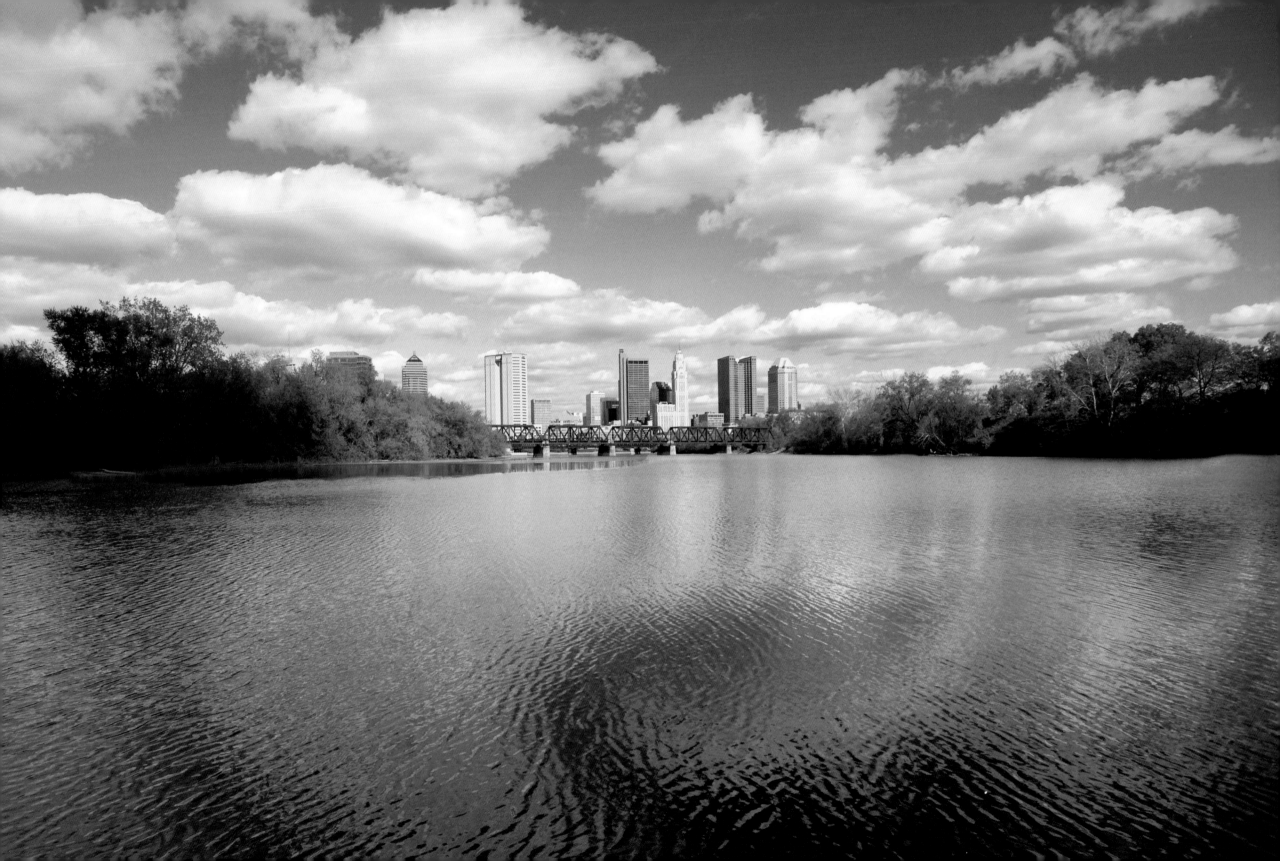

·o·
AFTERWORD
BY ROBERT A. FLISCHEL

My primary question regarding The Ohio State University was this: "What are the factors that contribute to the lifelong bond between the university and its students, faculty, alumni, and friends?" The obvious answers are an exceptional education, a robust athletic tradition, and the enduring legacy of this great university. My search for additional answers began during the winter of 2008 while shuttling my teenage daughter and her friends to concerts in Columbus. I used that four- or five-hour "waiting period" to explore and observe the OSU campus. I soon discovered the opportunity for a great story, and by spring I was making regular trips to Columbus to photograph and research The Ohio State University.

Very early in this process I sensed a growing bond with this "place." The seasonal changes, dramatic art and architecture, lush landscapes, and a reverence for tradition—these threads were starting to weave a visual tapestry. After four years of work I had my answer. I understood the transformation people undergo in this place because it happened to me. What began as a detached observation led to a deepening commitment and culminated with a personal devotion. Yes, just being here over time can do that. Remarkable!

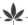

ACKNOWLEDGEMENTS

It is extremely important that Kim and I take this time to thank and acknowledge all the individuals who made this book possible. Starting with our own families, who at various times pitched in and helped make this book a reality. We are profoundly grateful.

The first people I presented this idea to, Steve and Tammy Blowers, "pure scarlet and grey," immediately pledged their support. In fact, they generously underwrote the preliminary design for this project. Jared and Bridgit Davis quietly supported this project at critical times. Duke McGonegel was my "go to" field editor who worked alongside me throughout the project. Sincere thank you to advisors Cheryl Krueger, Dottie David, and John Shepherd. Bob and Carol Byrne were tremendous supporters throughout the whole process.

Our association with the Ohio State University has been very gratifying. In every way possible, individuals, departments and administrators have provided support. President Gee enthusiastically supported our efforts and wrote the heartfelt introduction to the book. Jason Slough, from the president's office, served as our indispensible point man for the university. David Schneider from the registrar's office helped open doors throughout the university. The entire facilities team contributed, notably Sharon Bierman, David A. Coffman, Steve Wilson, and Andy Fetsko. It is important for us to applaud the efforts of the entire university library system. They were kind and generous with their time. Mary Maloney from Chadwick Arboretum, Steve Volkman, Landscape Architect, and Doug Sershen from the Knowlton School of Architecture answered all questions with grace and insight. Kathy Smith from the university bookstore was our champion supporter during the development of this book. The Ohio State University marching band, its director Dr. Jon R. Woods, and assistant director Jonathon Waters, provided us with complete access to the band and their facilities. We were grateful to have the support of Raymont Harris from the Athletic Foundation and Diana Sabau from the Athletic Department. The management team from the Ohio Union, most notably Eve Esch, Bert Stebens, Beth Ullum, and Mark Fair, were wonderful to work with. They also recruited students Dan Roberts, Anthony Gilmore, Nicholas G. Dvorslak, and Daniel P. Numer to help with the photography of Archie Griffin's 1975 Heisman trophy. Jay Hansen and Rick Harrison from the Alumni Association provided helpful guidance along the way. Our work at the Schottenstein Center was aided by Leslie Lane and Dave Redelberger. We were grateful to have support from the Nicklaus Museum; our thanks to Steve Auch, Barabara Hartley, and Merideth Warriner for their assistance. We would be remiss if we failed to mention our help from the trademark and licensing office at OSU. Rick VanBrimmer, Rob Cleveland, Gretchen Webster, and Karen Dertinger were always available for questions and guidance.

Our publishing team tackled this project with unbridled enthusiasm. We were fortunate to partner with LEAP Publishing Services. Jean Findley, our intrepid editor, recommended Craig Ramsdell for the design of this book, which has proven to be a great choice. She also recommended color specialist Charlie Behlow who, along with our digital retoucher Linda Schardine from Robin Imaging, provided the beautiful color throughout this book.

Our team at David-Flischel Enterprises, LLC, was remarkable. Kim and I would like to thank Mara Mulvihill our managing editor, Suzi Jolly our senior editor, Hugh McManus our wonderful wordsmith, Joe Simon my friend and technical advisor, and Maggie David our multi-faceted production associate. A special shout out to my Columbus scout and researcher Brianna Powers. Dean Sherman and Kim Liou from Oceanic Graphic International, Inc. are acknowledged for the remarkable printing of this text. Finally, thanks to our Executive Committee: Scott David, Leo Flischel, Pat Gaito, and Kathy Smith, for their support and guidance.

Our sincere thanks,
Kimberly L. David and Robert A. Flischel

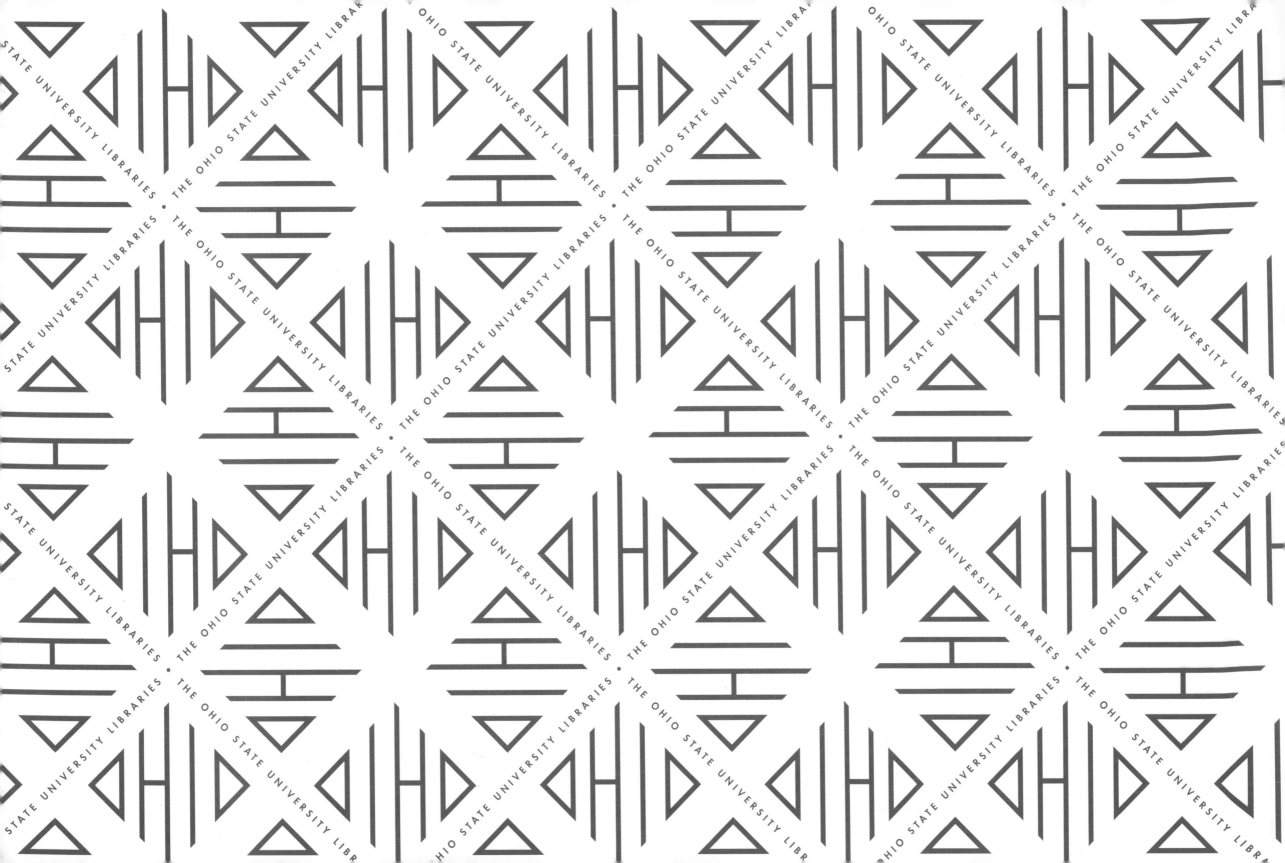